the
POWER
of
FLOWERS

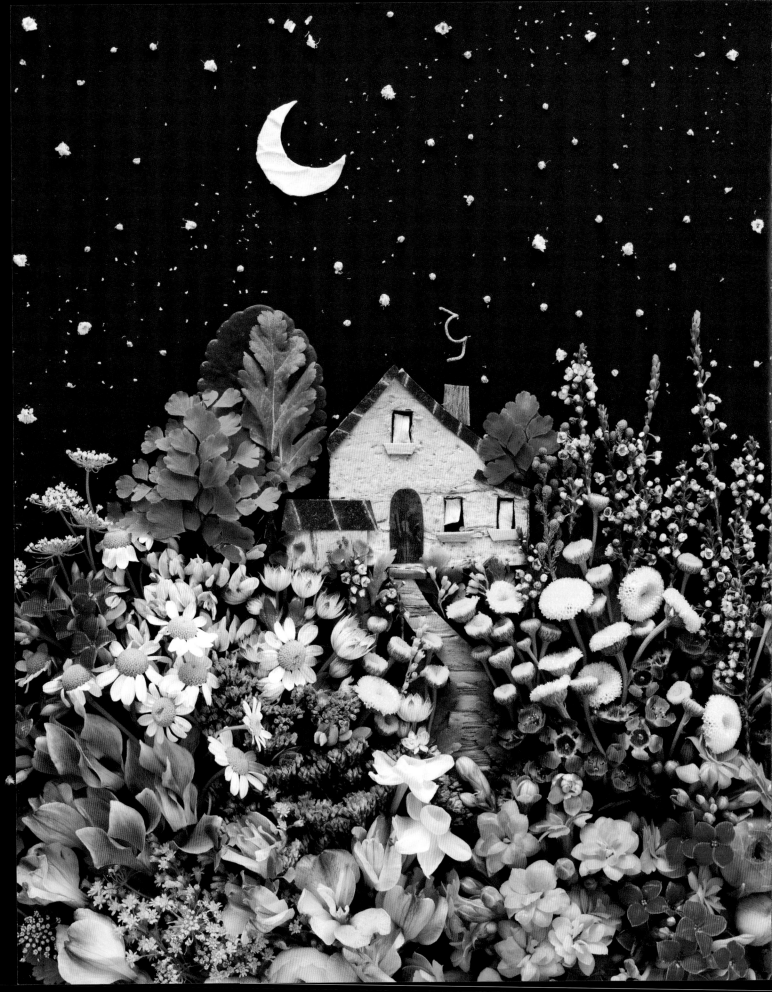

the POWER *of* FLOWERS

TURNING PIECES

OF MOTHER NATURE

INTO TRANSFORMATIVE

WORKS OF ART

FOLIAGE ART BY VICKI RAWLINS

ROCK
POINT

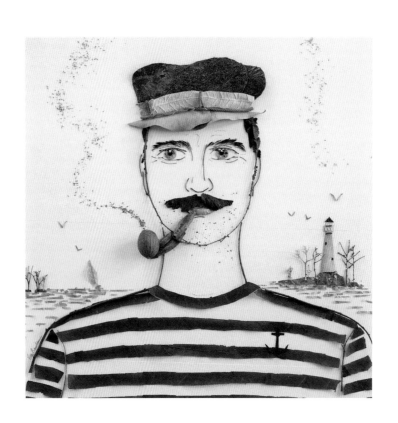

FOR CRAIG, BROOKE, AND ANDREW,

YOU ARE MY EVERYDAY SUNSHINE

LEFT: THE WANDERER · PREVIOUS: HOME SWEET HOME

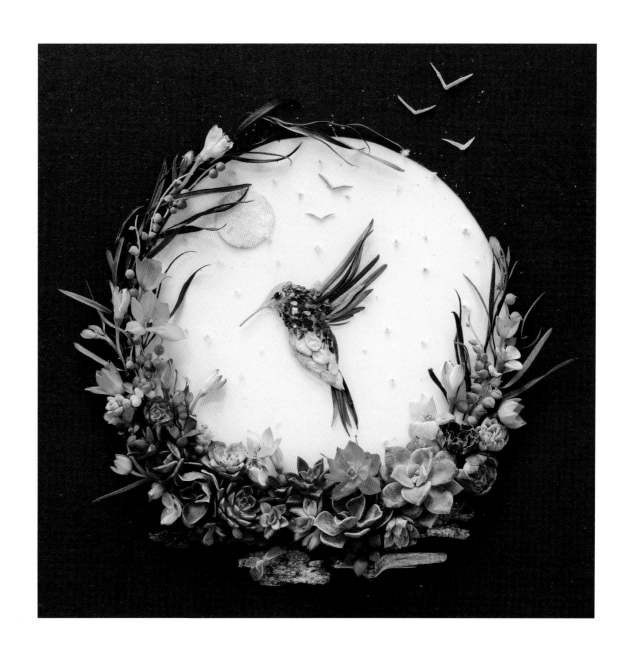

LIVE LIFE FULLY

CONTENTS

Introduction

I simply can't remember a time in my life when I wasn't creating. I can remember from as early as age five feeling deeply connected to that place within myself where wholeness lives when making art. My parents were always incredibly supportive and never asked me to reconsider my life's direction. This set me up with a nurturing environment ripe for exploration and growth. While studying fine art in school, I had a deep love for drawing, especially portraits, and for painting. My first real "art jobs" were in graphic design and freelance illustration. This wasn't really where my heart was, but it was a good place to start. Being born back in 1960, I've had plenty of time to explore many mediums over the course of my life. Each medium is very different, but I knew that if I felt a connection to it, it was worth delving into. I believe this is a healthy exercise for an artist at any age.

My mother taught me how to sew when I was in high school, and I wound up making a lot of my own clothes. While living in downtown Chicago as a young adult, I found myself painting on fabric, then turning that fabric into handmade pillows and clothing that I sold to boutiques. Being able to combine painting and sewing into creating usable art was really exciting and prompted me to break out of my artistic safe place. I think of this time in my life as "the exploration phase." Being in school and always having someone tell me what I was going to be creating made me want to explore what else was out there *for me*.

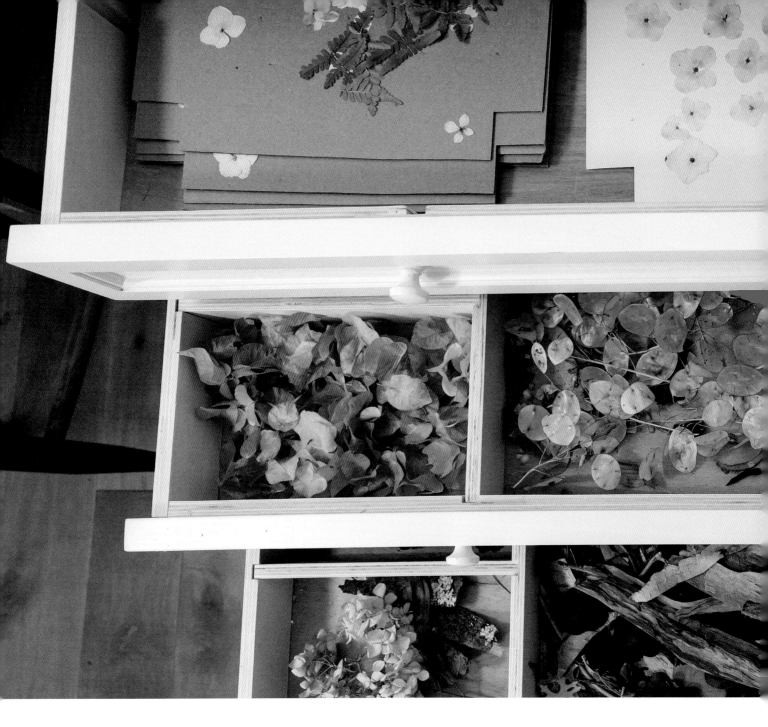

Every time I walked into any art supply store, my mind would explode with the endless possibilities for creation (this hasn't changed). Polymer clay was one of those things I just knew I had to try. I had always wanted to work with clay, but aside from at school, I was never in a situation where I could use a kiln. Polymer clay, for me, turned out to be the ticket. I could mold and sculpt tiny faces, flowers, insects, and even little pieces of furniture, to create miniature scenes. No kiln required! I then turned these creations into jewelry, frames, and very detailed mirrors, which I was able to sell.

Once my young children started school, I got back to my painting. Only, this time it was on walls and ceilings, painting murals for some of Chicago's top interior designers. Working for someone else as an artist can be

a challenge. They were counting on me to bring their vision to life and to do it flawlessly. At times, I was pushed to my limit mentally and physically. Working out the logistics on some of the murals was like solving a very complicated puzzle. During this time, I learned so much and met some incredible people while also working in the most beautiful spaces. I ended up doing this for over 10 years, until my body finally said "no more" to the ladders that mural art required. It was time to listen to my body, and to my husband who encouraged me to rent studio space and get back to painting on canvas. It was like coming back to an old friend after a long time away.

Sometimes, just when you think you have things all figured out, life has other plans.

This is the part of the story I never thought I'd be telling, but sometimes things aren't all cupcakes and rainbows. I believe the messy, hard parts of life are worth sharing. Especially because, in the end, they have gifted me so much.

About 10 years ago, almost immediately after finishing a 10-day round of a common antibiotic, my health began to decline rapidly. It became so unbearable, and I was so ill, that I ended up in the hospital seeking the help of countless doctors and specialists before I was finally diagnosed with antibiotic poisoning. A fluoroquinolone antibiotic literally turned my whole life upside down. The list of symptoms sounds just like all the TV pharmaceutical ads we collectively cringe at. Disabling and potentially permanent, these symptoms include a full-on attack of my central nervous system along with tendon, muscle, and joint damage. I was experiencing debilitating neuropathy, muscle and joint pain, difficulty walking, burning skin, vision impairment (neuropathy in my eyeballs!), and so much more.

My life was completely devastated. On most days, all of the symptoms were happening at once. On some days, I

couldn't feel my legs from the waist down, literally feeling like I had been struck by lightning. The palms of my hands felt like burning cigarettes were being snuffed out on them, and holding anything was difficult because they were so painful or numb. I had intense pain and neuropathy from head to toe, inside my body and out.

As time went by, and the symptoms persisted, I was frightened for my future. This was not fitting into my "50-years-old-and-enjoying-life" plans. Not at all. There also came a harsh realization that nobody was going to fix me. The doctors didn't know how to further help.

Somehow, I was going to have to figure my way out of this, and that started with creating a "new normal." I just kept wondering if I would ever get back to doing the one thing that, for my whole life, had made me, me. Being able to create art was always the lifeline to who I was. Art was where I got lost, where I was in my flow, and where I felt complete. At this time, more than ever, I needed art as a distraction from my fear.

I've always believed that things happen *for* us, not *to* us; we just need to figure out what the universe is asking of us, and why. From me, it was asking for small steps.

> "Flowers reconnected me with the outdoors, bringing all their beautiful color and joy inside."

I had some paintbrushes at home that I knew would be a killer for my painful hands to hold, so I wrapped the brushes in ace bandages (which I thought was pretty clever!). This helped me get back to painting on a 5"x5" watercolor pad. It was a step, albeit small, and I was thrilled. Being able to work on a small scale allowed me to paint in my home and not feel guilty about not being in the studio. Little did I know that home would turn out to be the perfect place to create.

Home, at the time, was a sun-filled, third-floor condo two blocks from the Northwestern University campus in Evanston, Illinois. It faced east and south, and I always felt so grateful to have beautiful light all day. Secretly, in low moments, I sometimes thought to myself, *If I ever do end up completely disabled from this illness, the condo would feel like a tree house—safe, with a bird's-eye view of everything.*

Spending so much time at home, having fresh flowers from the local florist in a vase on my kitchen island always made me feel renewed and hopeful. Flowers reconnected me with the outdoors, bringing all their beautiful color and joy inside. Typically, when the flowers started to wilt, I'd take out the old stems and redo the bouquet to keep everything fresh. One time in particular, I left them to wilt. After a few days I had a pile of petals lying around the mostly dead arrangement. I remember scooping up the petals and going to sit by my windows. I started to push them around, no plan in mind; I was just having fun. I began to form a face with rose petal lips, then kept filling it in with more and more details. I loved the whimsical nature of how all the botanical bits, if arranged in the right way, looked like something else. Suddenly, there was a spark, a light, that just filled me up as I was arranging those petals and stems! I was getting lost, back in a flow, and doing something different than I usually did. This was a much-needed surge of new energy. So, day after day, as if it were a self-prescribed therapy, I'd head back to my window to sit and play with flowers.

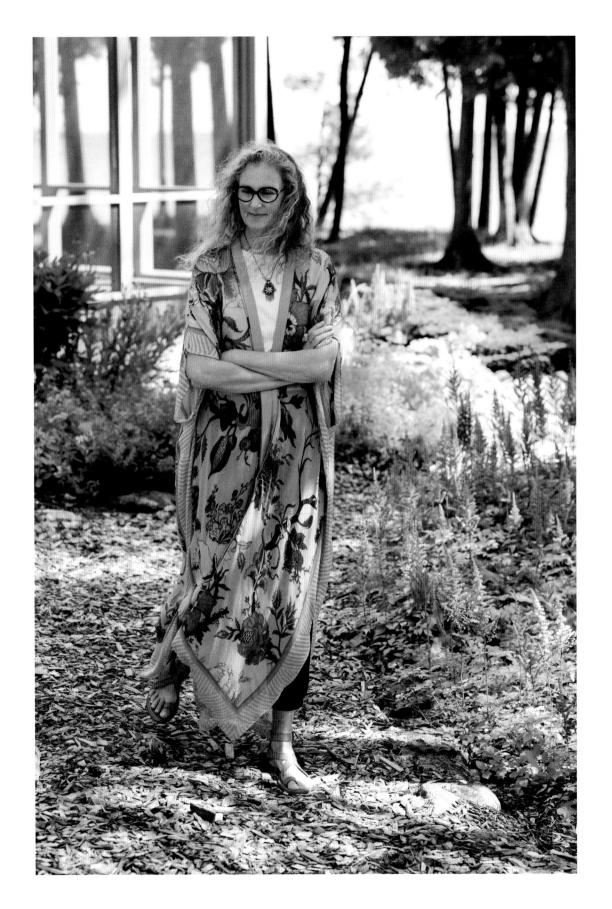

I've always said that working with plants "showed up" for me. Out of all the mediums I've used to make art, foliage art pushed me out my door and into the outside world again. It would have been so easy to just stay safe inside and paint. I had been frozen in fear: Fear of walking, fear of moving, fear of setting off a pain cycle that would steal my day from me. I remember timidly staying very close to our building to find foliage to work with. There was a basswood tree nearby, a locust tree just steps away, and bushes with vines I could use without going too far. Sometimes, I'd get my husband to drive me to the Northwestern campus so that I could gather leaves from under the trees in the fall. But, little by little, over time, I took more steps away from the condo, on my own. Small steps…

down the alley…out to the street…around the corner… For the first time in a very long time, I was focused on creating, rather than my pain.

It's been a little over seven years that I've been creating art with gathered foliage. It's also been seven years since my daughter, Brooke, came to me with a crazy question. "Mom, will you start a business with me?" I heard myself say yes, but everything inside of me was saying no. I should have seen this coming: We had talked numerous times about wanting to have a space where we could sell the work of independent artists doing one-of-a-kind handmade work. After all, Brooke had grown up with a mom who was an artist, and sharing art with the world was important to both of us. But for me, the timing

felt wrong. I didn't feel ready at all. I was now in a very unpredictable body and still getting used to navigating life in a new way.

I asked her how she thought we would start such a thing. Brooke was living in La Jolla, California, at the time, a four-hour flight away from where I was living. She said, "We start with your artwork, online!" Good thing we were on the phone and not talking in person so she didn't have to see the freak-out I was actually having when I heard myself say, "Oh yes, great idea!" I hadn't been consistently creating for a while and felt hesitant to jump in. Brooke persisted though, and Sister Golden, our store, was born. We started by selling prints of the watercolor paintings I had been working on from home.

Meanwhile, I was creating more and more with foliage and becoming completely obsessed with it, until finally painting had taken a back seat.

Once again, it was like the universe was showing up for me, forcing me out of my comfort zone. Today we not only have our online business, but we also have a thriving brick and mortar store in beautiful Door County, Wisconsin. As we were remodeling the building that is now home to our store, I told Brooke that we'd use the back room as a storage room. The first words out of Brooke's mouth were, "Are you kidding me?! It's going to be the gallery for all your flower art!" Thank goodness for all the people in our lives who see what we can't and push us to where we need to be.

Therapeutic Foraging

I start my pieces by taking a walk down the street, a stroll around my yard, or anywhere that inspires me. It's like "earthing" or "forest bathing" to me—very therapeutic. As I walk, I try to empty my mind and just connect to what's around me. I'm not really looking for anything specifically, I'm just attracted to anything that looks interesting, especially dried seeds or pods, colorful foliage, and unusual leaf shapes. The most fun are the times I have unexpected foliage finds. For example, finding beautiful brown leaves in the CVS parking lot, of all places! I used them for the windblown hair in the piece *Wild Heart (page 118)*. A good foliage find is always worth the stares from people passing by. It's fun being able to forage in two completely different parts of the country during the year. In Door County, where I spend the summer months, I'll find things like Queen Anne's lace, daisies, black-eyed Susan, chicory, sweet peas, white yarrow, mushrooms, goldenrod, and lots of thimbleberry. In La Jolla, where I am during the winter, I use all different varieties of succulents, roses, poppies, lupine, hibiscus, camellia, jasmine, birds of paradise, bougainvillea, eucalyptus leaves, paperbark, and mimosa. The beach down the street is great for sand, little shells, and small pieces of driftwood. Let's face it, the beach is good for everything!

No matter where I am, I'm always excited to get started once I have a handful of something green.

Studio Time

My studio in Door County is just steps away from our home on Lake Michigan, surrounded by tall pines and maple trees. It's not hard to get inspired here, as I always feel completely immersed in nature. Working with natural lighting is the only way I like to work, so I have a table set up near windows facing north and east. Because I'm using live foliage, for the most part, I need to work rather quickly before things start to wilt or shrivel. This gives me a couple of hours to build my piece before I take photos. If I think it will be cloudy and the lighting won't be great for pictures, I won't even start a piece.

In La Jolla, my workspace is light-filled all day, every day. Here, I find I need to block out streaming sun to get just the right light for photos. It's a good problem to have! I would say that the majority of my work is actually created in La Jolla. It's my time to really focus, away from my busy summers in Wisconsin.

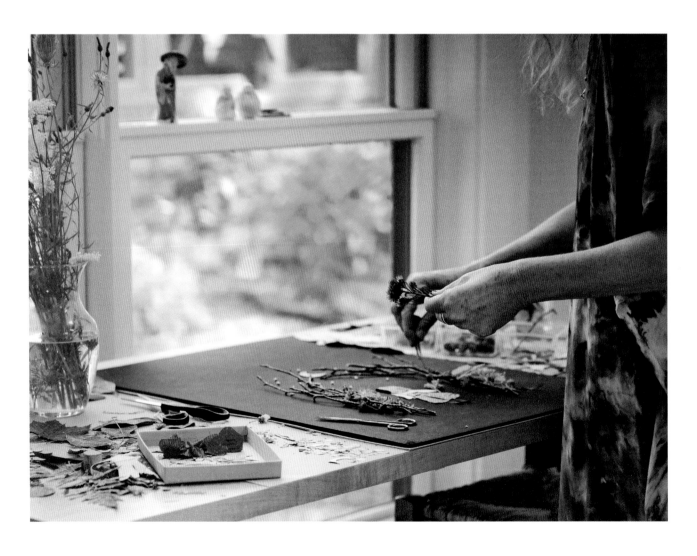

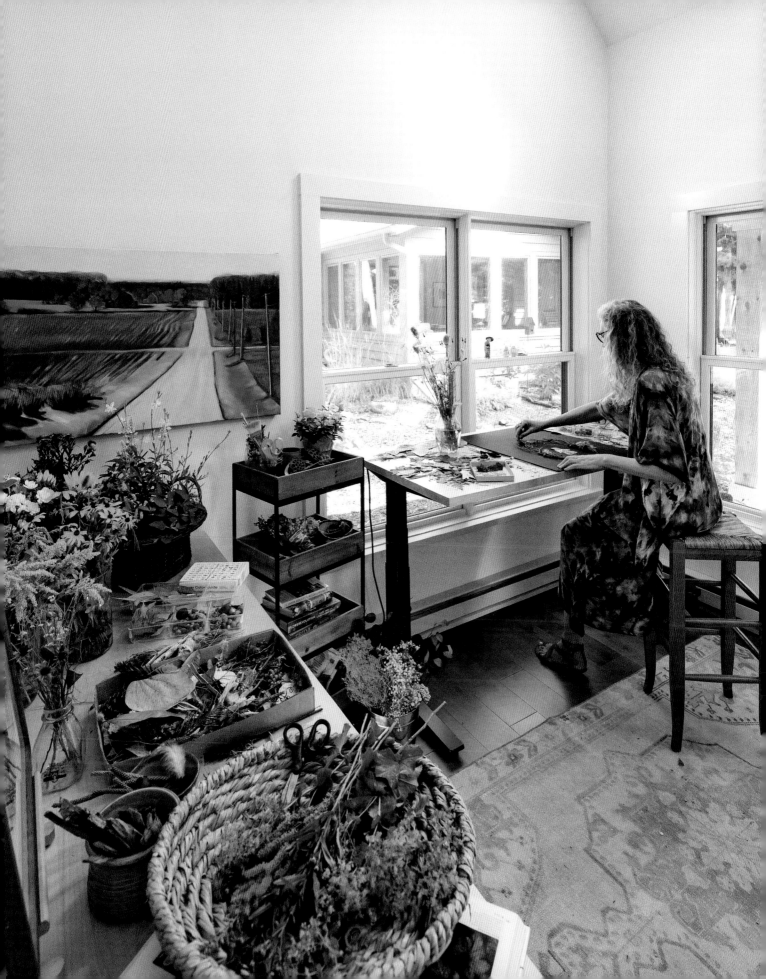

"I take all the foliage outside to recycle it back into the earth for a new life."

I don't have a ceiling fan in my studio, and I won't keep windows open close to my table. These are real hazards for an artist who is counting on gravity to be her glue. Even with these precautions, there have been times when I've walked back into the studio to find parts of a face completely messed up from some adventurous bug who's decided to take a stroll through my work.

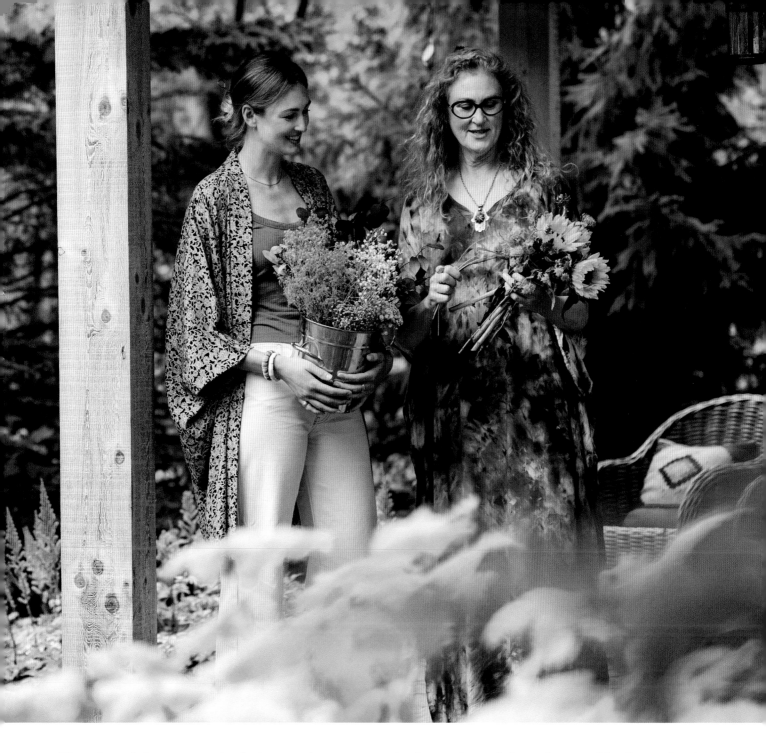

The only tools I use are a pair of scissors and tweezers. Tweezers are a must so that I can place all the small details without disturbing anything else around. I've learned that lesson the hard way! Since I'm not gluing anything down or adhering things to my background surface in any way, it's all just delicately balancing on my board. A little bit like Tibetan Buddhist sand paintings, where they're creating and destroying mandalas from colored sand with the intention to create positive energies in the environment and the people who view them. It's really why I fell in love with working with foliage. I love that everything I'm doing is impermanent. After I photograph my finished piece, I take all the foliage outside to recycle it back into the earth for a new life.

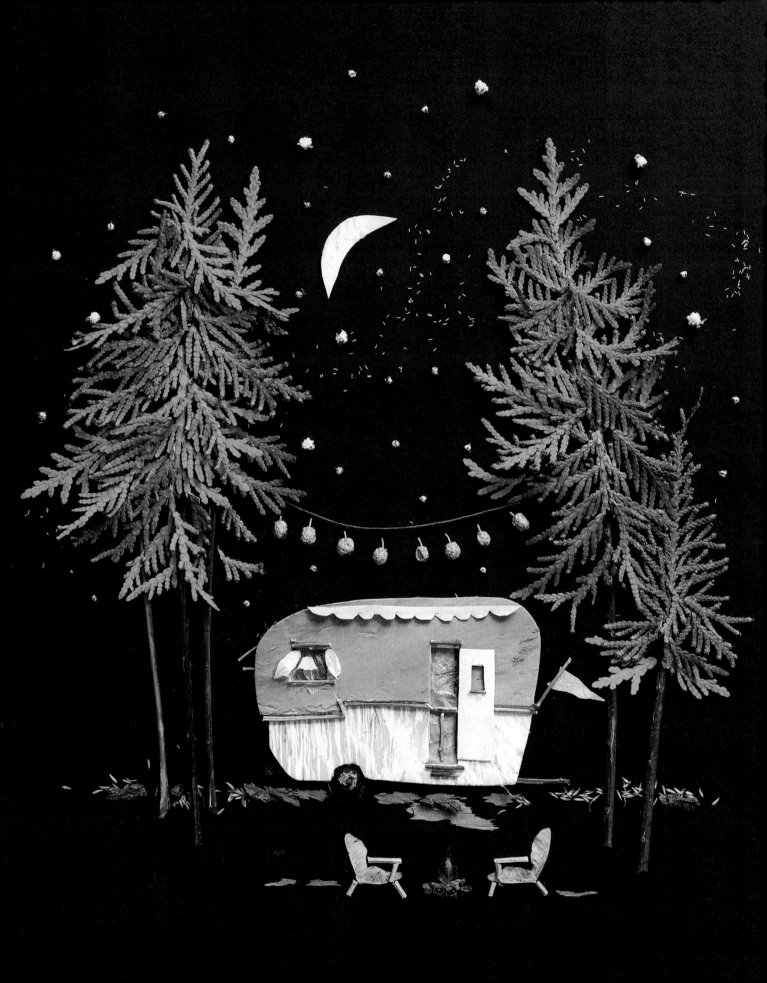

Under the Moon & Stars

I have fond memories as a child of laying in the grass, gazing into the night sky, and pondering what I was really seeing. It always felt almost unreal and yet somehow I knew I was connected to whatever was going on so far beyond me. Living in Door County, I have witnessed some of the most incredible night skies, from moonrises that felt like sunrises to milky ways so dense there seemed to be zero space between stars. Working on a black background naturally lends to contrast for stars and moons to twinkle and shine. Each of these pieces celebrates time, dreaming, making wishes, and connecting to the universe.

ADVENTURE AWAITS

Working so close to Peninsula State Park, I get to see amazing campers and tents of all shapes and sizes. I haven't camped in a very long time, so sometimes in the summer my husband and I will just take a slow cruise through the park to see all the great camping set ups. We love smelling the campfires and seeing family and friends gathering together under the stars and trees.

UNDER THE STARS

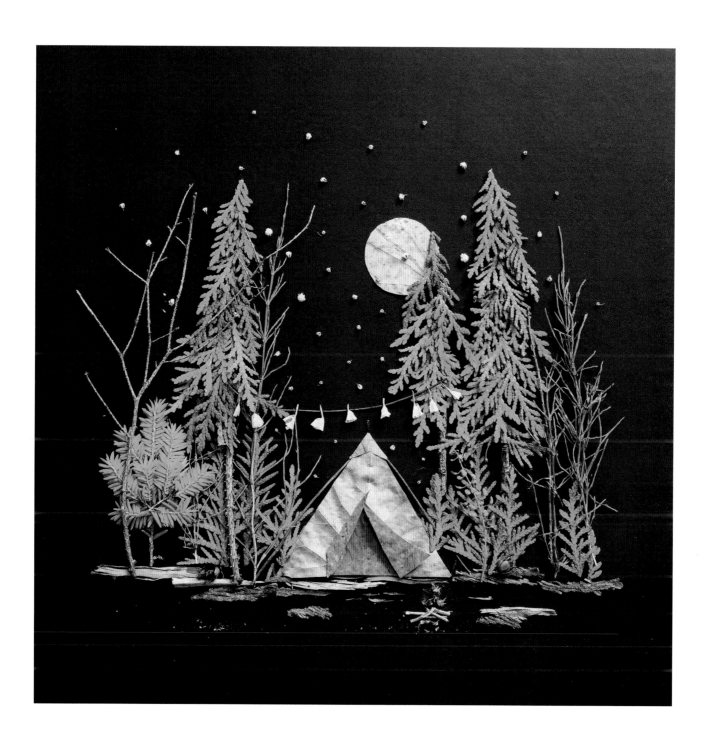

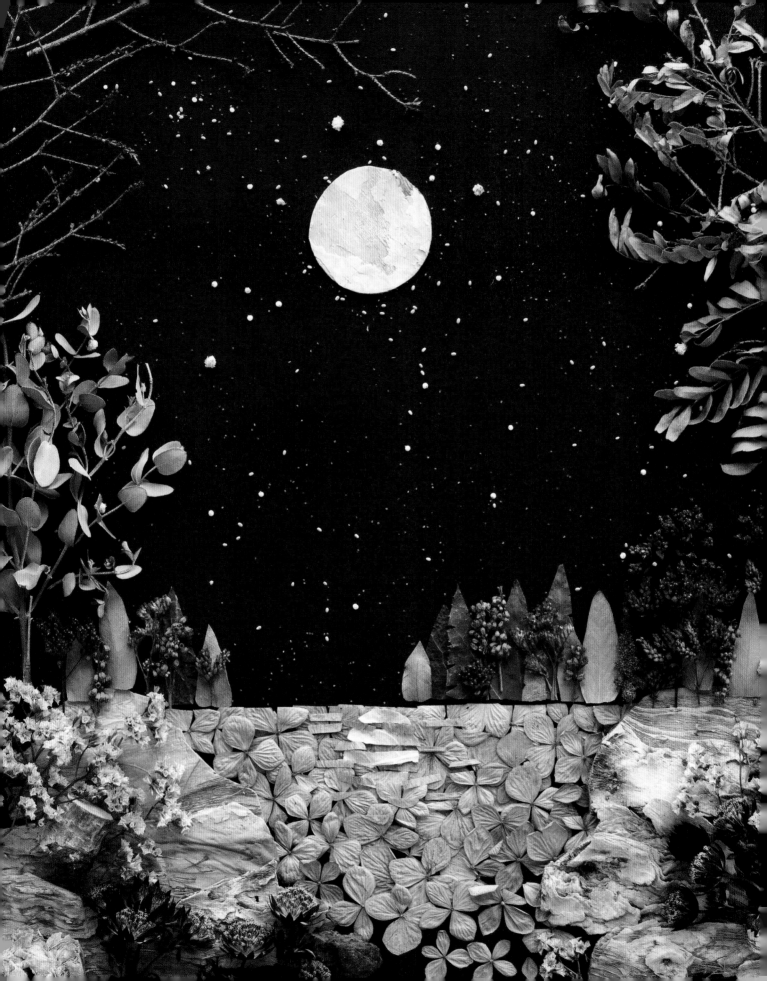

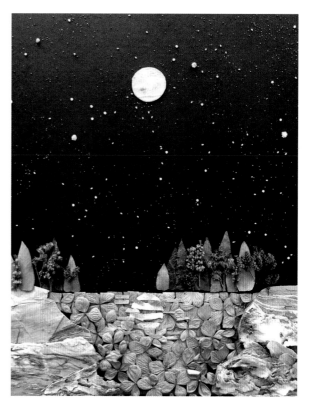

PINK MOON

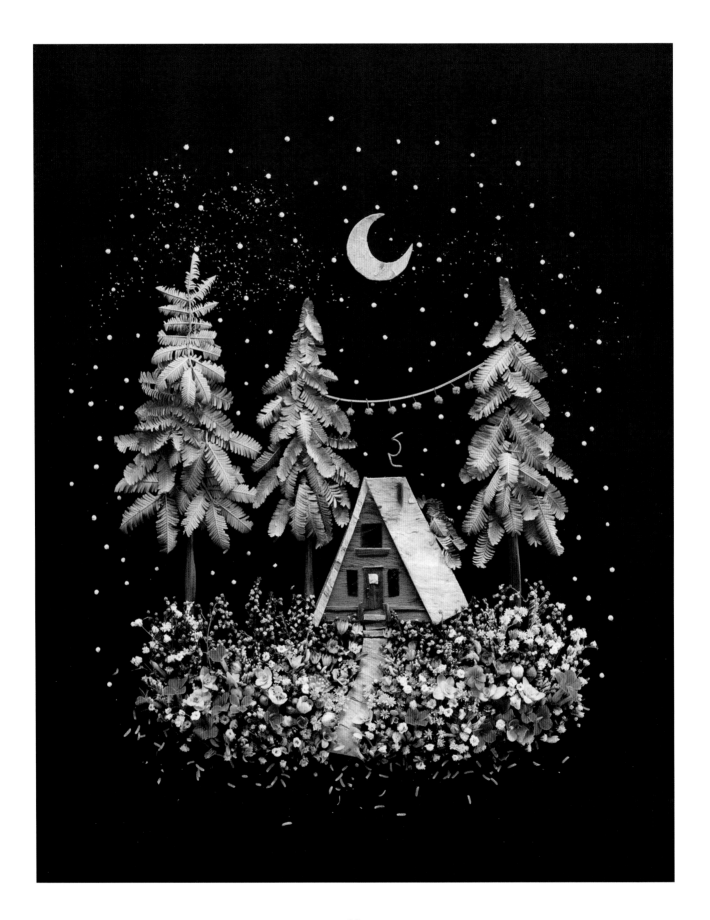

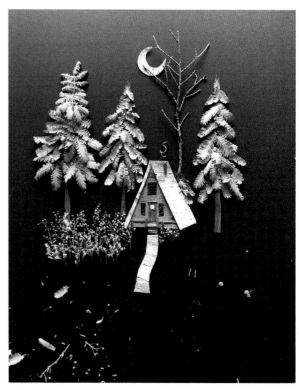

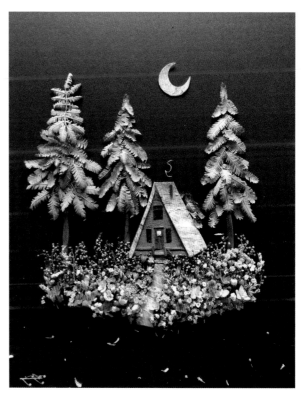

A-FRAME

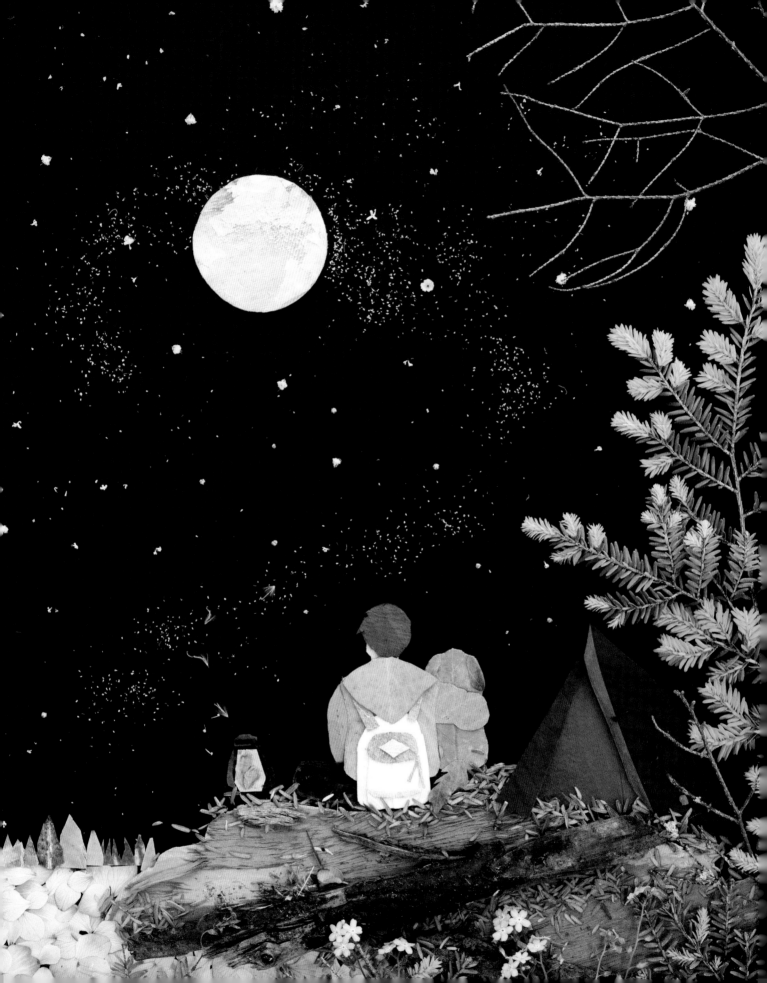

After I completed this piece, I had a moment where I realized that this was a boy who seemed to be looking into the sky to find shapes created from stars. Just as I was an artist walking through the vast world of nature gathering leaves and flowers to create things that would be reimagined from what they originally were: A boy, his dog, and a tent. In the words of Van Gogh, "I know nothing with any certainty, but the sight of the stars makes me dream."

STARGAZERS

Silent Night was much less about creating a scene as it was about creating a feeling. Made from cedar foliage, branches, and fall leaves from my yard, this tiny little house is getting a warm hug from the tall pines surrounding it. There's a feeling of being safe and cozy here, sitting by a fire and reading a good book. My favorite little details are the smoke from the chimney and the red cardinals flying through the trees above. The "snow" is made from baby's breath and carnation petals.

SILENT NIGHT

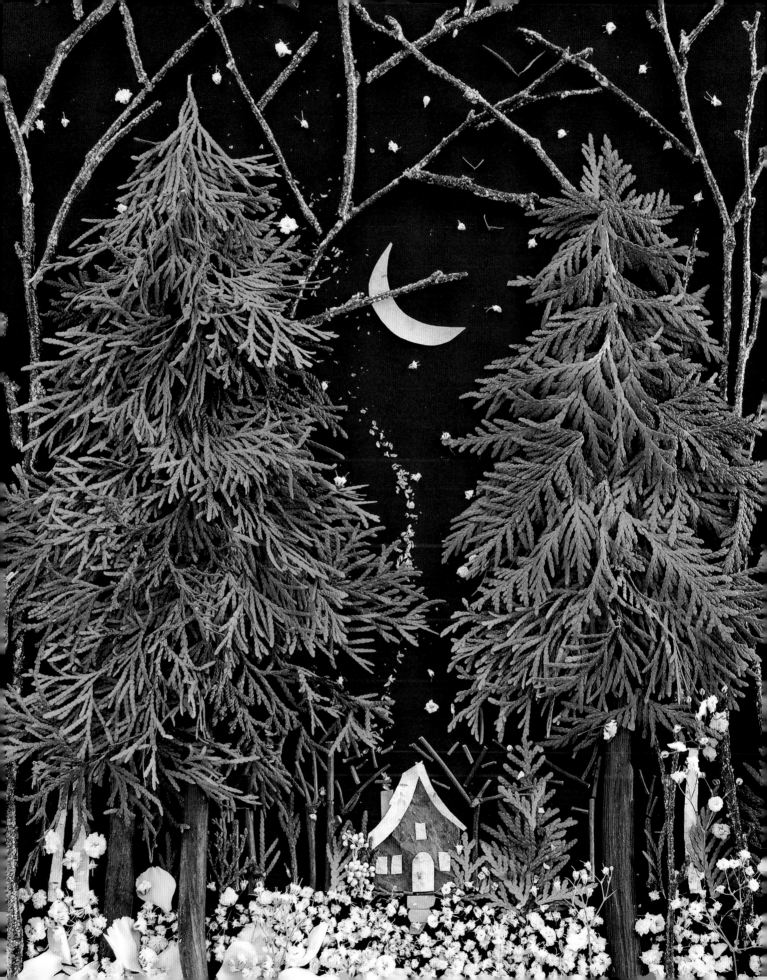

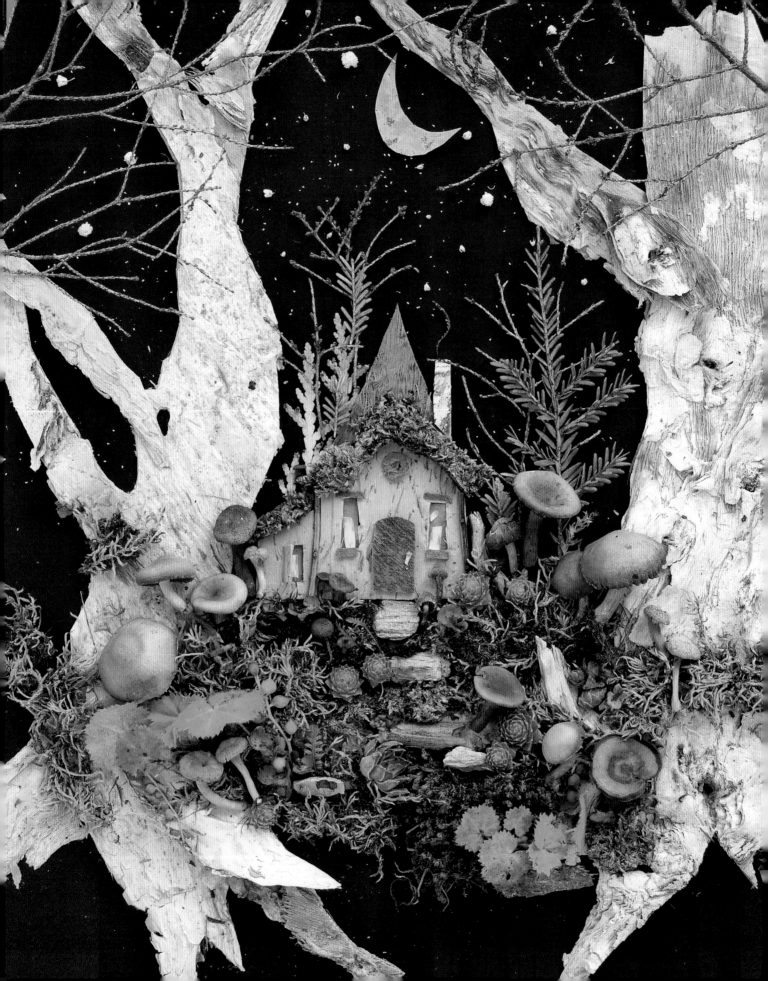

There's a very old hemlock tree that lives behind my studio in Door County. The bottom of the trunk is hollowed out and holds what looks to me like a miniature world filled with rotted bark, lime green moss, and a family of the sweetest little mushrooms. I've always imagined it to be a little Mushroom Inn for fairies and gnomes needing rest after a long journey. I'm sure it holds many silly secrets!

MUSHROOM INN

I know I'm probably not supposed to pick favorites, but I love succulents and this piece was an absolute joy to make. I remember living on Sea Lane in La Jolla for the winter and walking down the street to find all the small greenery that would turn into the "large" tropical plants along the sides of the scene. Most satisfying to me is the time I get to "paint" with live foliage, carefully selecting color and texture that, when placed next to each other, will create visual harmony. This is why I love working with plants.

PARADISE COVE

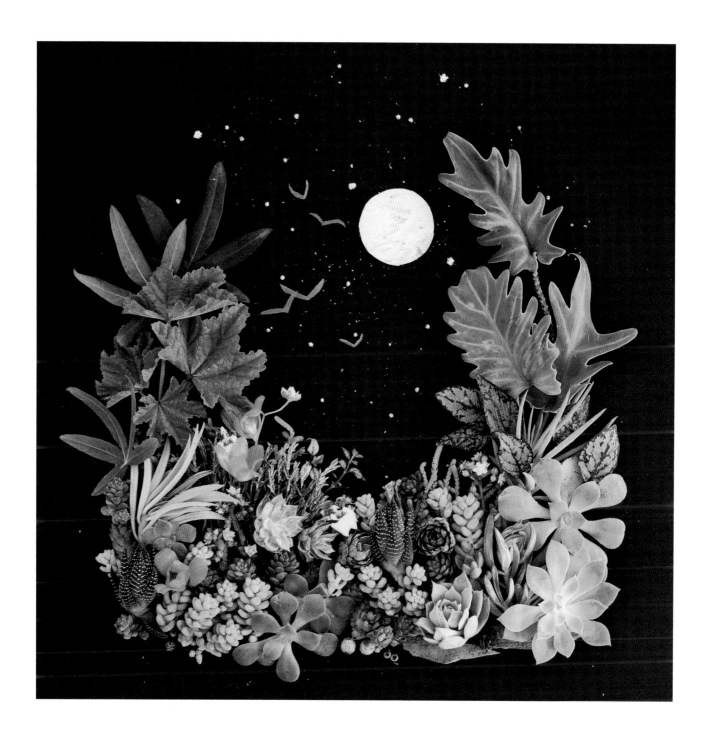

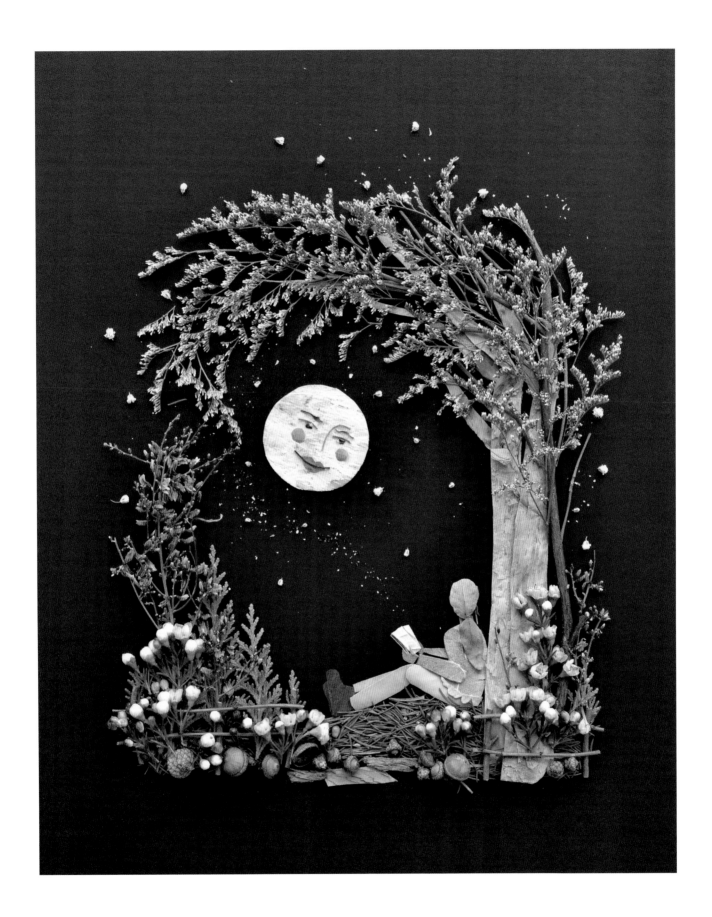

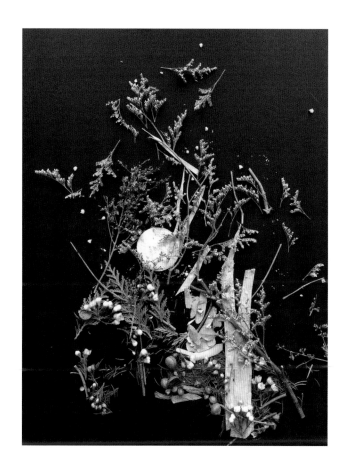
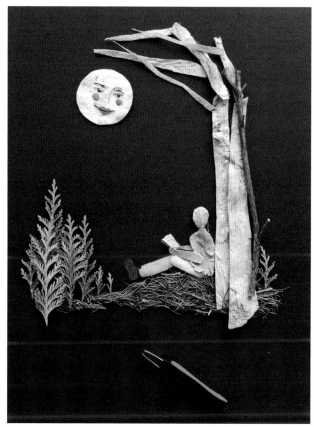

MOON & ME

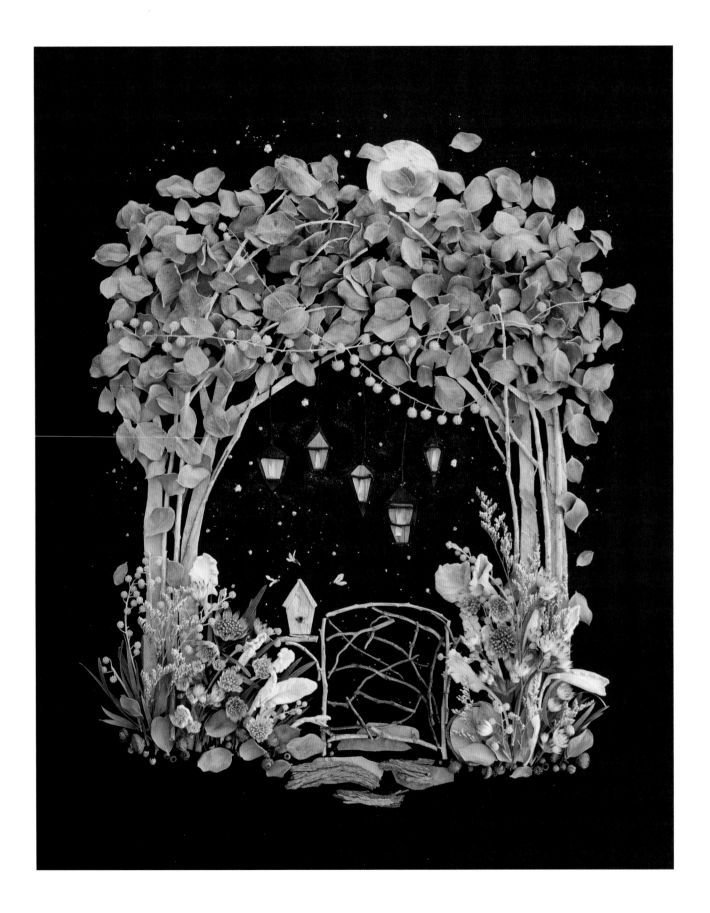

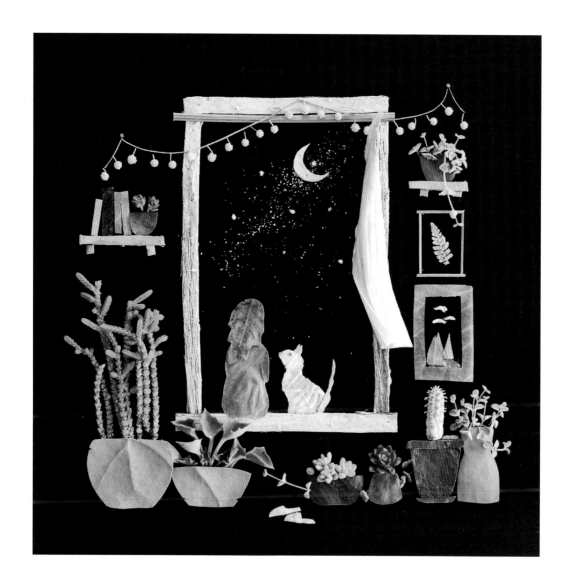

The original inspiration for *Stardust* was the "curtain" I found on the sidewalk. This little room would have been my teenage dream-bedroom: A huge window with twinkle lights above and a sill large enough to sit on to contemplate the night sky, surrounded by potted plant-babies, my favorite art on the walls, and a fur baby to share all my dreams with. What are dreams made of? Bamboo, mimosa, palm frond, eucalyptus bark, dusty miller, dried leaves, and of course, succulents.

LEFT: MOON GARDEN • ABOVE: STARDUST

Driving home from Brooke's house one evening, I experienced this very scene. The sky was dark, and I looked up to see the moon just sitting in a cloud, glowing. The fields below were lit with such beauty from the rays of the moon that I had to remember to keep my eyes on the road when suddenly, out of nowhere, flies a sweet surprise. Barn owls are a very rare site to see because they are usually only out at night. These owls hunt over open fields and meadows and have excellent low-light vision. Catching mice in total darkness is one of their transcendent superpowers.

NIGHT OWL

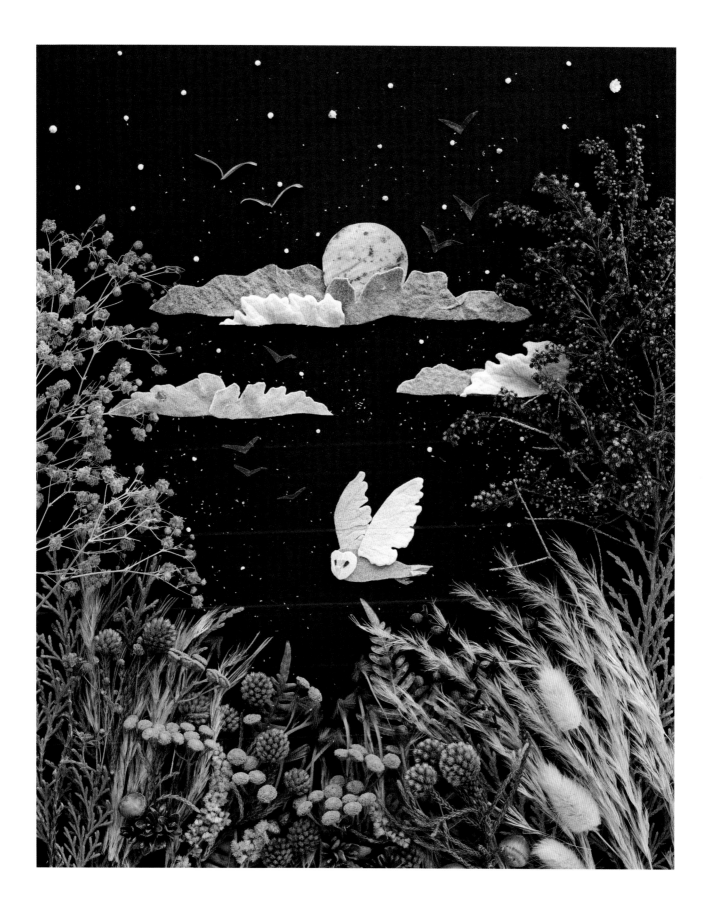

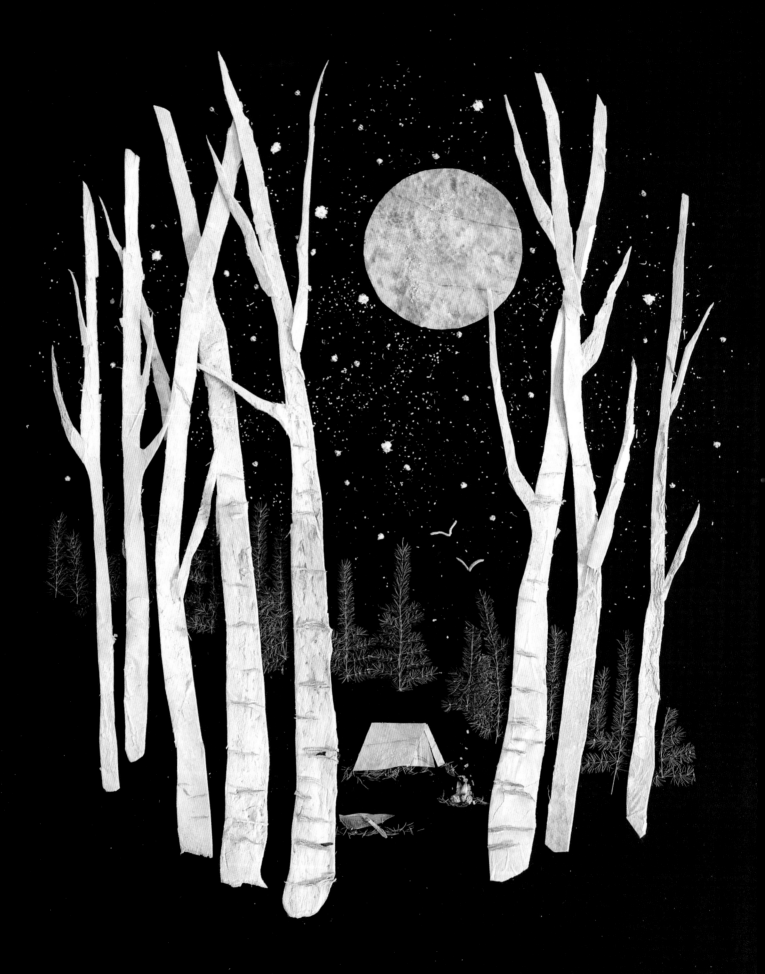

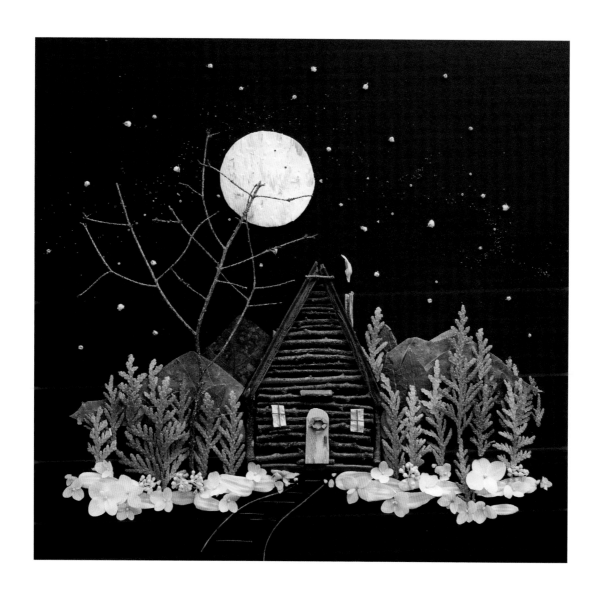

LEFT: SUPER MOON • ABOVE: UP NORTH

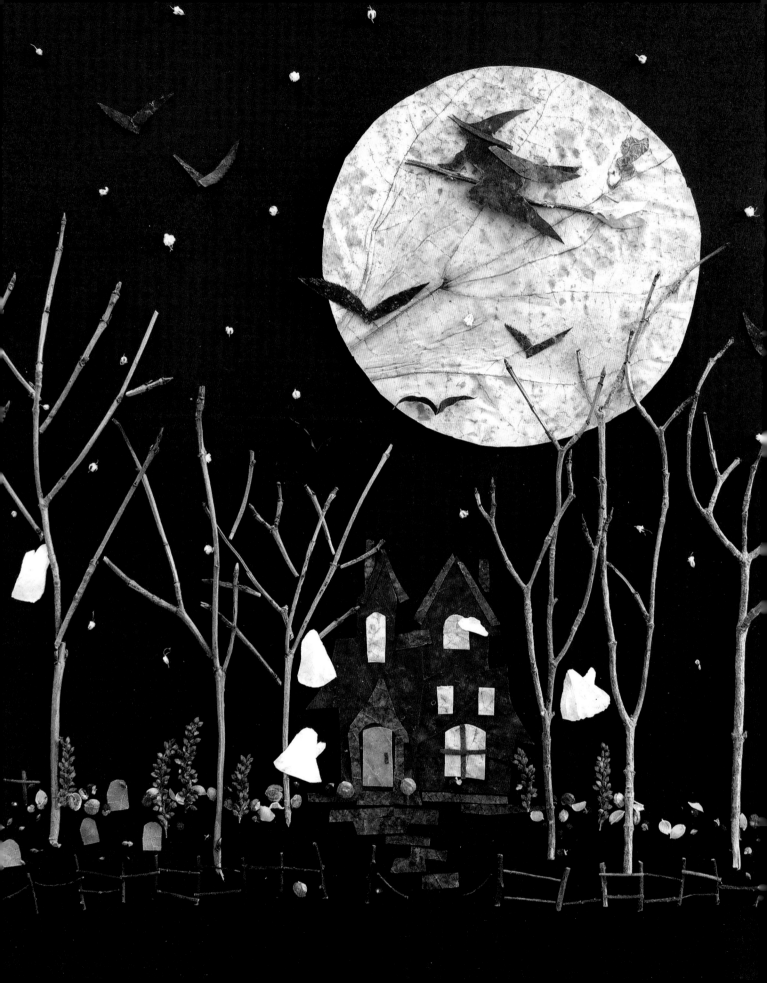

Happiest
of
Holidays

Halloween costumes made out of cattails and dusty miller, Japenese lanterns become pumpkins, and fall leaves transform to scary bats. Creating holiday pieces, for me, is all about re-creating those warm fuzzy feelings. I get the pleasure of reliving each holiday as I move foliage around on the studio table. I want every piece to feel magical and to bring back childhood memories: The twinkling lights, glowing candles, warm fires, watching holiday movies, and gathering with friends and family. The fun is always in the details that bring each piece to life.

HOCUS POCUS

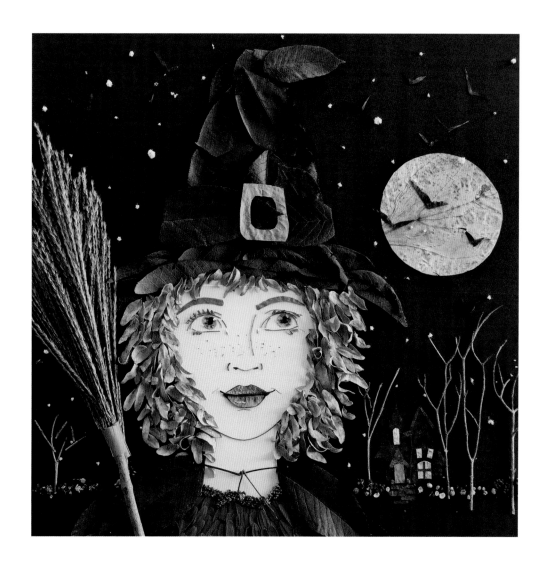

WITCH HAZEL

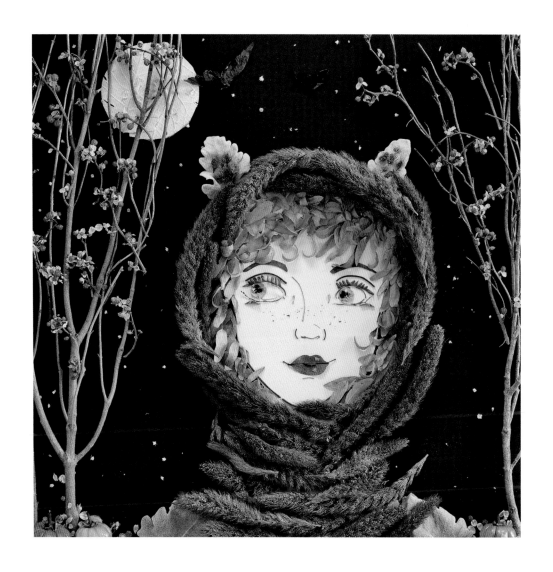

HAZEL IN COSTUME

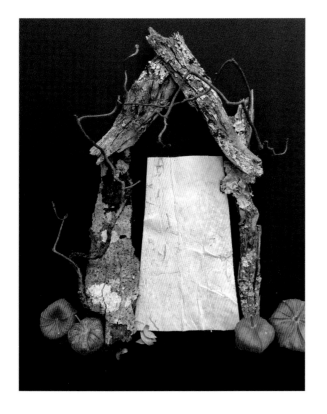
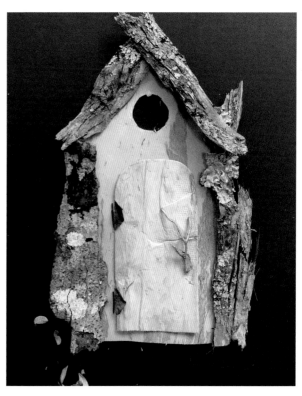
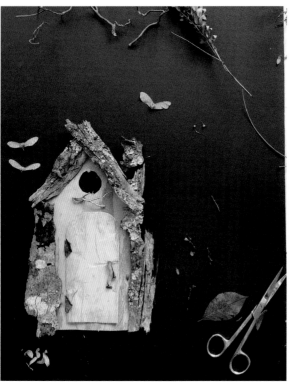
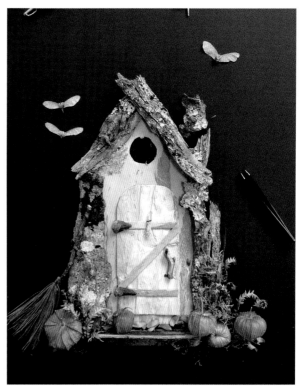

BOO

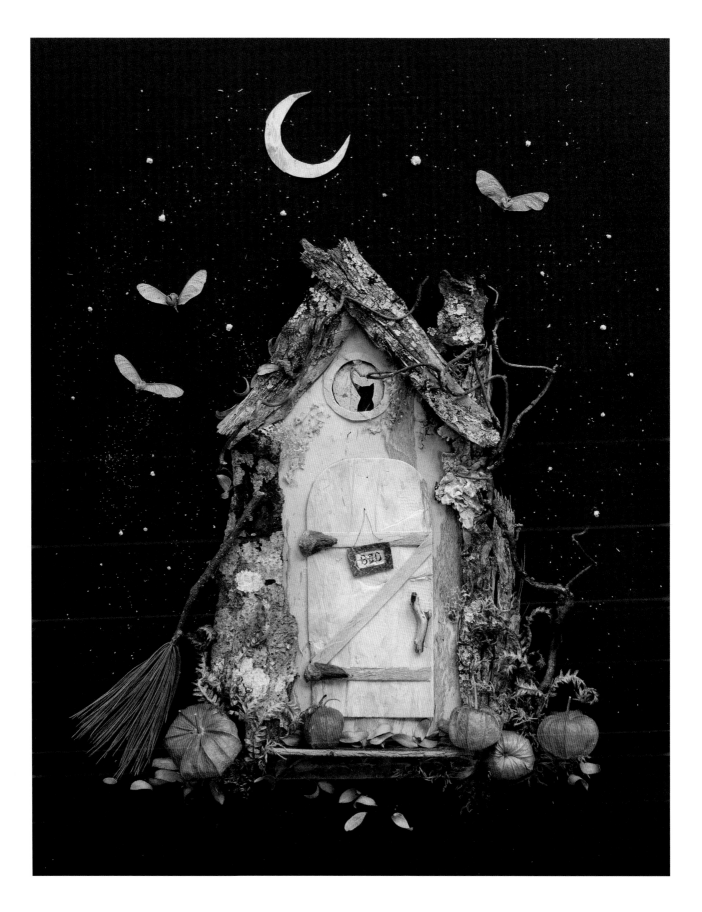

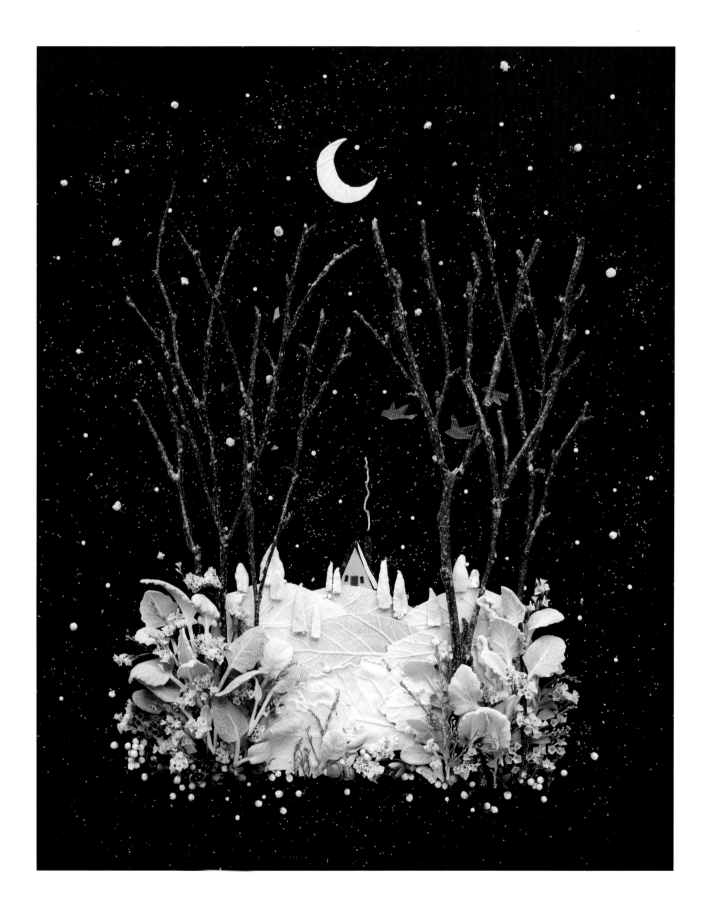

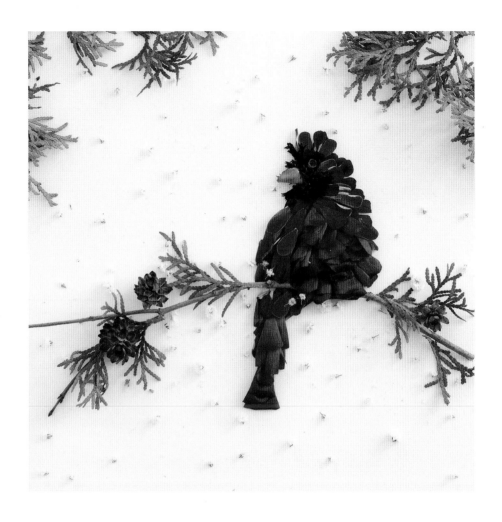

It is said that when a cardinal shows up in your yard it's a visitor from Heaven. What a beautiful thought! They also symbolize friendship, love and devotion, good luck, and messages from the angels.

LEFT: FLIGHT OF THE CARDINALS • ABOVE: CARDINAL

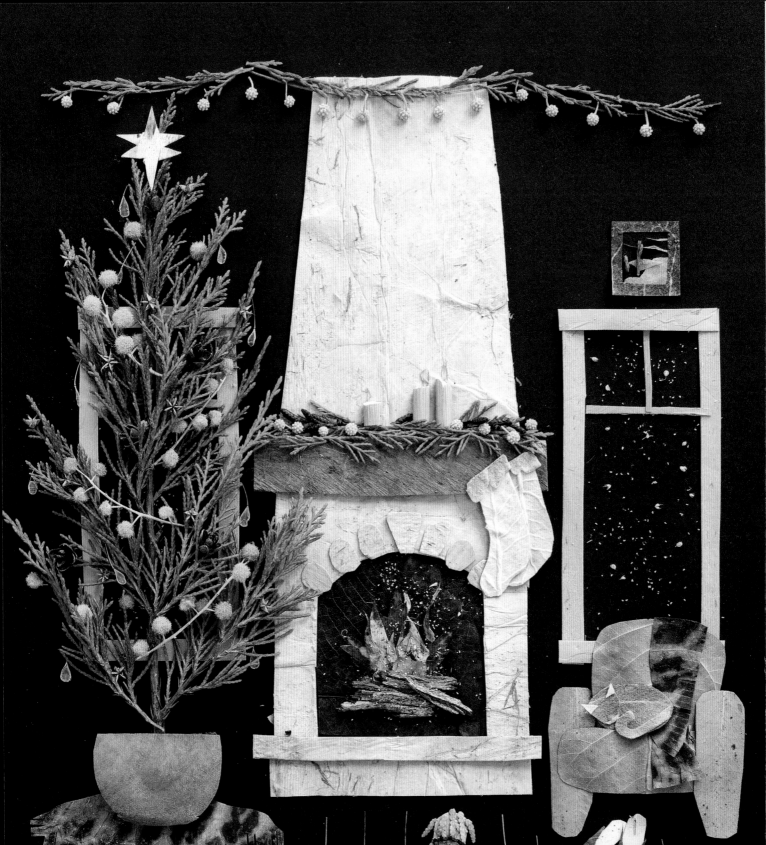

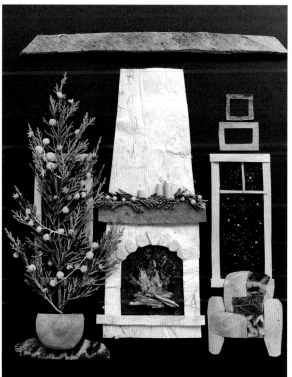

FIRESIDE FRIENDS

Many believe that a Full Moon has the ability to purify and release fear from our souls. This moon phase can also represent transformation, fertility, abundance and more. Many Native American cultures honor the Full Moon each month by giving it variations on special meanings and representations: January's Wolf Moon, February's Snow Moon, March's Worm Moon, April's Pink Moon, May's Flower Moon, June's Strawberry Moon, July's Buck Moon, August's Sturgeon Moon, September's Harvest Moon, October's Hunter's Moon, November's Beaver Moon, and December's Cold Moon. Each carry with it unique and resplendent power.

MOONLIT FOREST

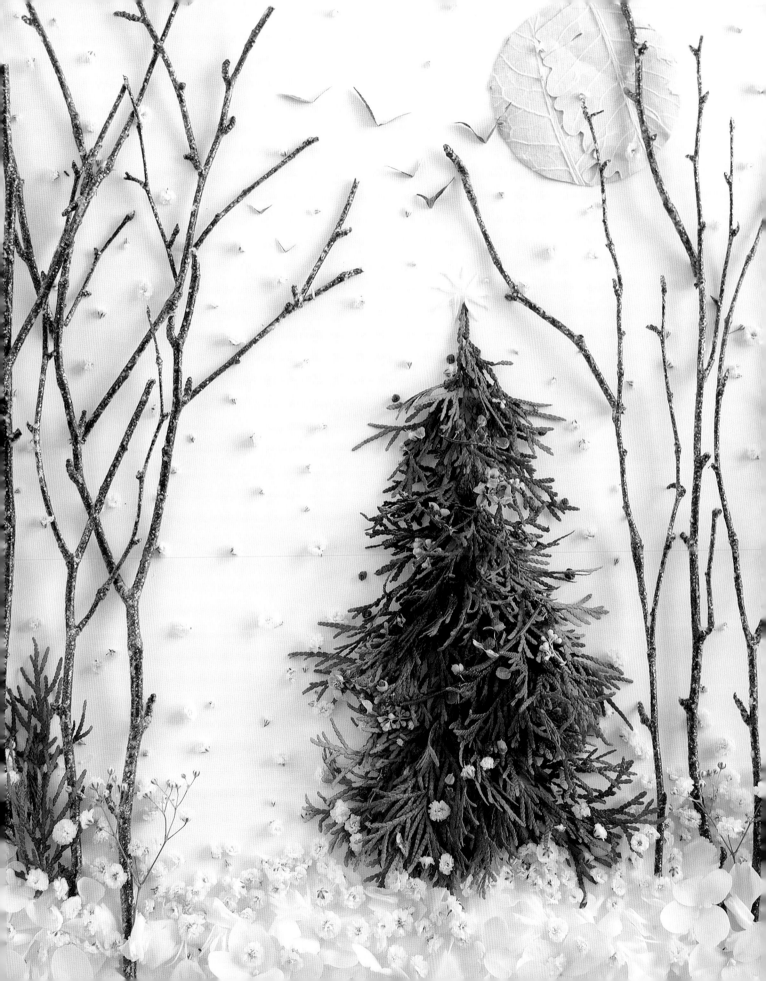

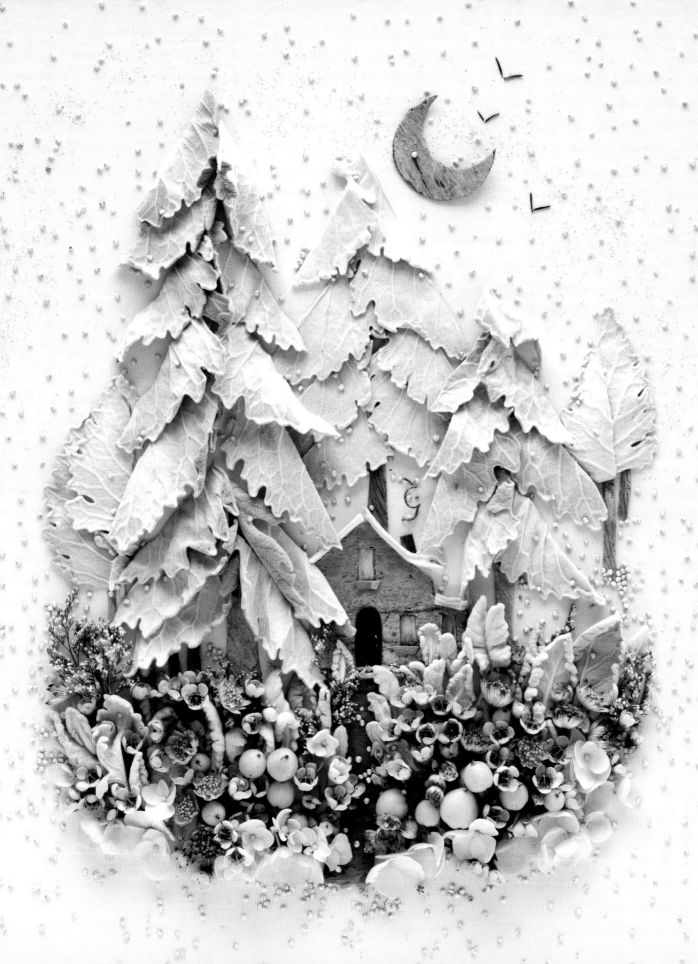

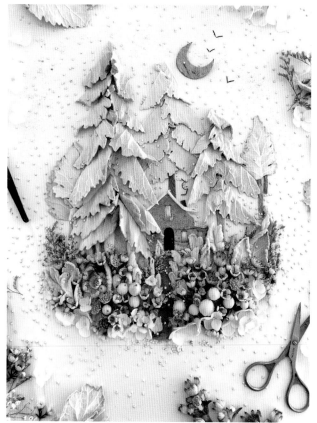

WHITEOUT

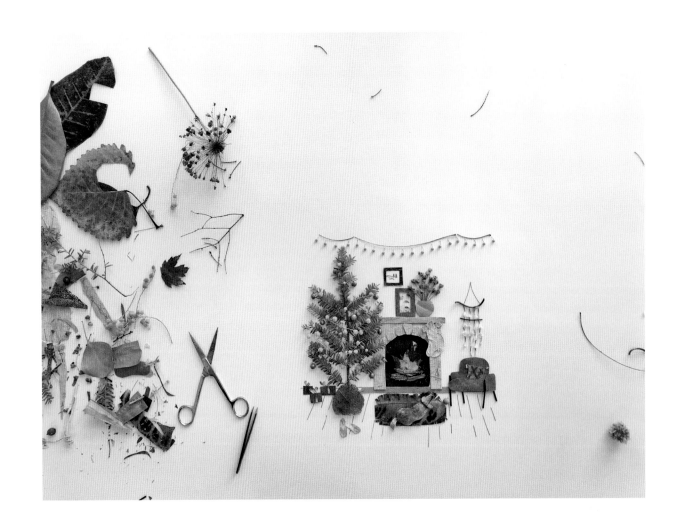

HOLIDAY HOMEBODY

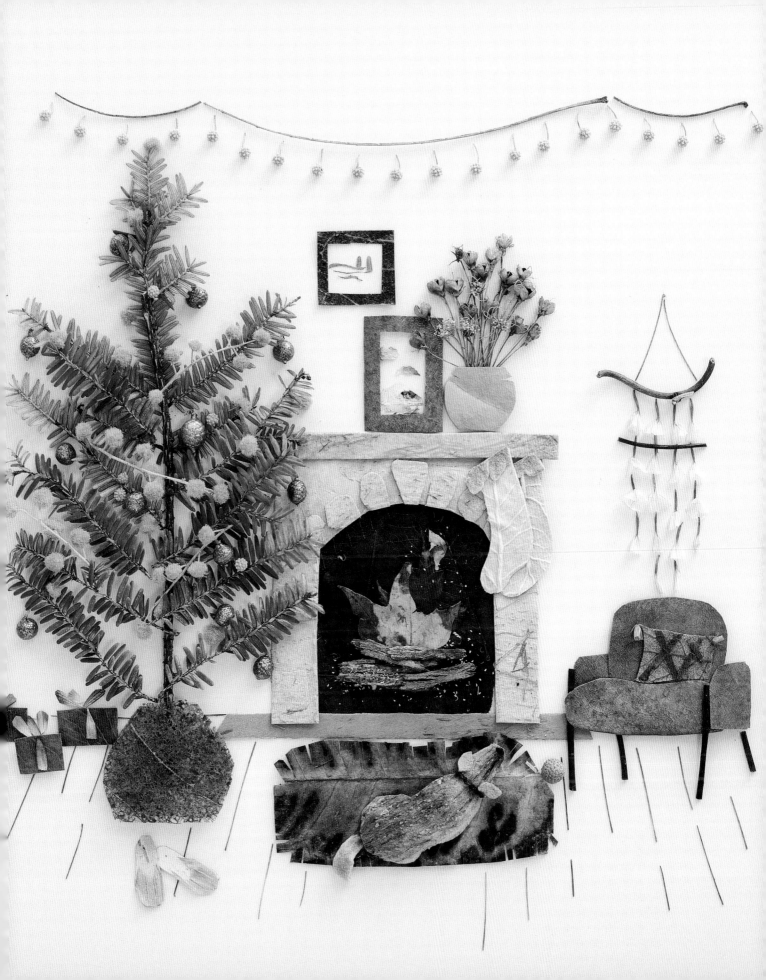

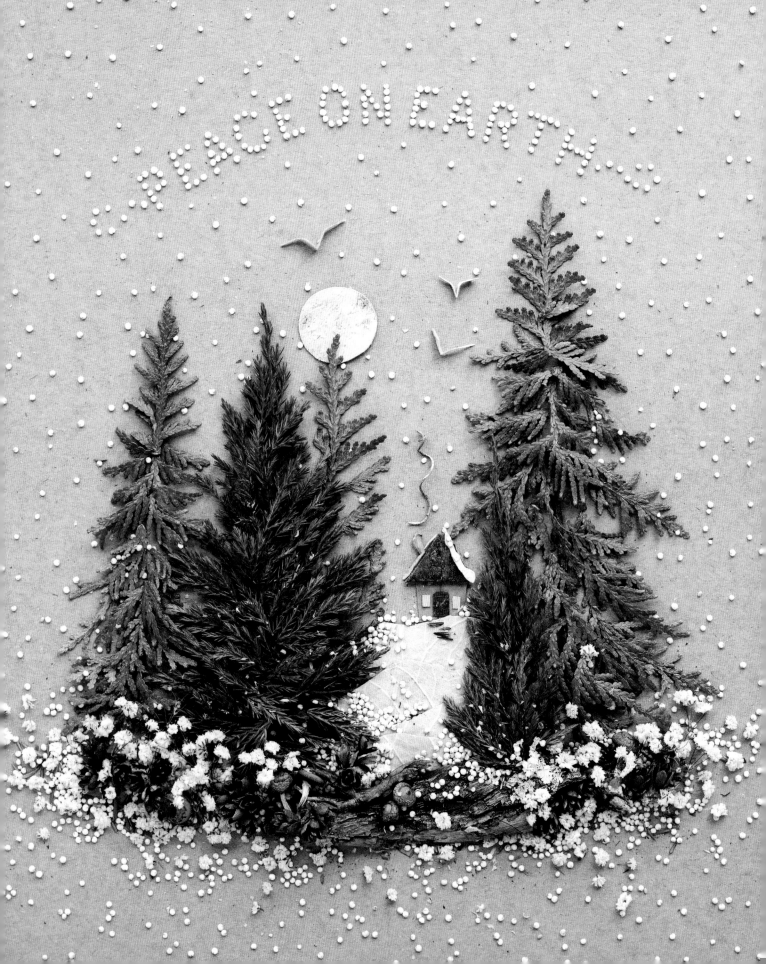

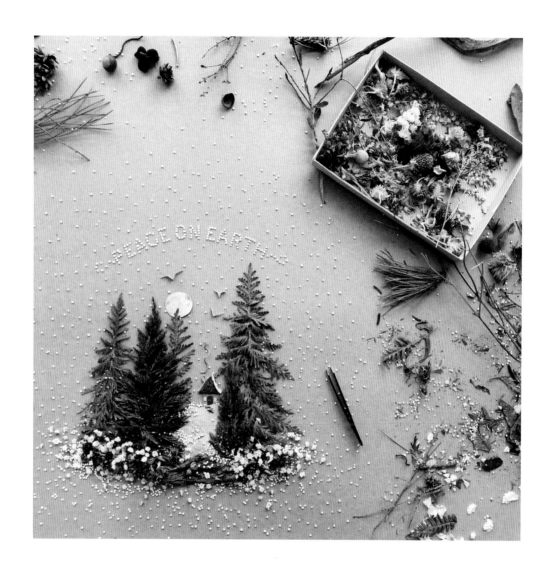

PEACE ON EARTH

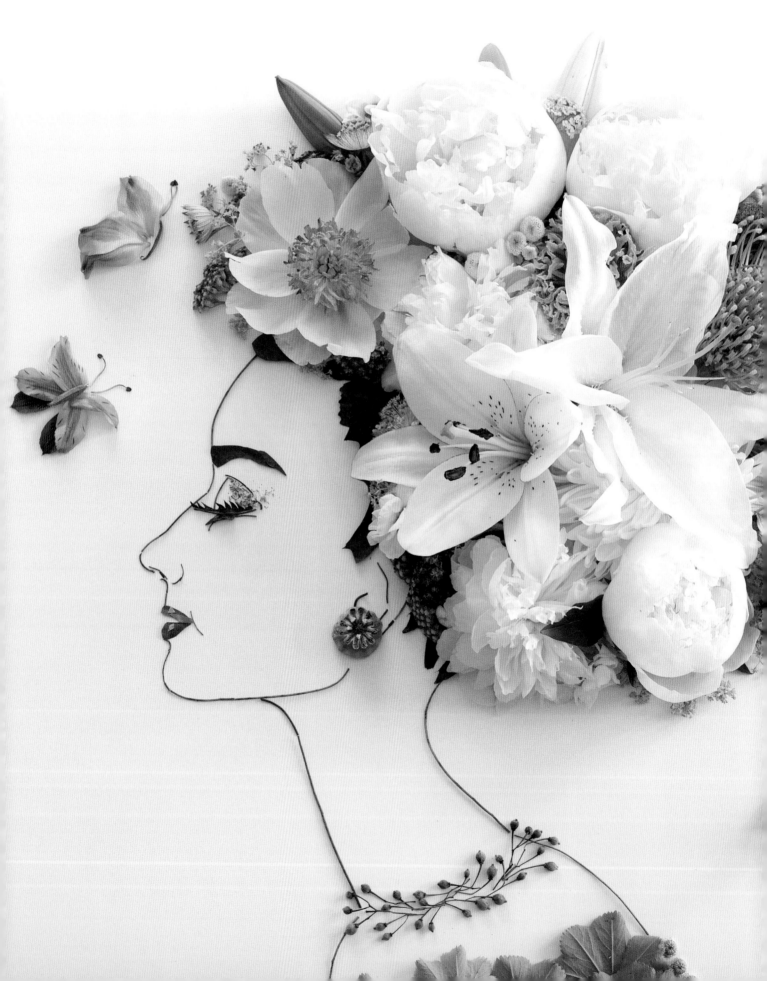

Famous Faces

When I was young and started to draw people, especially women, I would comb through fashion magazines looking for a model or actress I could use as my muse. Something special about the person would have to resonate with me; maybe their energy, or their soulful eyes. For some of these famous faces, like Diana Ross, Cher, and John Lennon, I loved their free-flowing hair, and just like the drawings I used to do in my youth, when I created them in foliage, I added a pop of color in just one place for drama!

BREAKFAST AT TIFFANY'S

Ruth Bader Ginsburg is an incredible role model and inspiration to so many women—I just had to try her.
I also knew she'd only be complete with a well-deserved crown!

R B G

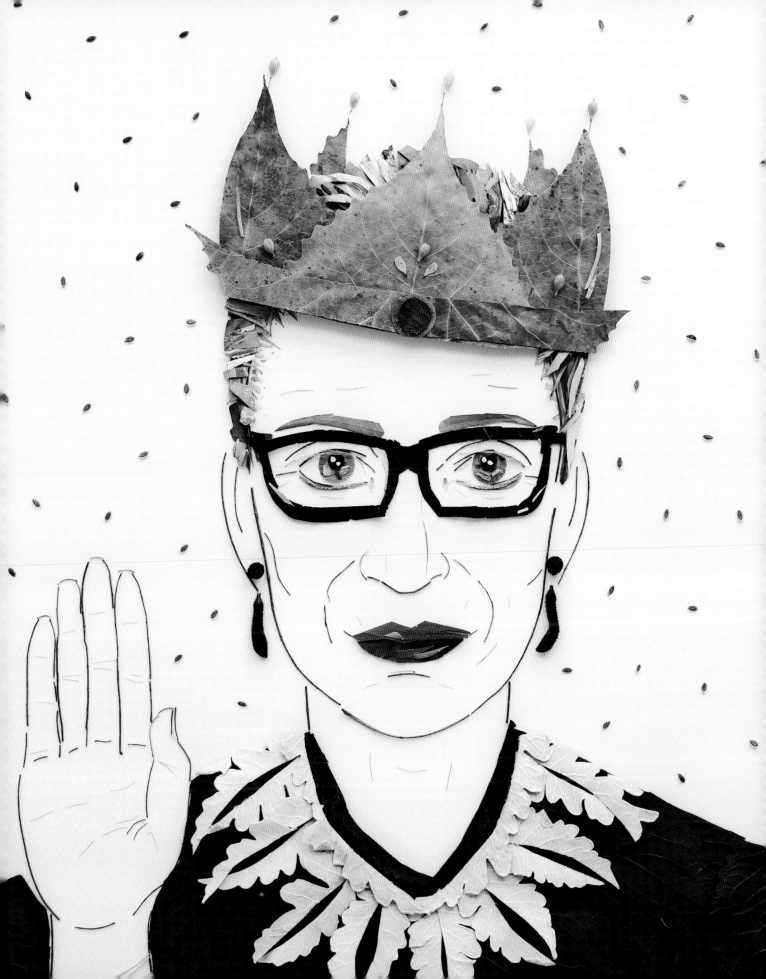

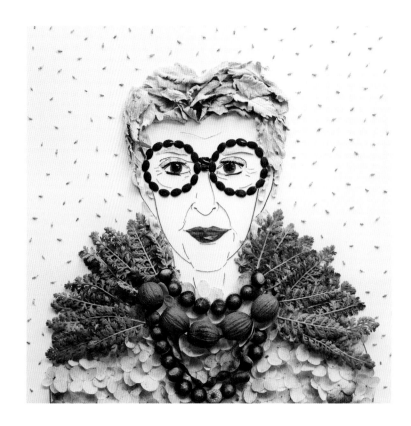

Iris Apfel was a dream to create. I couldn't think of anything better than foraging for big, chunky jewelry pieces and statement eyeglasses. Her style is everything, and I seriously could keep reinventing her over and over. I stopped after the third outfit change but could have kept going! I remember I had this big, beautiful spray of dried dill seed, and I started plucking off those tiny seeds to create her background. The circle designs seemed to fit her perfectly. They were fun and bubbly, just like her.

ABOVE: IRIS VERSION 2 • RIGHT: IRIS

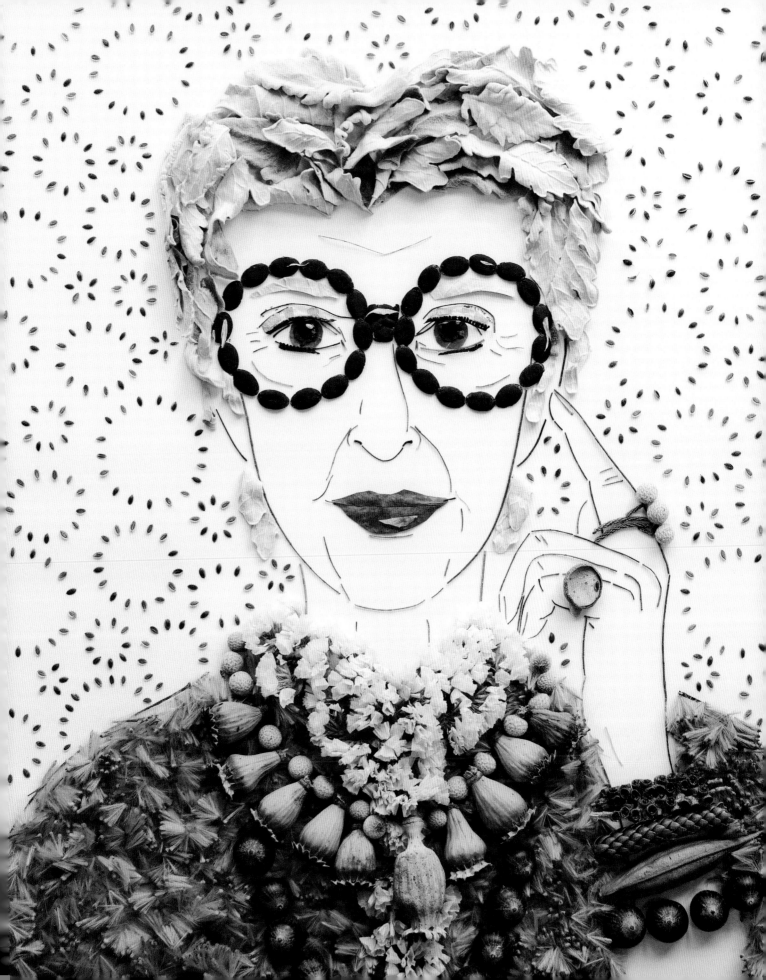

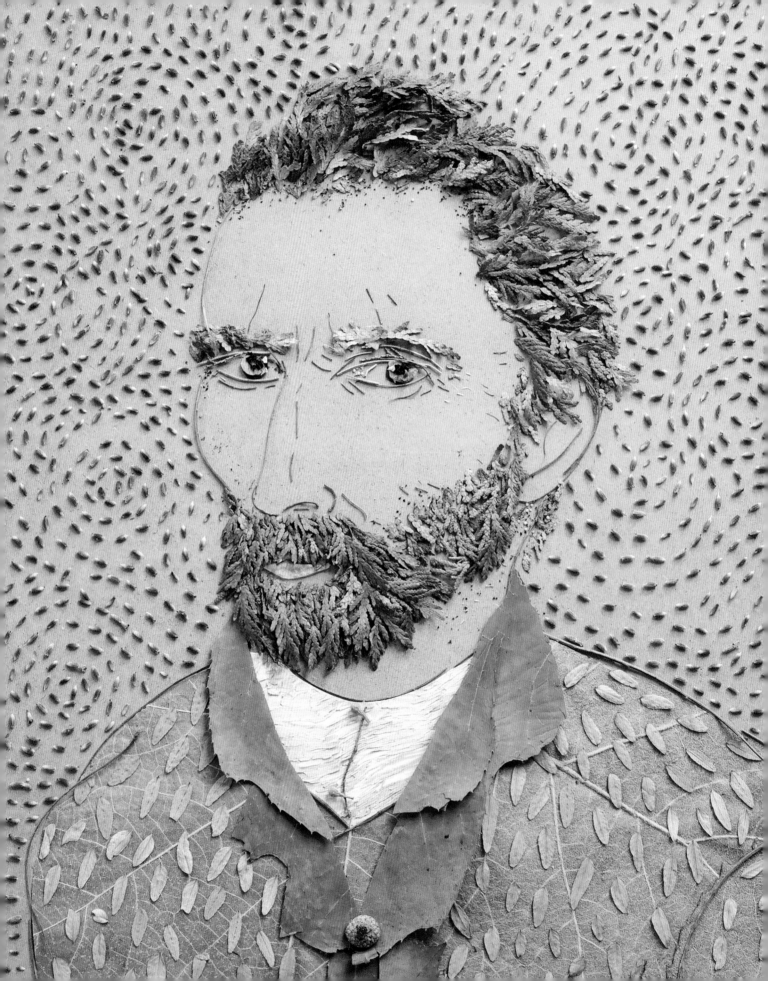

When I decided to do Vincent van Gogh, I felt like I was taking on a giant. I wanted to do him justice in foliage, but there have been so many times when I've thought about how much easier it would be to just paint or draw my vision of him. However, I also wanted to start pushing the boundaries of creating foliage portraits beyond just building the face and body, so I set out to do this background with dried lavender. I thought it would be fun to make it look like he was in his own painting. Well, I quickly realized that this was going to take me forever. It was going to take a lot of patience and time, but in the end I knew it would be worth it, so I pushed on. The more I started filling in, the more excited I got. It was really coming to life! When all was said and done, he gave me the motivation to create Iris Apfel and many others with a foliage background.

VAN GOGH

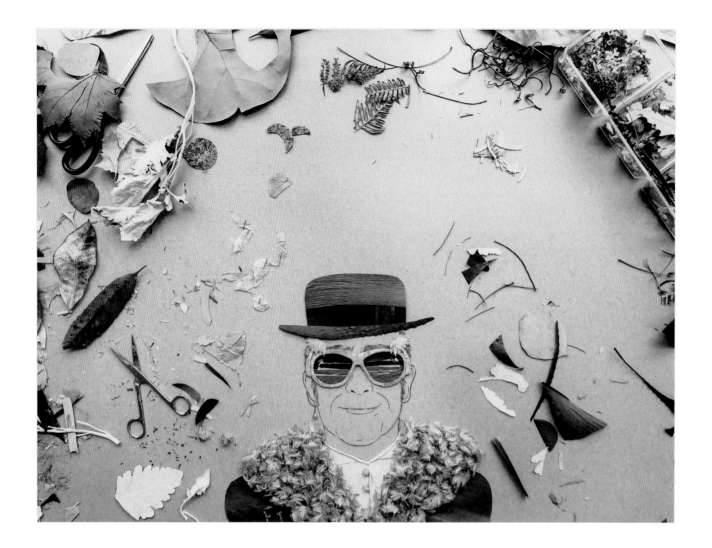

Elton John was a little intimidating to start working on. Everything about him is iconic: His glasses, his wardrobe, everything. I really wanted to do those famous palm tree sunglasses and was so happy when they finally worked. The gold shine that makes the frames are dried yellow bougainvillea, which kept blowing off every time I moved my arm to put down another piece. Every part of this one was a challenge. His hat and jacket are a dried banana leaf that I had hiding between background boards for months. I used the inside of a sycamore tree seed for his leather jacket collar and dusty miller for his shirt. In what can only be described as serendipitous, "Goodbye Yellow Brick Road" came on the radio at least three times while I was working on him.

ELTON JOHN

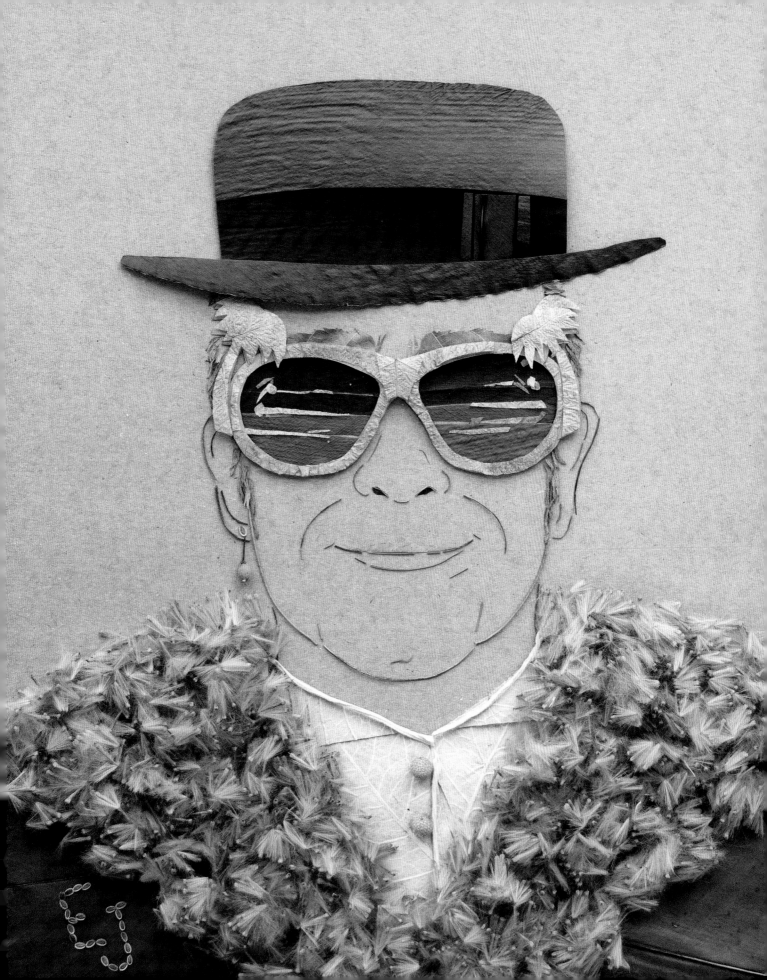

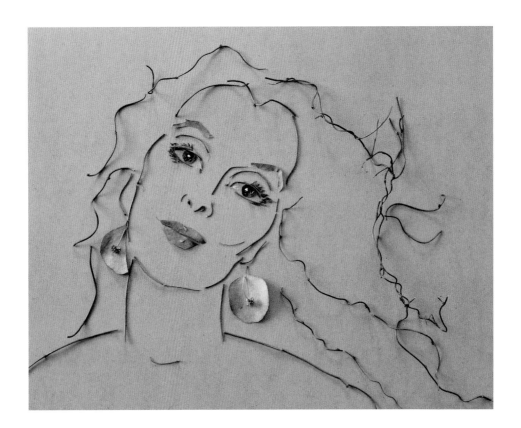

Rising to fame as the lead singer of the Supremes, Diana Ross is still making hit tunes today and Cher is a revered cultural icon. Both are legends.

CHER

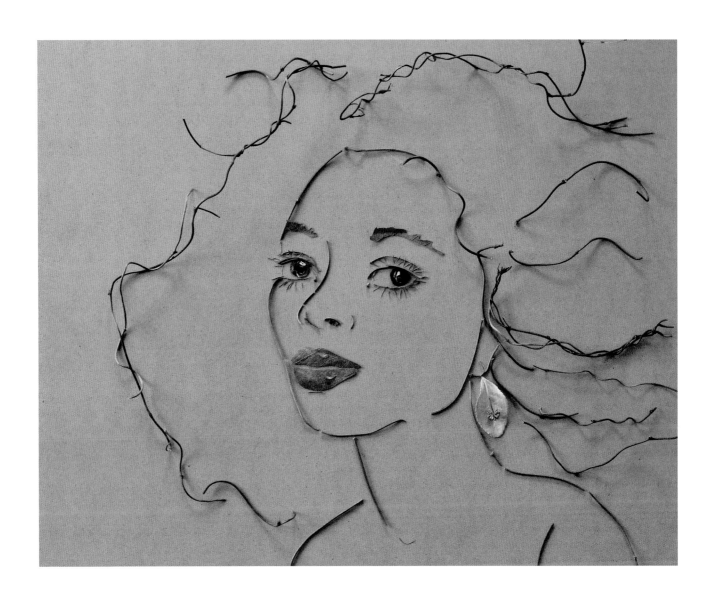

DIANA ROSS

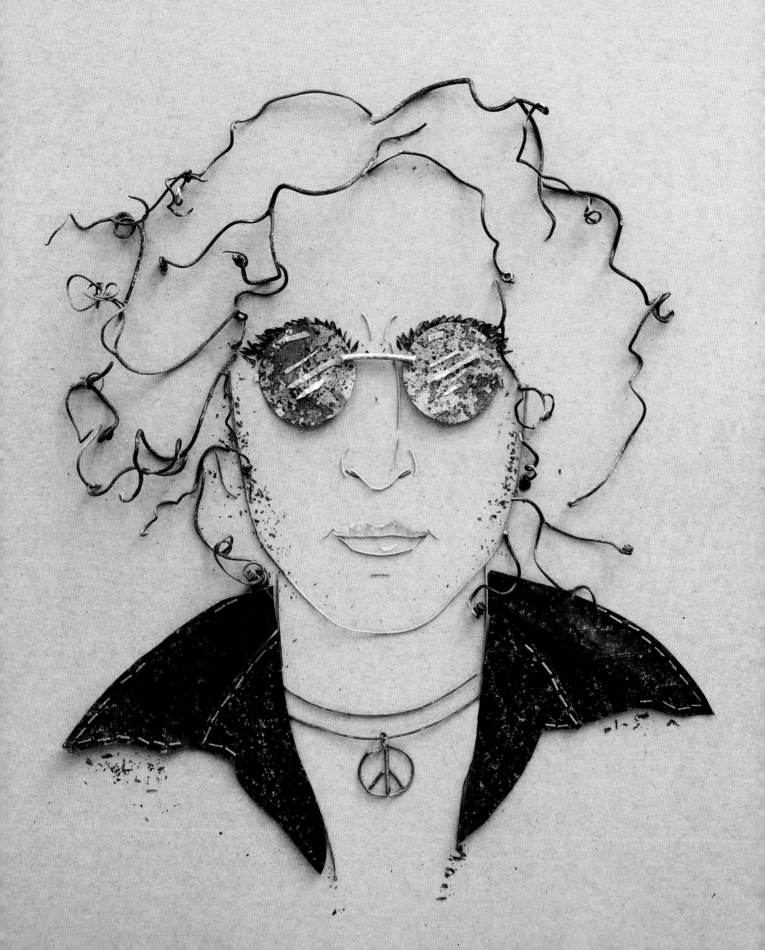

When I was born in 1960, the Beatles were in their heyday. Growing up, I don't think a day went by that I wasn't listening to them. John Lennon has always been one of my favorite musicians, so I had to create him. His glasses came from fallen eucalyptus leaves right outside my favorite Mexican restaurant in La Jolla. I always laugh when I'm bending down and gathering all these leaves off the sidewalk, knowing people inside the restaurant are probably wondering what the heck I'm doing. I'm not sure why, but under that tree, when the leaves fall they turn a beautiful patina color—like metal or reflective glass—absolutely perfect! His denim jacket is a blood maple leaf from the ground outside my doctor's office. I tell people all the time, I always walk with my head down.

JOHN LENNON

Einstein became one of the most influential scientists of the 20th century for his theory of relativity, which revolutionized our understanding of space, time, and gravity. His ideas have shaped the way we interact with and see the universe. I've always been inspired by his perspective on life: "I am enough of an artist to draw freely upon my imagination. Imagination is more important than knowledge. Knowledge is limited. Imagination encircles the world.

EINSTEIN

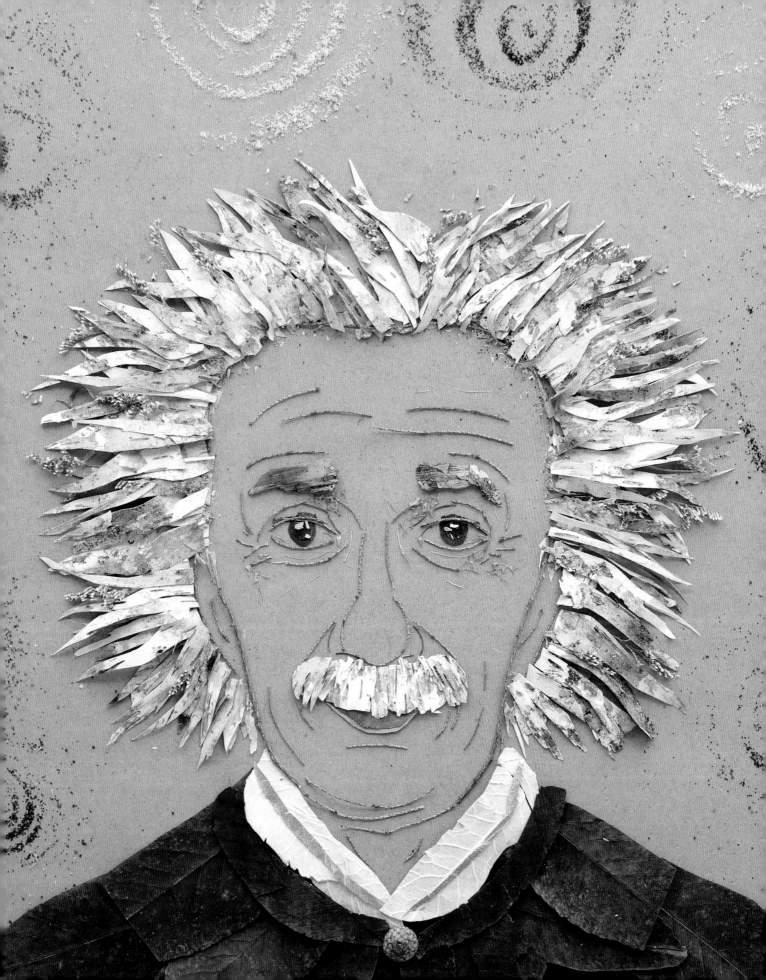

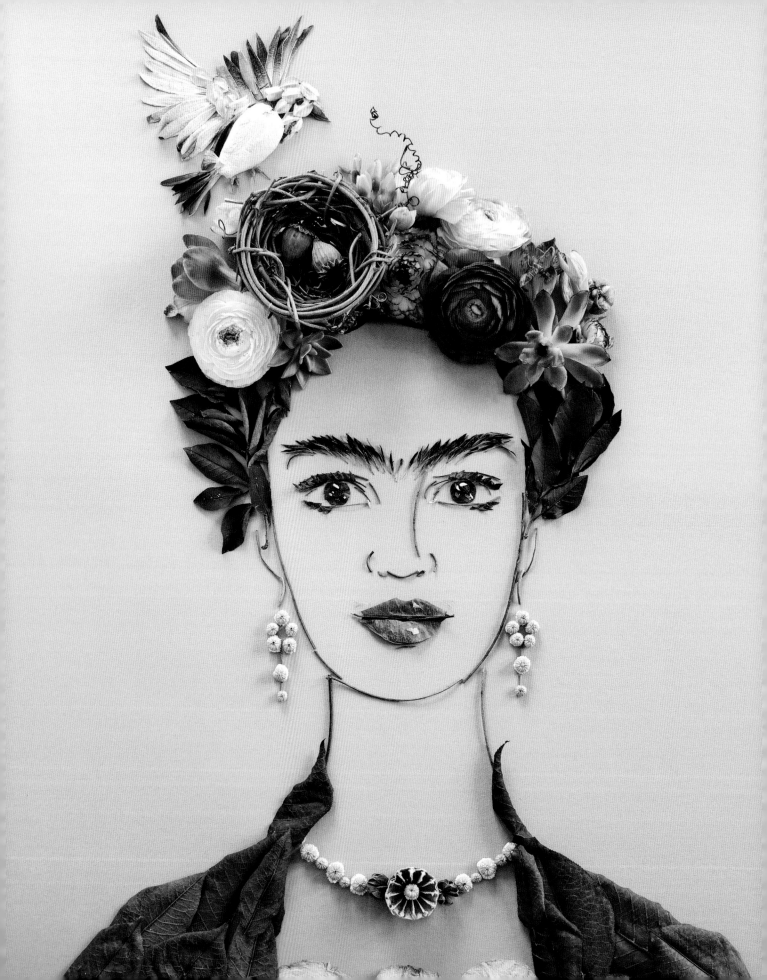

Foraging for Frida

As a female artist, I've always had respect and love for Frida Kahlo. I felt personally connected to her story, having gone through my own dark and scary physical challenges. When I've felt like my pain was too much to handle, she would be in the back of my head saying, "Pull it together, girl!" After I did my first piece, I just couldn't stop recreating her! 49 Fridas later… I'm not sure where in the timeline of my 49 Fridas she falls, but building Nesting Frida was the first time I really felt like I had captured her. Her jacket is made from leaves from the neighbor's tree, the bird's body is the inside of a rose, and the feathers are made from chrysanthemums. The chrysanthemum petals were so wrinkled, I had to pull out my iron and straighten a few. Ironing flowers made me think I had kind of lost my mind at that point, but the extra effort was so worth it.

NESTING FRIDA

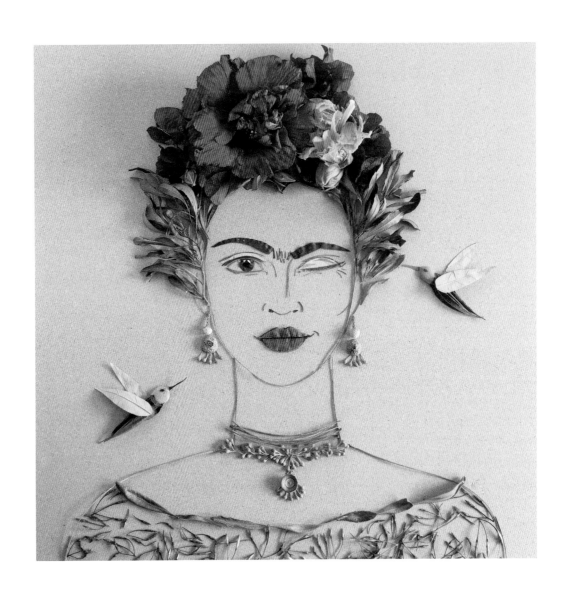

ABOVE: WHAT WOULD FRIDA DO · RIGHT: ENDLESS SUMMER FRIDA

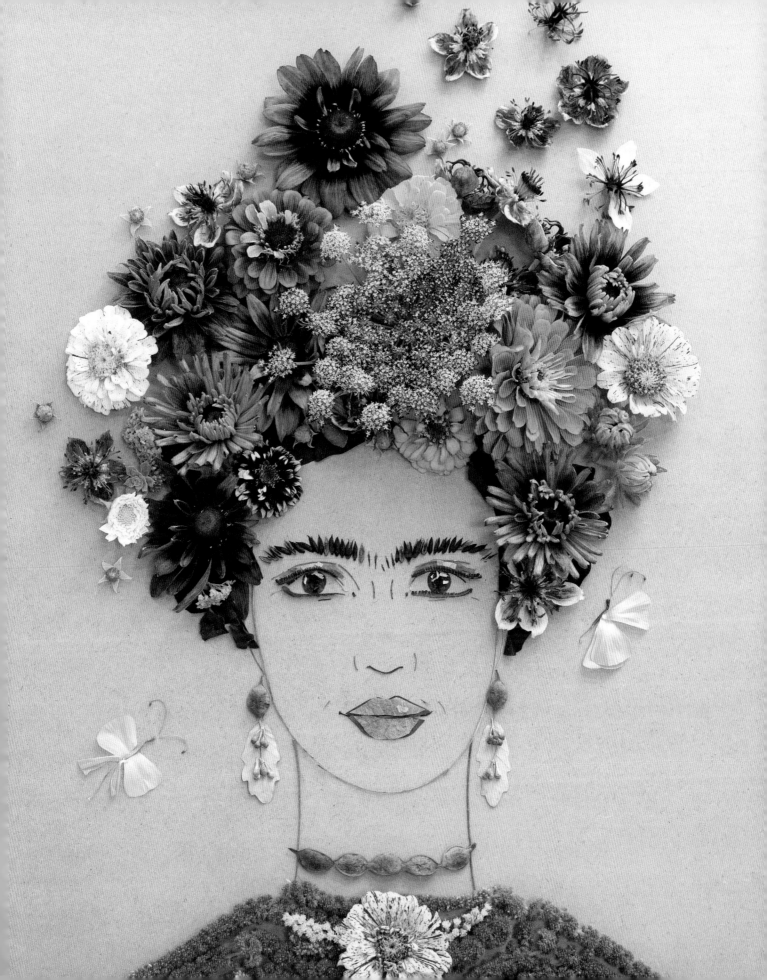

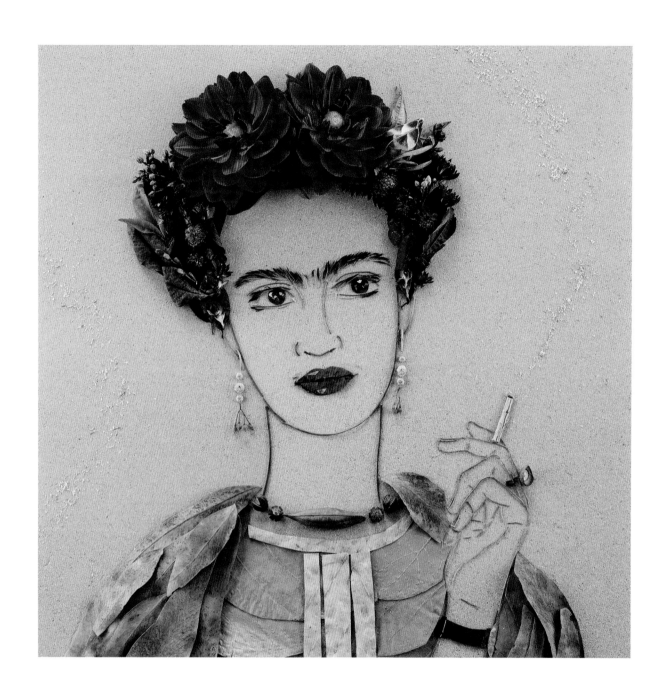

86

I had to create *Fierce Frida* smoking a cigarette. She's Frida after all! All of the plant-balancing logistics were challenging: Having her shawl look like it was loosely wrapped around her shoulders, building her dress, her twig hand, and her watch. When drawing and painting, you can put in all of these details without worry. But doing it without glue...yikes! When it works out though, it's a thrill. The cigarette is a dusty miller stem with the tiniest German statice on top to look like the cigarette is lit. She is one of my very favorite Fridas.

FIERCE FRIDA

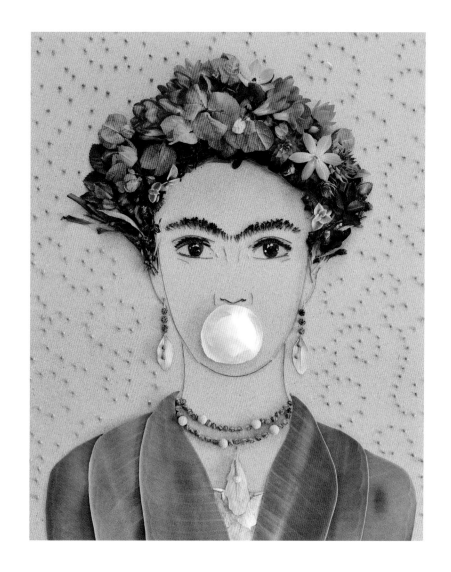

BUBBLE GUM FRIDA

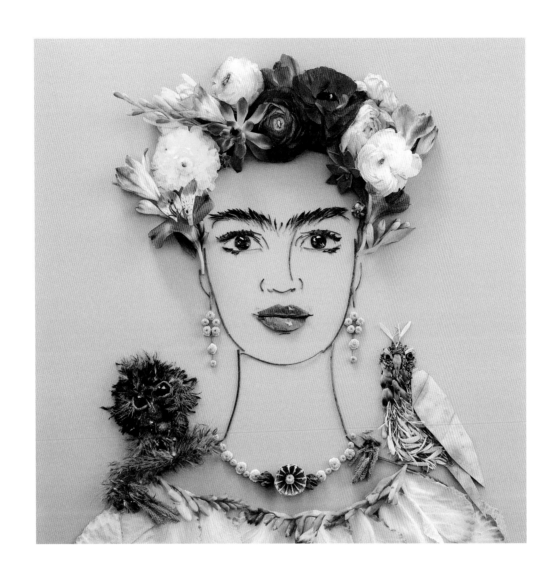

FRIDA & PETS

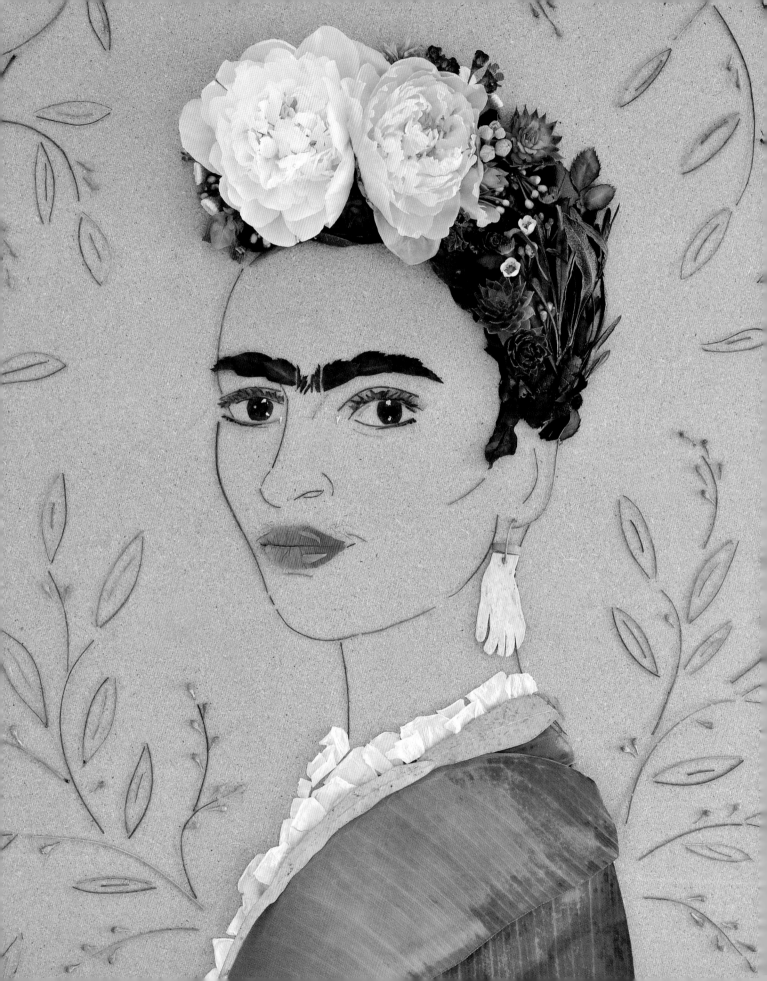

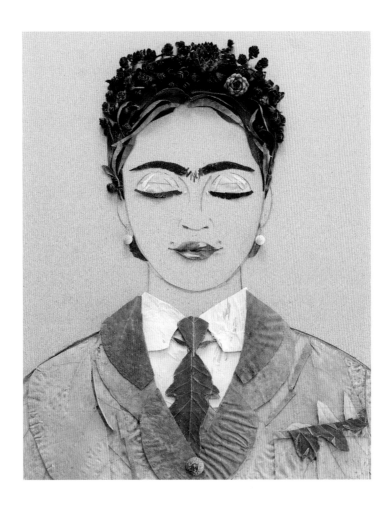

The neighbor's rubber tree plant gave birth to *Suprema Frida*. The plant was hanging long over the neighbor's driveway fence—fair game, and I only needed two leaves. What caught my eye was that the leaves were turning a beautiful pink color. I thought they'd make a perfect satin jacket for Frida. These leaves and two absolutely gorgeous peonies were a beautiful start. Her blouse is dried ranunculus and those famous hand earrings gifted to her from Pablo Picasso are made from eucalyptus bark.

LEFT: SUPREMA FRIDA • ABOVE: THE FUTURE IS FEMALE

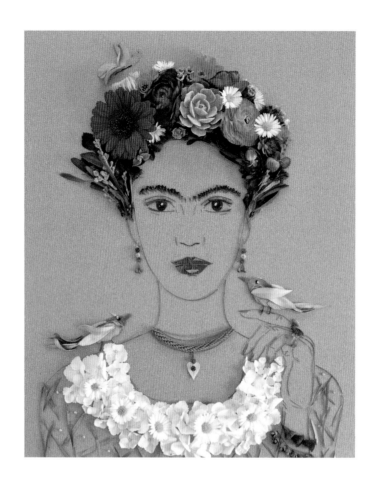

Dia de los Muertos - or Day of the Dead - is an ancient festival celebrated every year in Mexico on November 1 (All Saint's Day) and November 2 (All Soul's Day). These two days honor ancestors and celebrate the lives of loved ones passed by wearing colorful costumes and painted skin. I had wanted to create Frida in her costume and paint for a very long time. So, when the perfect zinnia for her hair and dill seeds for her painted face showed up, the time was right. Her little hummingbird friend was sure to wear the perfect costume too!

ABOVE: FEATHERED FRIENDS FRIDA • RIGHT: DAY OF THE DEAD FRIDA

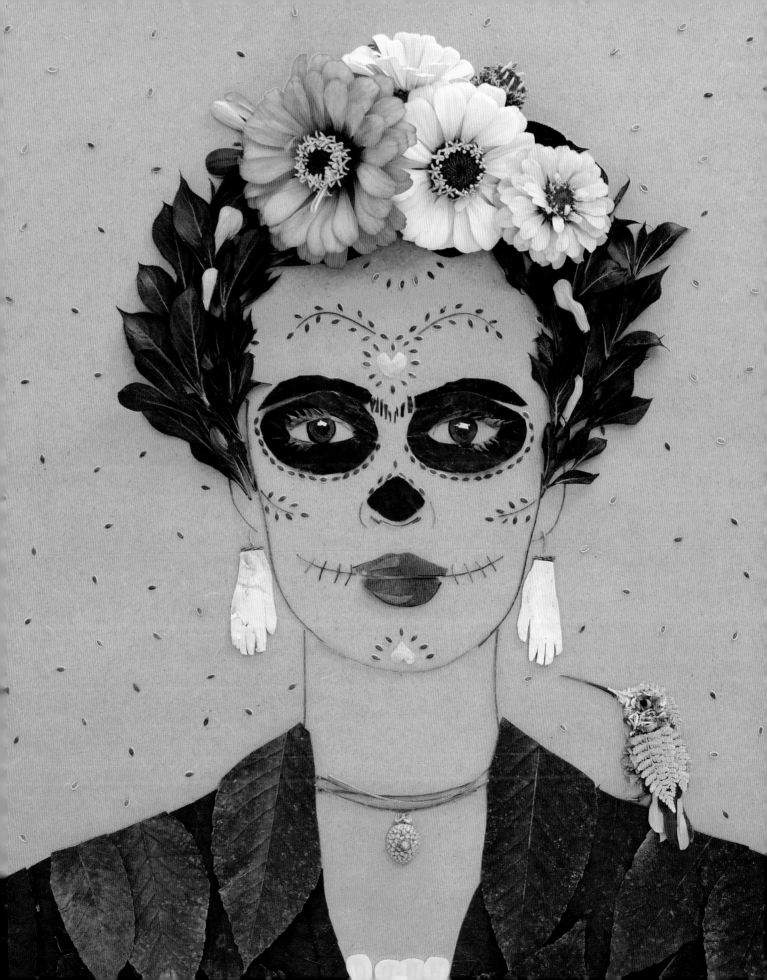

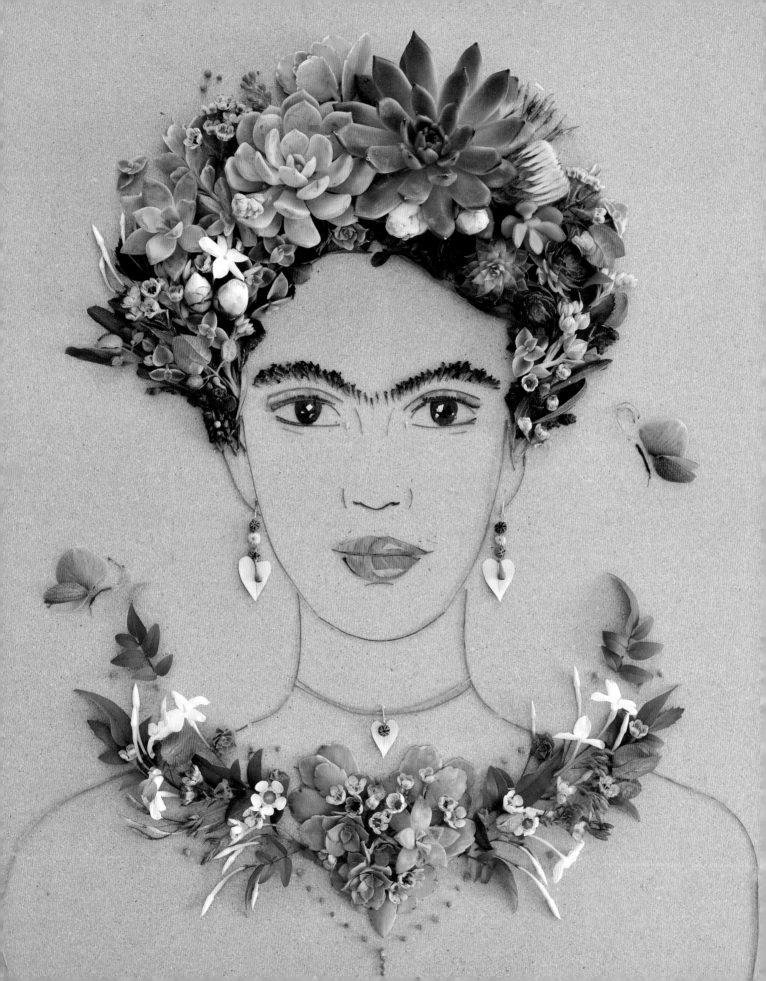

I could stare at this succulent arrangement all day. I felt in a deep dream state the whole time I was placing these blooms. Sometimes things just "flow" and you wake up and it's perfect. The best part was having all the ingredients right outside my door in La Jolla. I had to fight hummingbirds off the Camellia tree and the bees off of the Jasmine to make this piece. In my world, the only fairy garden I want to live in, is one in shades of blue, green and pink. I imagine Frida feels the same.

FAIRY GARDEN FRIDA

Our little cottage on Sea Lane in La Jolla had the most beautiful rose bush out front. The only problem was, when we were there it wasn't always in full bloom with roses ripe for lending to art. These two beauties were worth the wait! Frida sometimes used ribbon in her hair along with flowers, so it was fun to add the pink eucalyptus running through her 'purpurea' hair. She is wearing a pair of earrings Pablo Picasso made for her and I'm sure she's feeling good. Here, I imagine her meditating in her lush garden.

FRIDA KAHLO

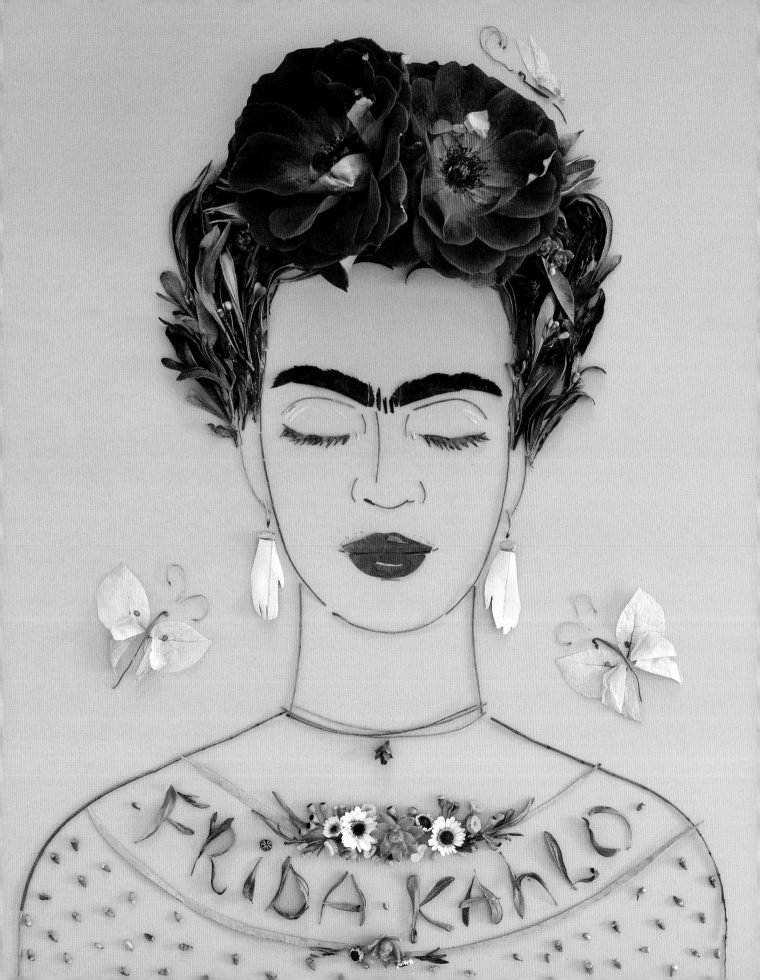

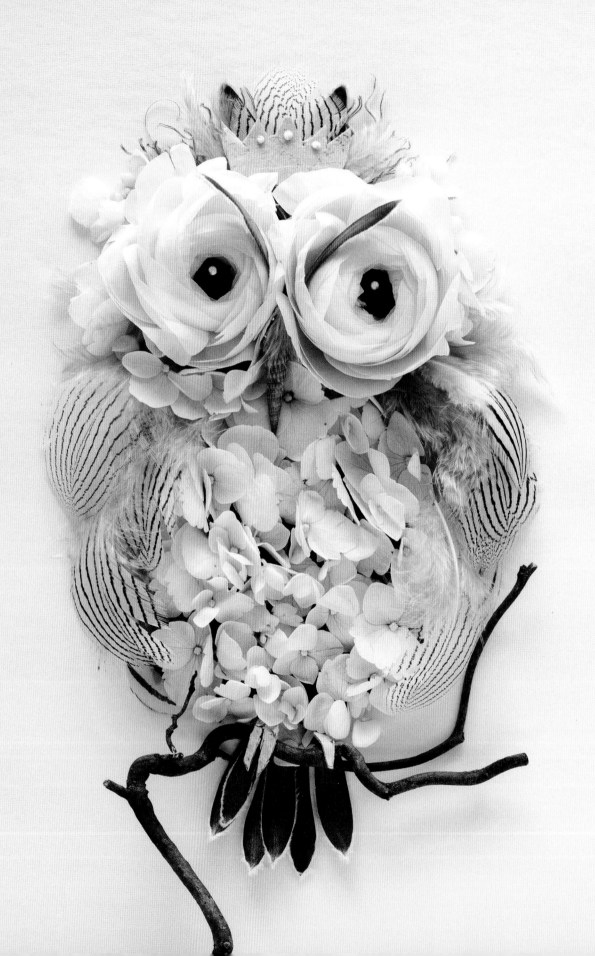

Into the Forest

This is a big planet, and we have the privilege of sharing it with the most amazing creatures: Birds covered in beautiful vibrant colors that can sometimes repeat what we say or the sounds we make, fly hundreds of miles in a day for migration, and sing the most beautiful songs. Foxes are considered clever with impeccable hearing, and bears are extraordinarily intelligent animals. I love creating these magical creatures. Most of the foliage used to create these friends was foraged from my yard in Door County. In the fall, loads of cedar bark starts dropping from branches above, chewed off by red squirrels making their winter nests. Perfect for forest friends.

QUEEN FOR A DAY

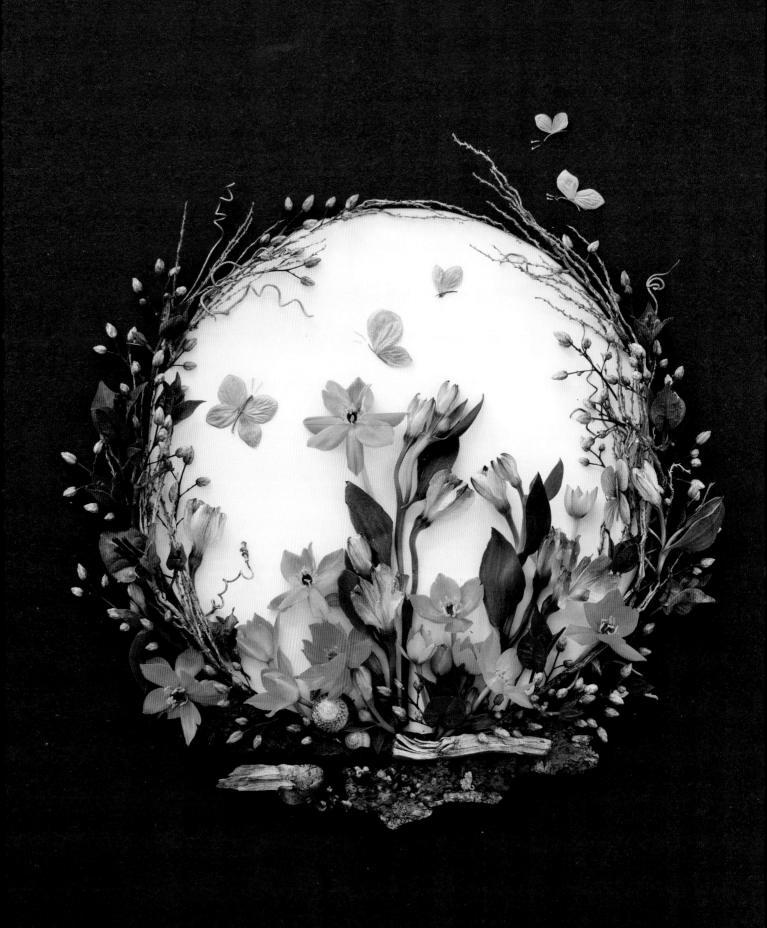

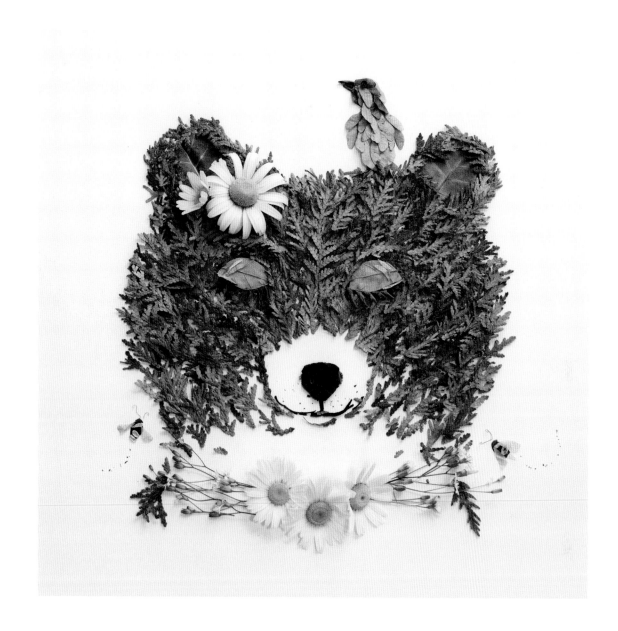

I thought it would be interesting to try playing around with a small-world terrarium feel, with all the dreamy details focused within a dark night or white day circle. The circle shape keeps it intimate, and rounded edges are softer and more approachable. One of the things I enjoyed most was blurring the lines between being inside or outside. Are the birds, bees, and butterflies flying in or out?

LEFT: RADIATE • ABOVE: MAMA BEAR

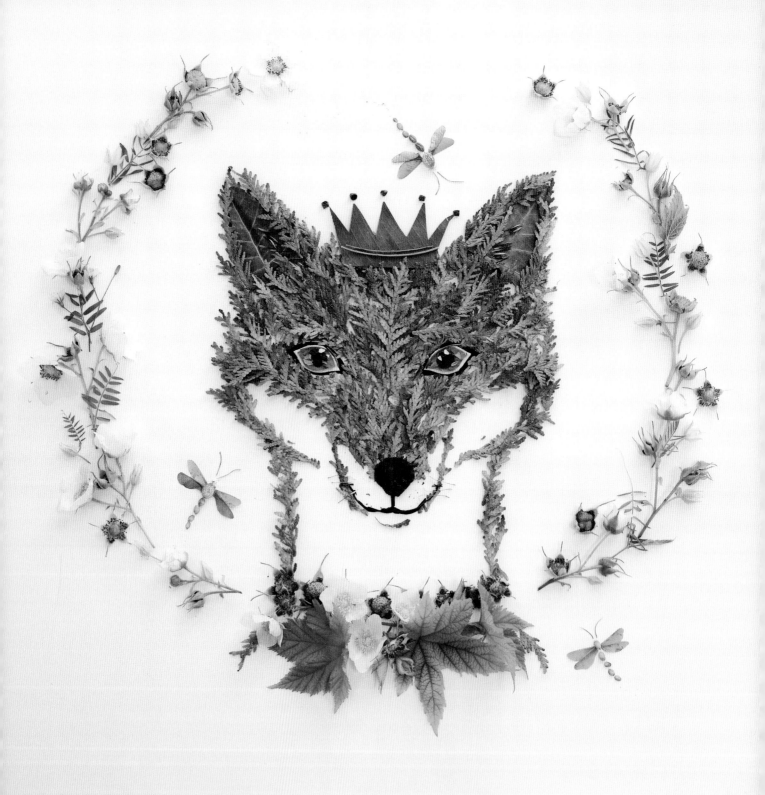

PRINCE OF THE FOREST

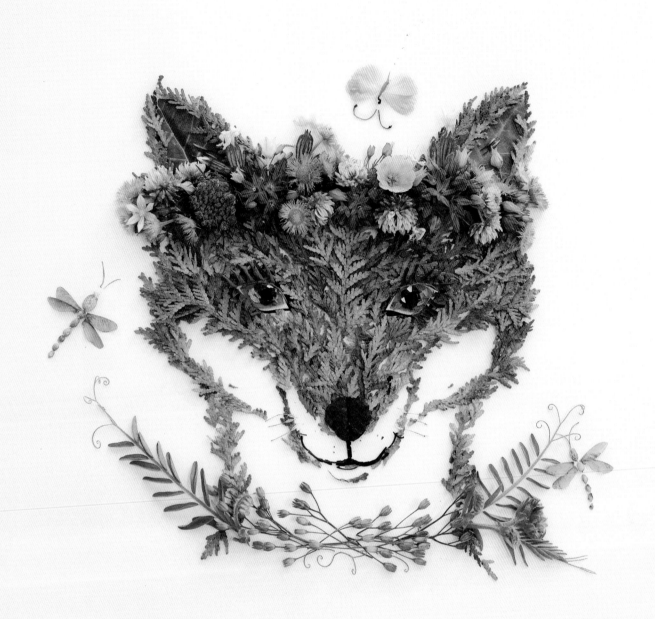

PRINCESS OF THE FOREST

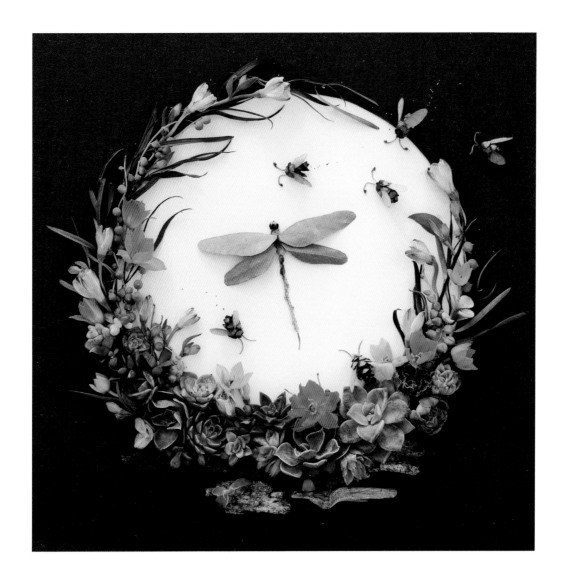

When I was working on *Owl You Need is Love*, I had leftover flowers from a different project and took the chance to play with adding a little bit more to enrich the piece. I started pulling off all the petals on my carnation and gerbera daisy flowers, laying them out from bottom to top, adding in talons, eyebrows, and eyes. So much fun! Usually while I'm building a piece the name will come to me, but this time Brooke came up with the title and it seemed to be the perfect fit.

ABOVE: LET LIFE IN • RIGHT: OWL YOU NEED IS LOVE

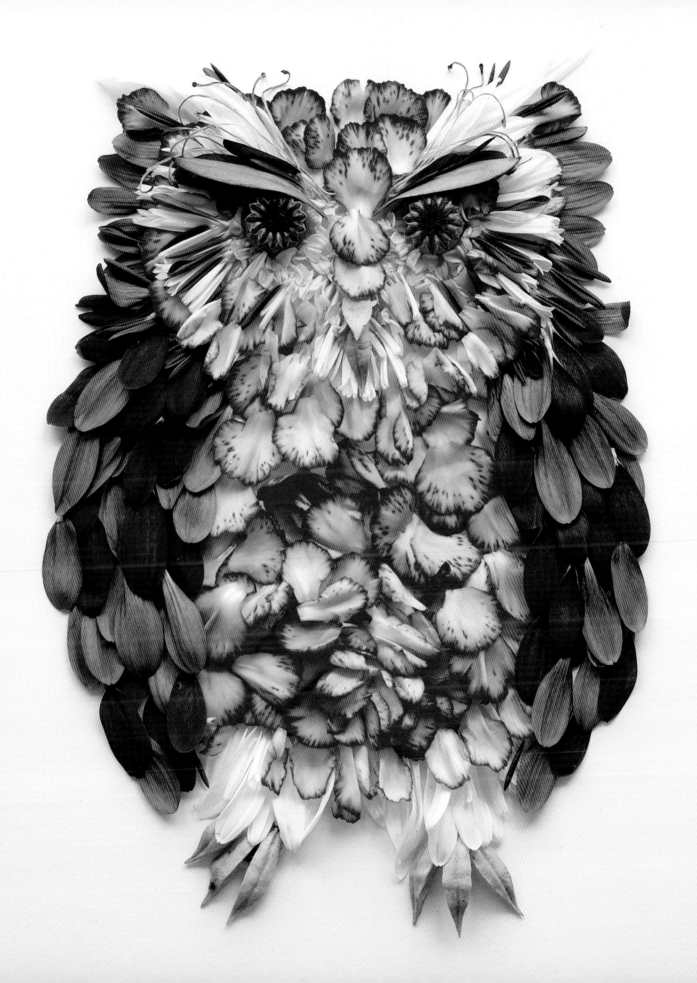

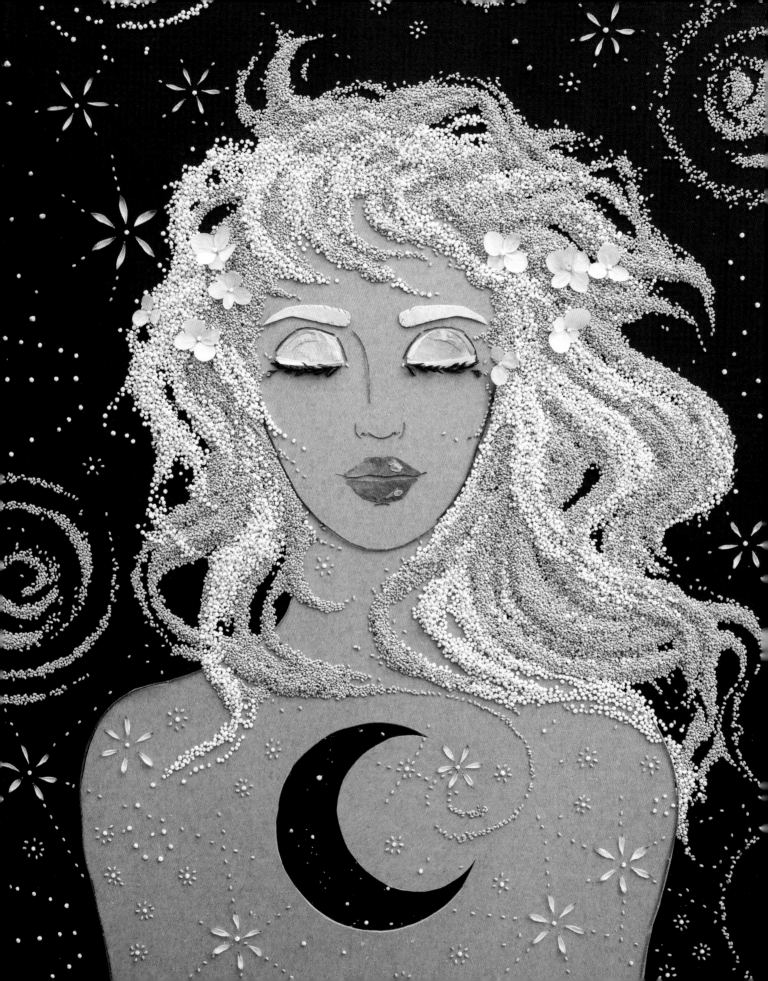

Everything You Need Is Inside You

All of these women are inspired by the meditative, therapeutic, and healing journey I've been on. Meditation has not only turned into a devoted practice, it has brought me to many self-realizations and awakenings in my life. One of the most profound is that everything I need is already inside of me. I just need to be present enough to see it and feel it. All of these women came from a place of truth.

GAMMA GIRL

There's a first for everything. I started *Free Spirit* as a completely different piece with lots of live foliage. She was complete and ready to photograph, but something just didn't feel right. I almost recycled her outside right at that moment, but I loved her expression. So, I took a break, as I often do, and began wandering around the yard, picking up sticks, leaves, and bark. Everything that wasn't alive, fresh, and colorful. I went back into the studio and just started laying things down on top of her in a total flow. Not thinking, just creating.

FREE SPIRIT

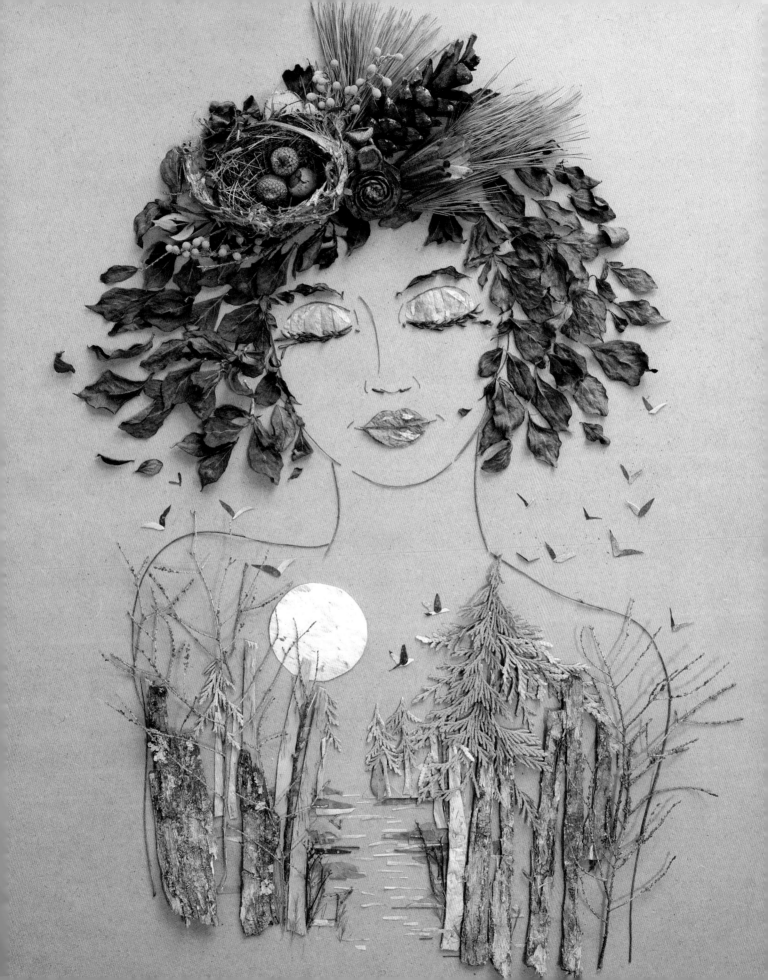

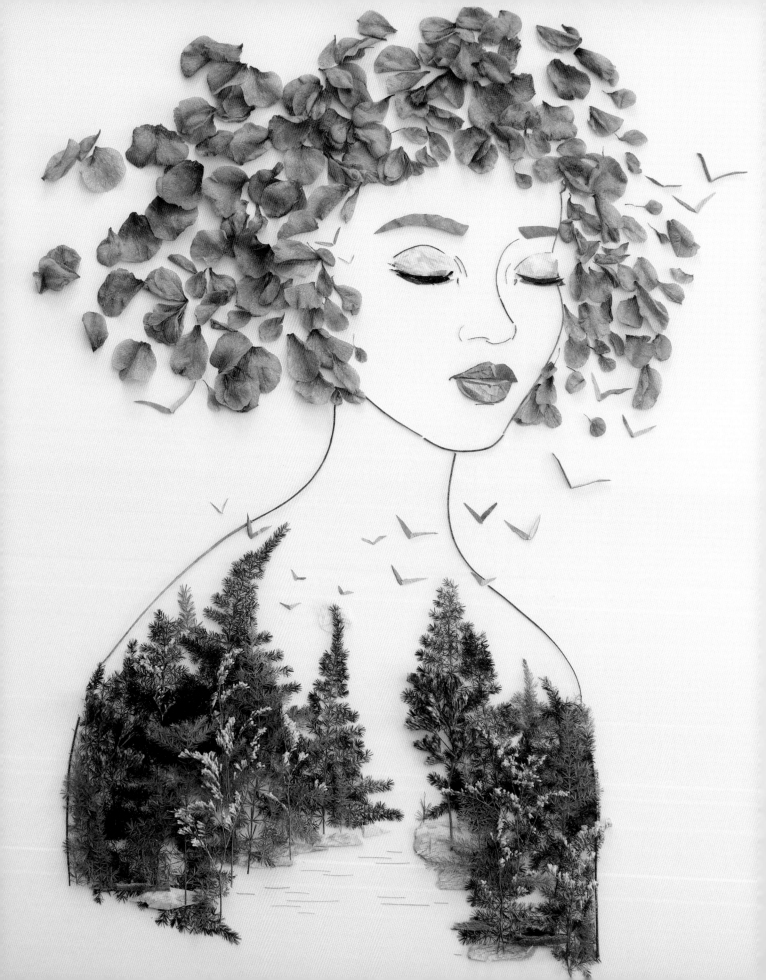

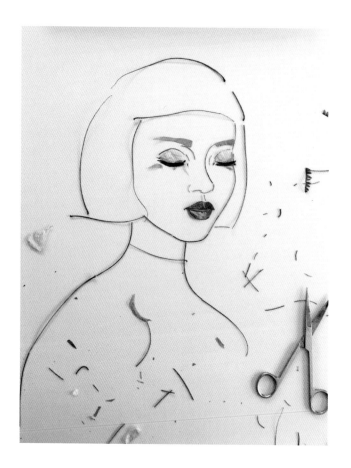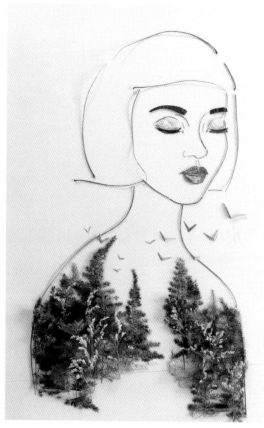

As I was finishing the face on *Be Wild*, I noticed how serene she seemed. I thought, *what is she thinking and feeling?* I was imagining her need to be connected with nature, to feel free and whole. I went outside for a break and noticed the neighbor's fence had these little fern-like leaflets that looked, to me, like tiny pine trees. I knew immediately that I was going to take what she's feeling and thinking and put those thoughts inside of her. She's standing by a river where the moon is rising over tall pine trees and birds are flying free. It was perfect. It felt like she was coming to life. The final touch, literally, was a quick finger through her camellia flower hair and she was done.

BE WILD

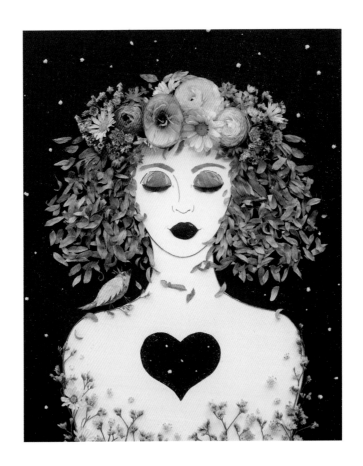

Butterflies symbolize renewal, rebirth, and powerful transformation in one's life. They remind us that when we look within, we can evolve and rebuild ourselves. Trust and surrender can bring renewal to our soul. I wanted to capture that in *Grace*.

ABOVE: OPEN YOUR HEART · RIGHT: GRACE

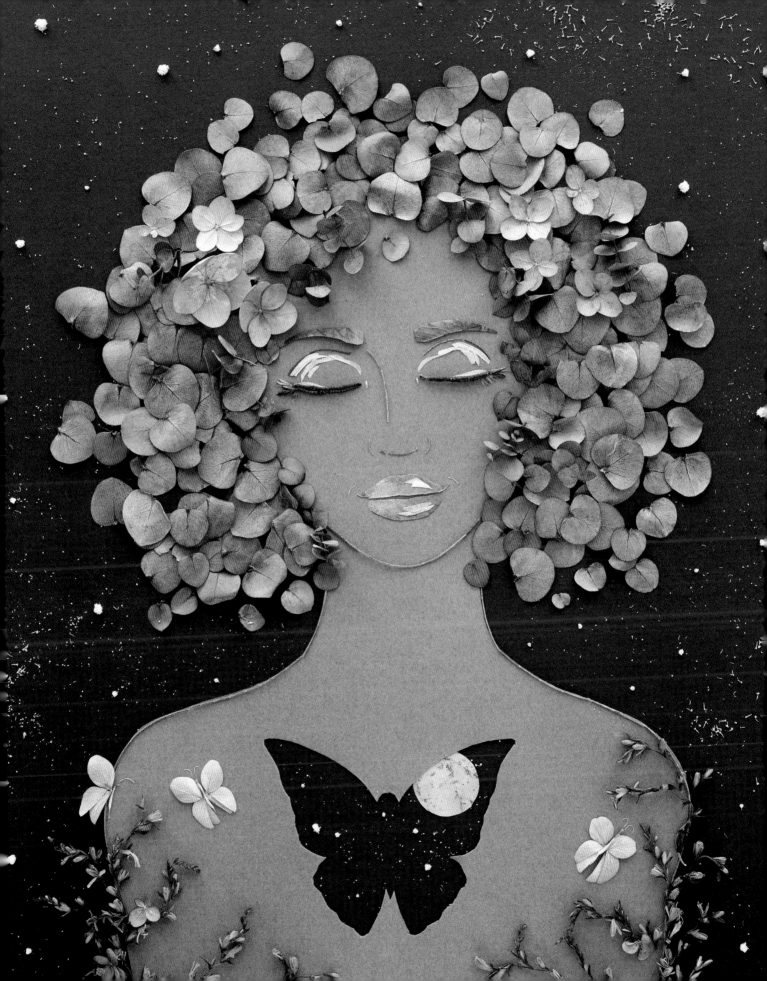

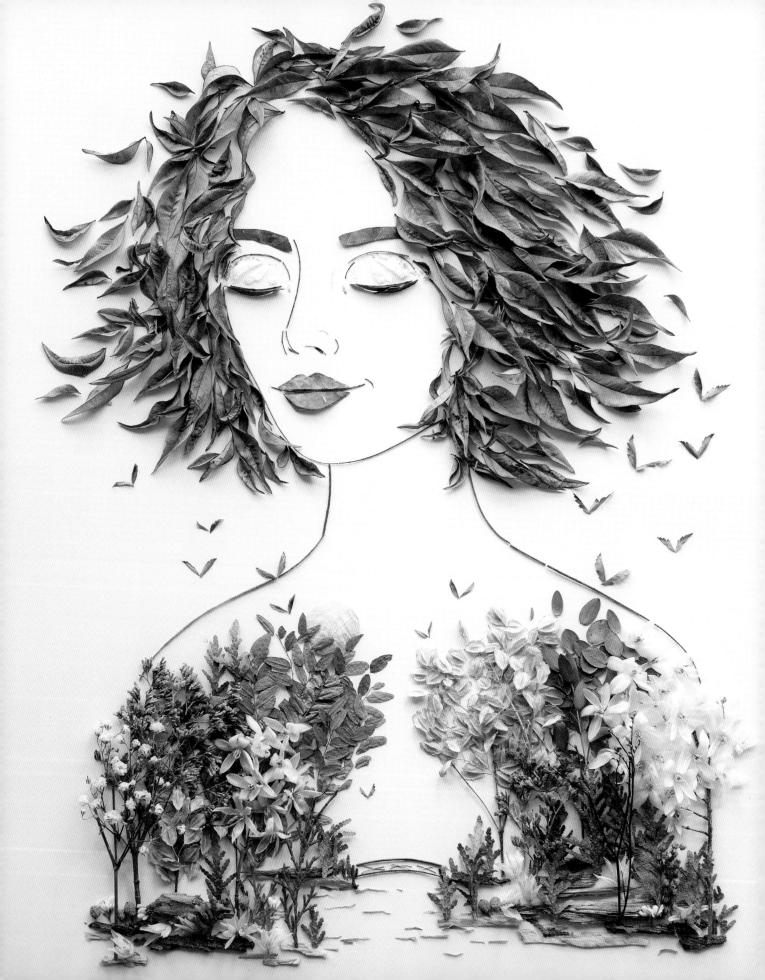

Peace is just on the other side of fear. I know this place so well, hanging right on the edge, so afraid to move. I've learned that the only way to peace and freedom is to trust and take that first step into the unknown. That's where creating your new future begins.

BRIDGE TO PEACE

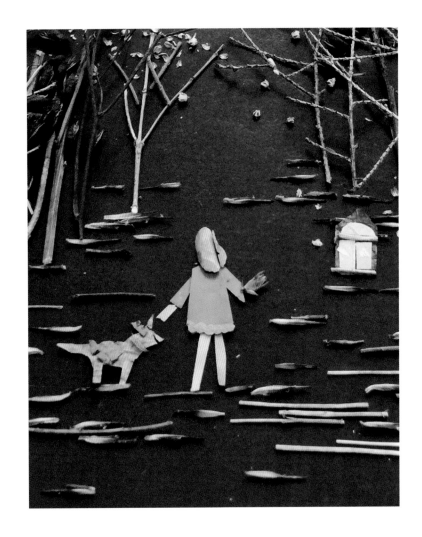

Stay patient, you'll find your way. Trust your inner light to guide you.

TRUST YOUR JOURNEY

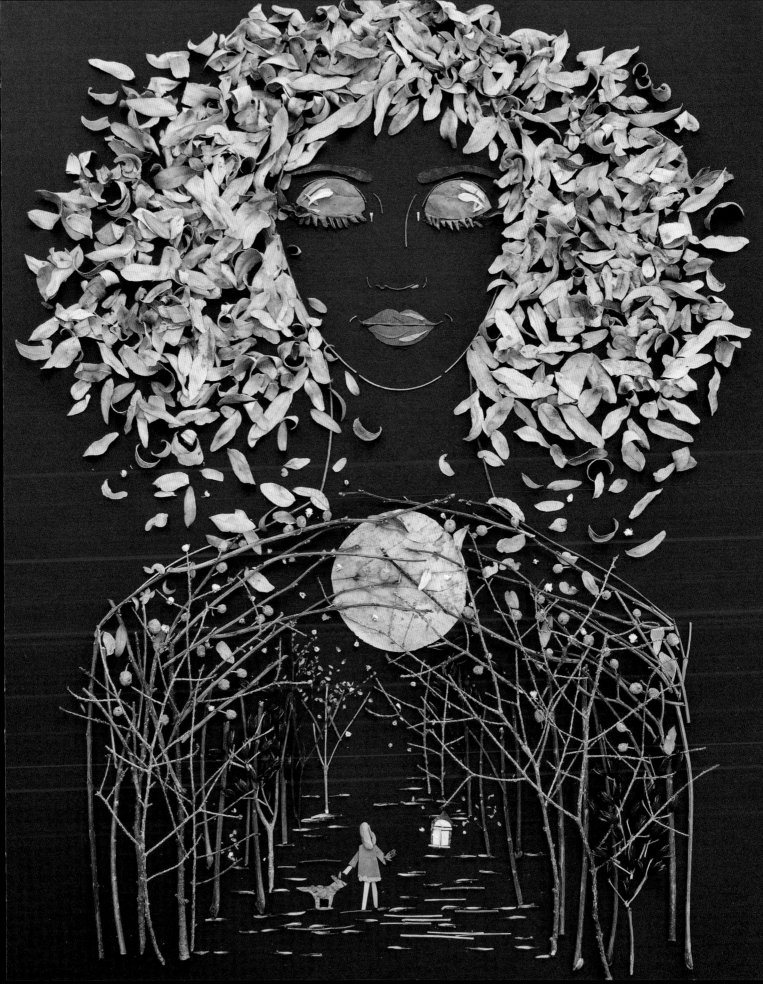

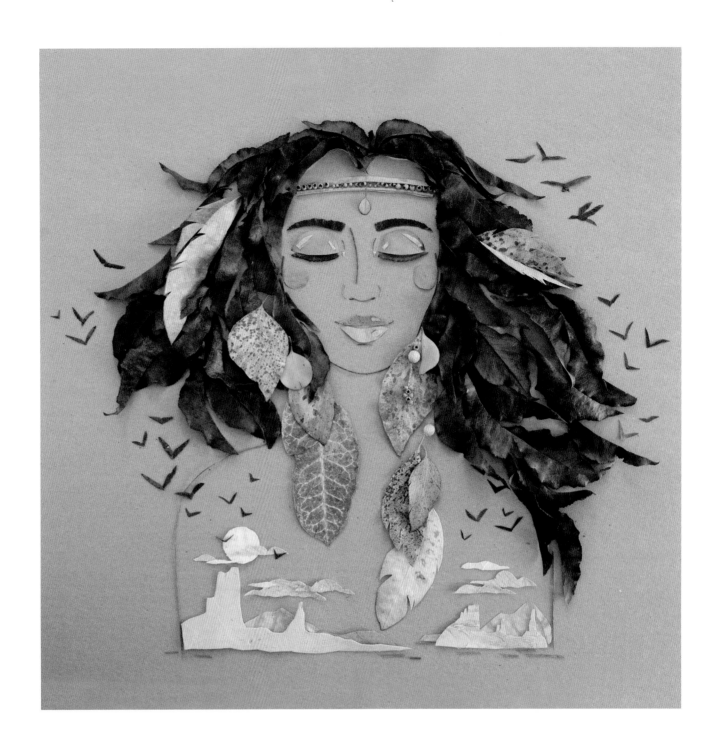

"Not all those who wander are lost." I've always loved this quote by J. R. R. Tolkien. I think it fits her wild, free spirit just perfectly.

WILD HEART

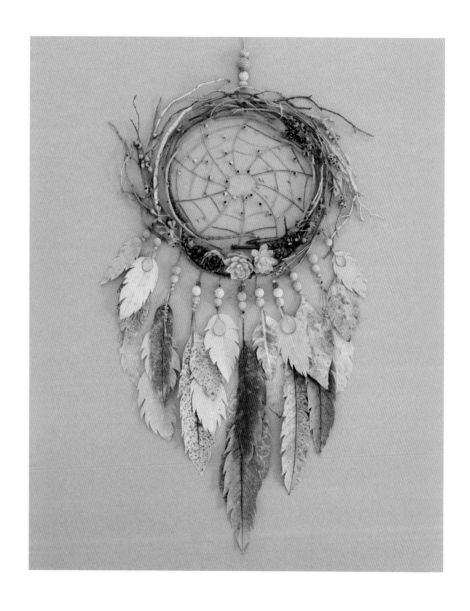

DREAM ON

If you're a "flower child," you are likely a free spirit with a deep desire to make this world a better place. You radiate positive vibes, sending love and compassion to everyone around you. To be a flower child, just sit in gratitude among the flowers and all Gods' creations. Let their beauty fill you up. Never forget, you are not separate from nature, you *are* nature.

FLOWER CHILD

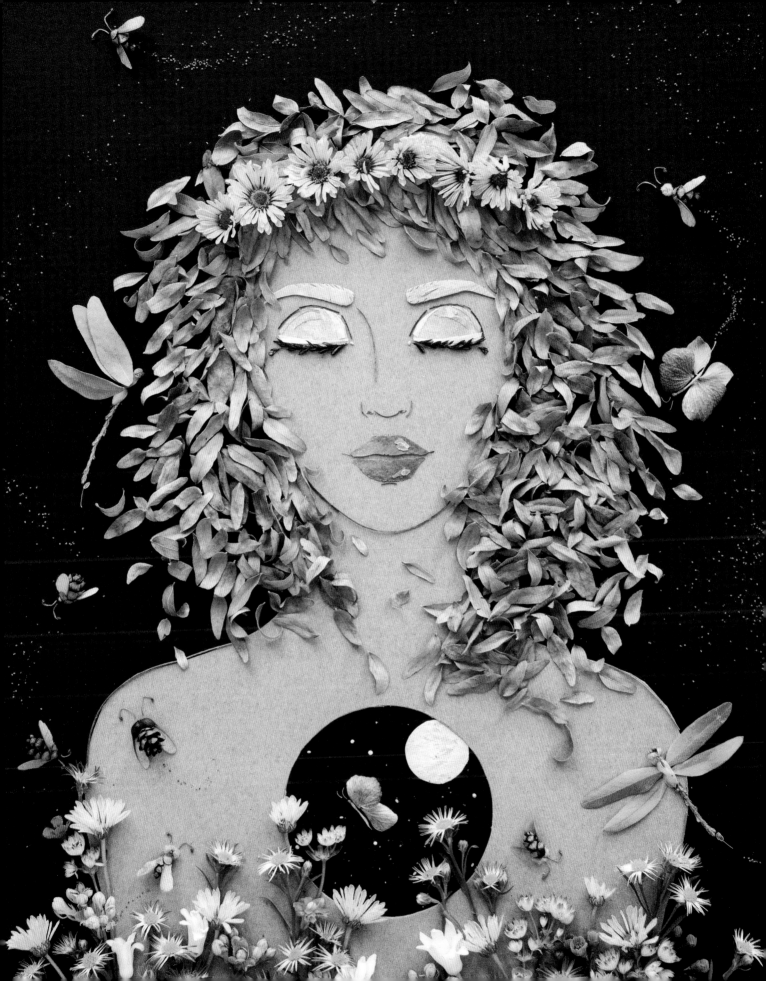

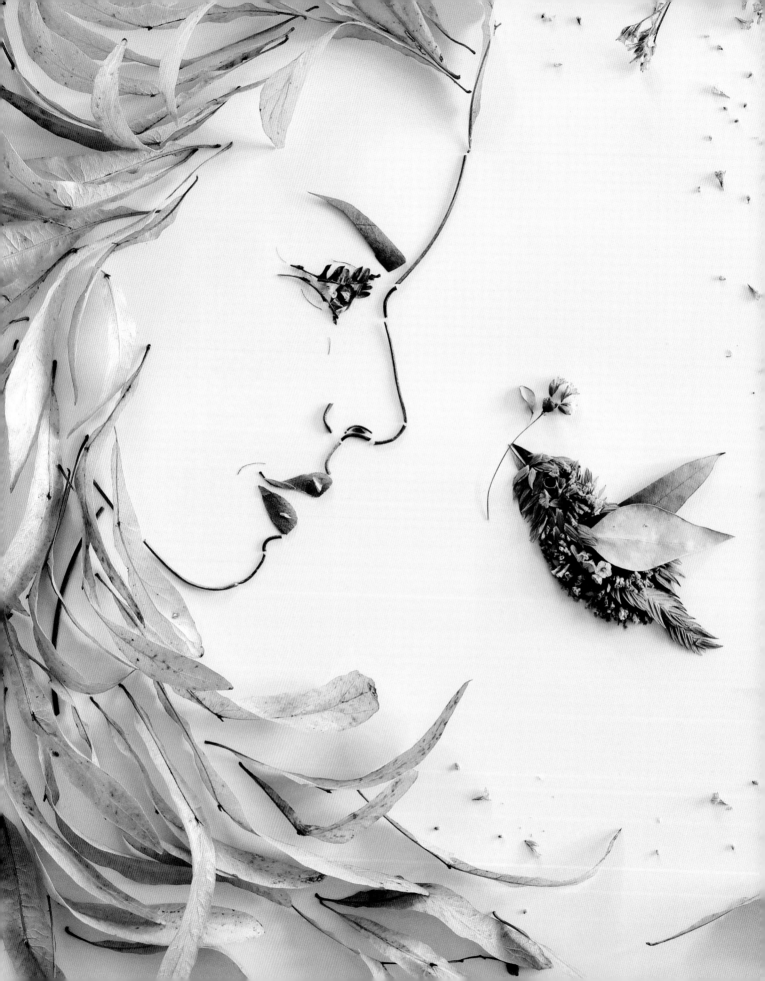

Just the Girls

Ever since I began drawing as a young girl, portraits of women have kept me busy for hours on end. Now, capturing women using bits of foraged locust tree leaflets and bougainvillea seems to come naturally for me. It's been fun to see how far I can push this medium. It's not easy when everything is just balancing there and any wrong move can ruin your hard work. Perfecting all the little details for these ladies and hunting for just the right elements to create necklaces, rings, brooches, watches, glasses, fun outfits to match their personality, and even hands with nail polish was just the most fun!

BE SOMEONE'S SUNSHINE

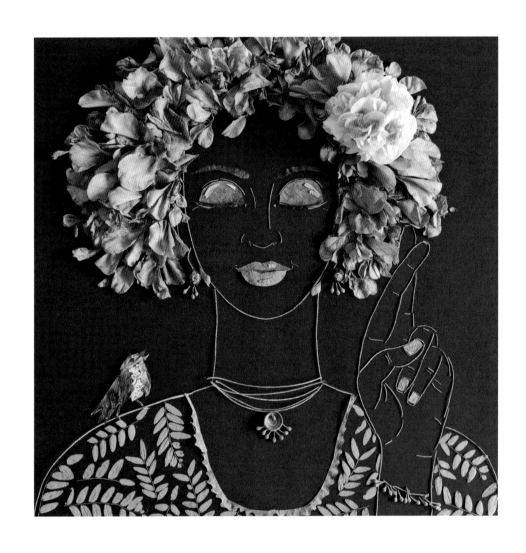

ABOVE: THINGS WILL WORK OUT • RIGHT: GROW GOOD THOUGHTS

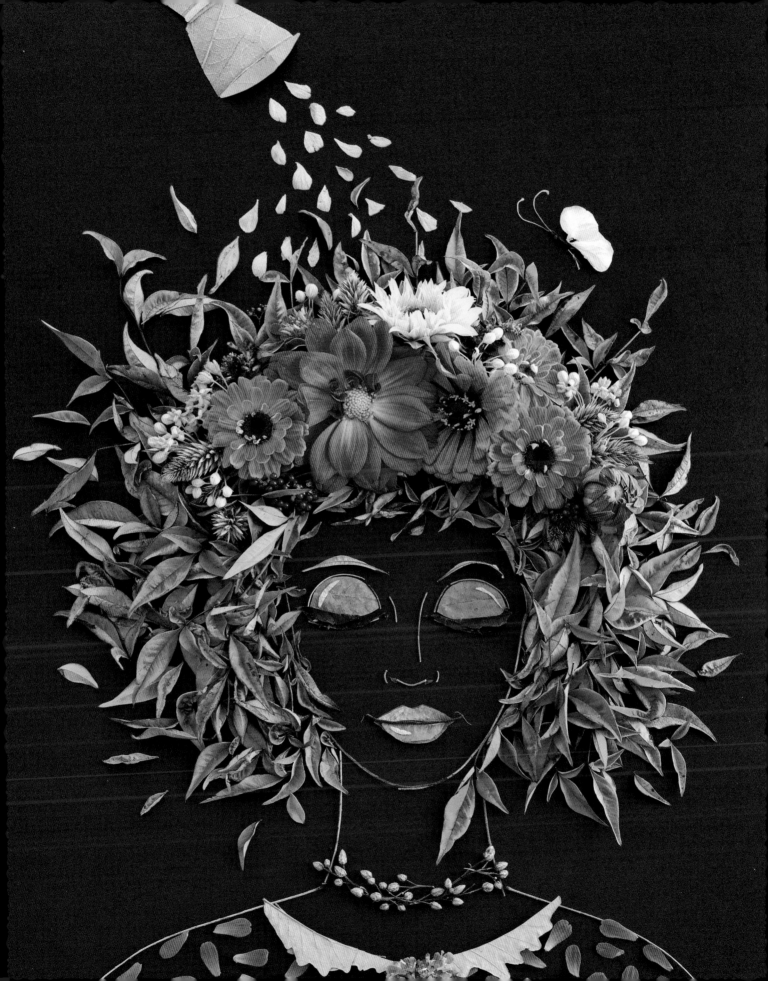

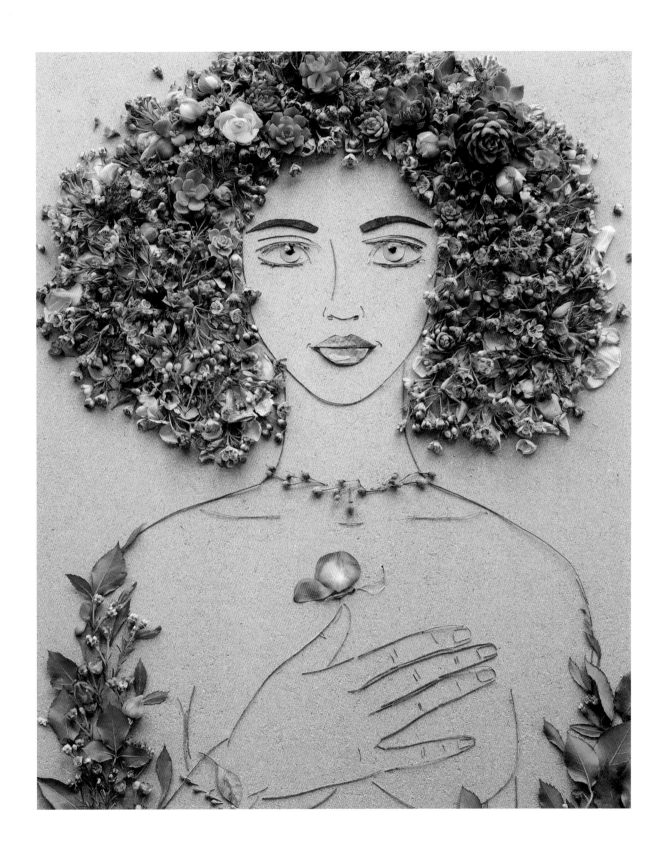

These pieces are a reminder for myself to show up every day, for *me*. When my body was facing so many challenges, I often felt like I was letting down the people I loved. Then I realized that this mindset was not sustainable or healthy. My problem wasn't about being good enough, it was thinking I *had* to be at all costs. I had to learn that taking care of myself with rest wasn't being lazy and having to say no wasn't selfish. You are amazing and you *are* enough.

YOU ARE ENOUGH

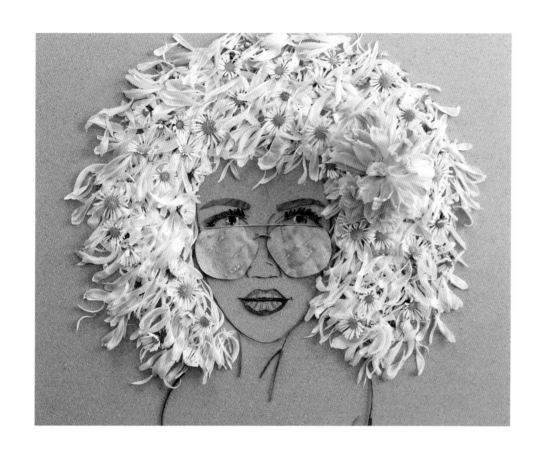

ABOVE: BEACH BABE • RIGHT: JADE

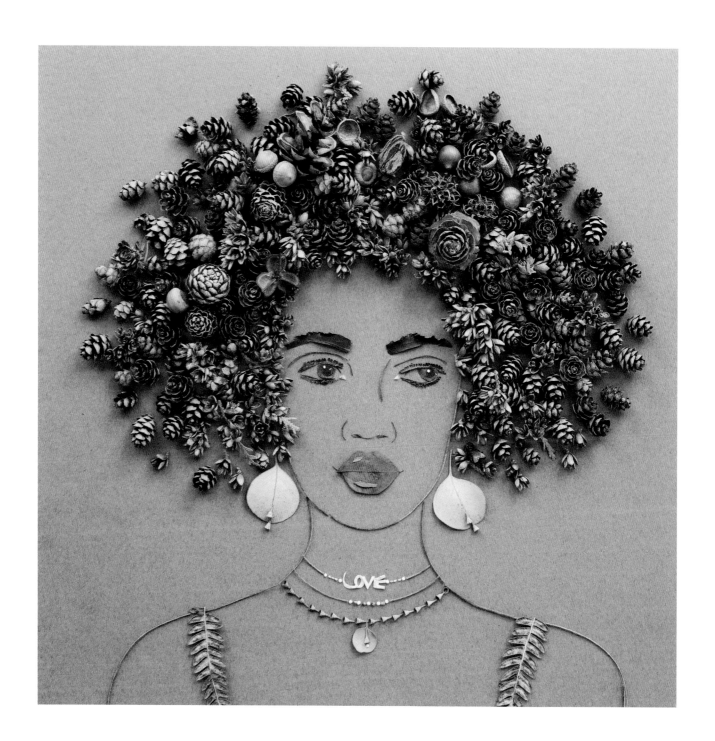

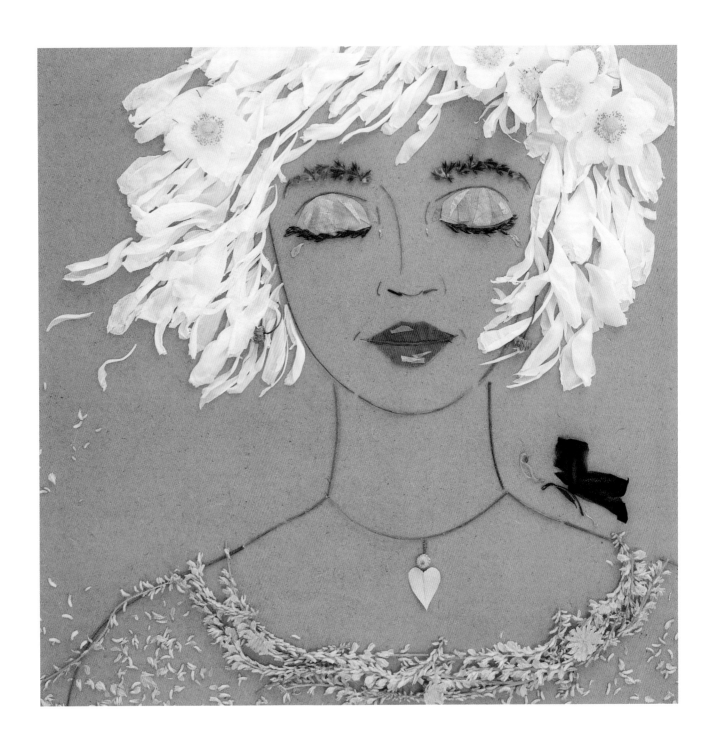

SUMMER BREEZE

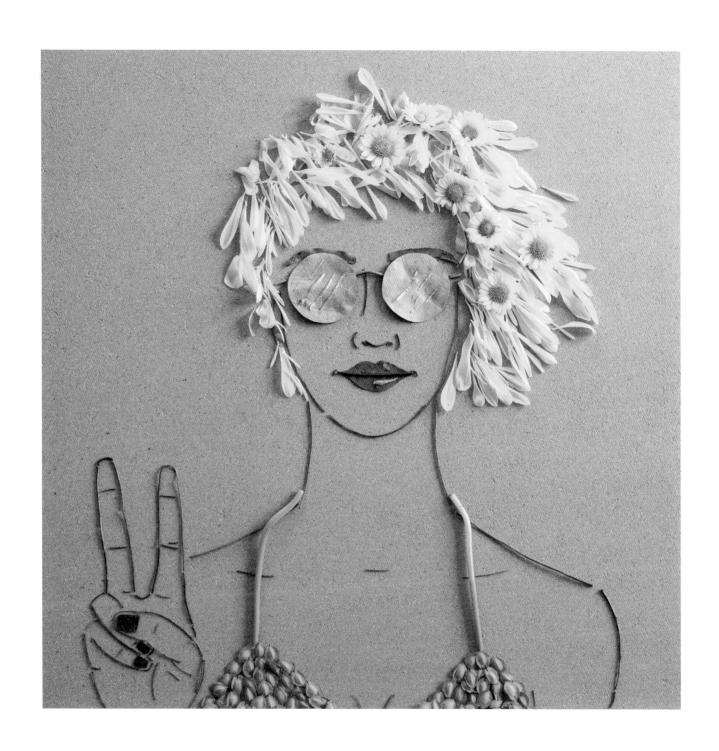

PEACE OUT

I came out of a coffee shop to find a branch from a locust tree laying in front of my car. It was still green, alive, and looked just like hair to me so I grabbed it and drove home to make *Greta*. I loved how the branches were curved to look like the wind was gently blowing through her hair, creating movement and framing her face. Building the little bird was so much fun and it felt as though I captured a connection between them, which in foliage language isn't always easy to do.

GRETA

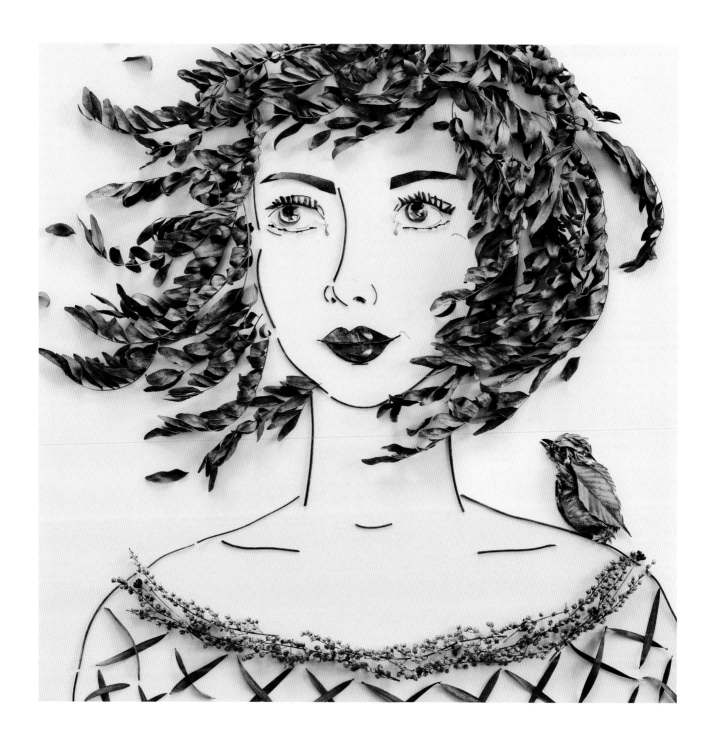

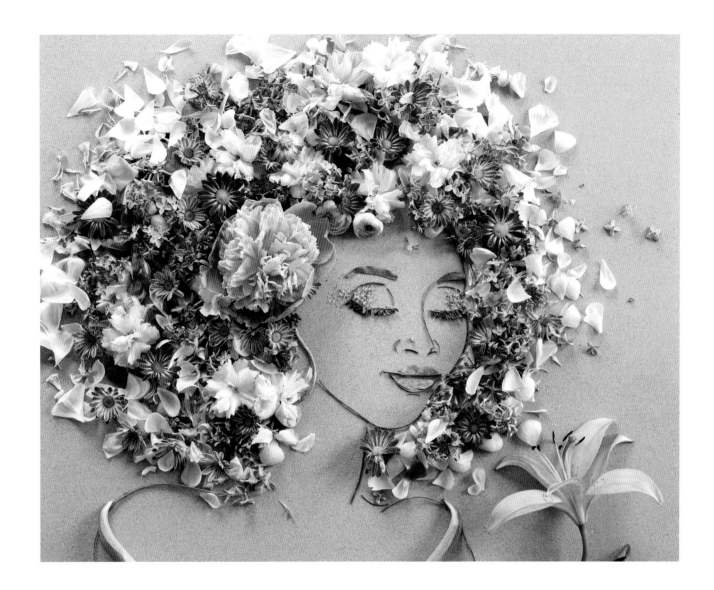

Big hair don't care! These ladies were commissioned pieces I created for a hair care company. I wanted them to feel feminine yet strong. Daisies, ranunculus, peony, lilies, and one sea grape leaf grace these free spirited women.

PINK BREEZE

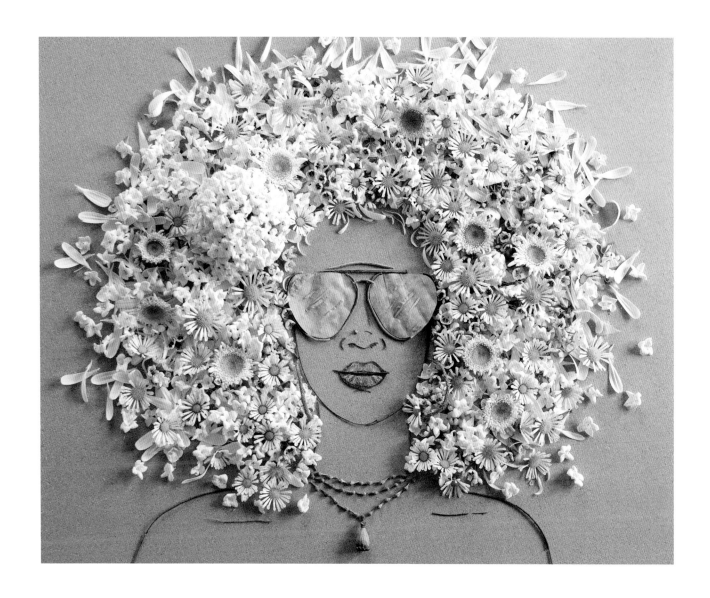

PEACE PETALS

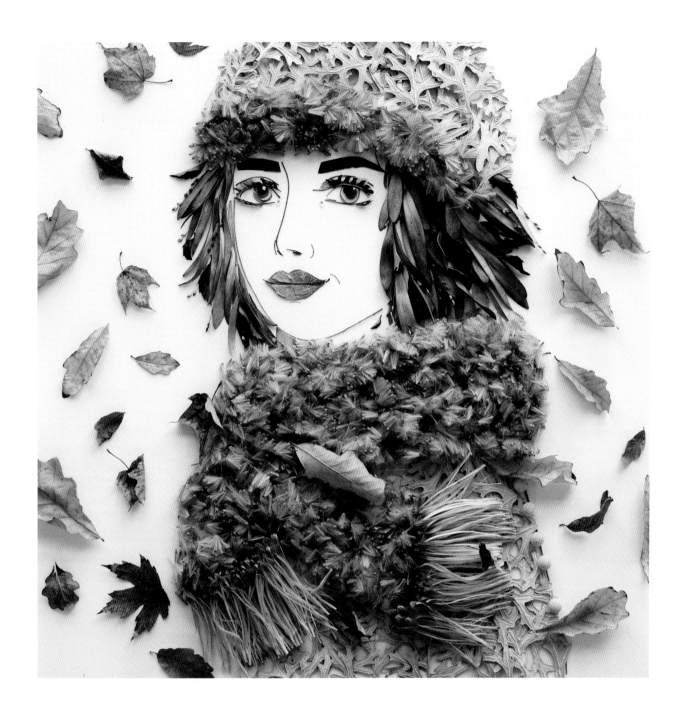

I had been wanting to create a mermaid forever. From her collected shell crown to her quinoa and chia seed hair, creating Shelly was like a day at the beach!

ABOVE: SOPHIE • RIGHT: SHELLY

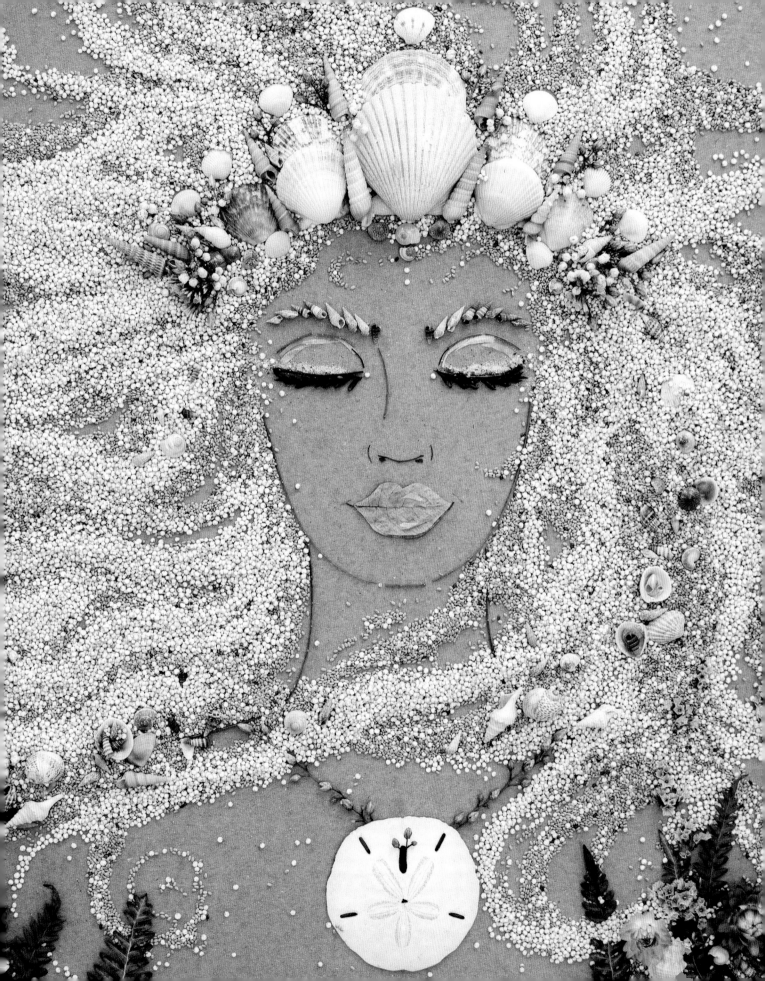

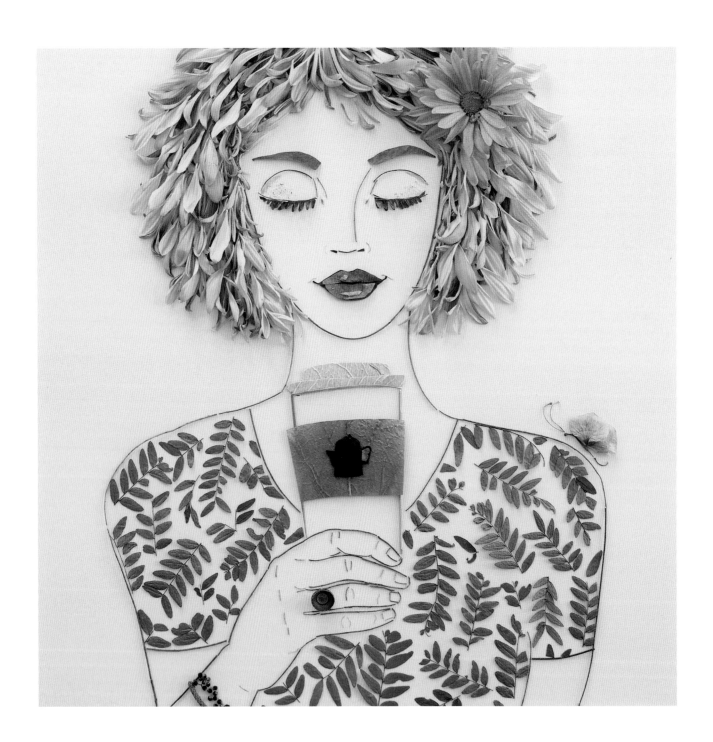

BUT FIRST, COFFEE

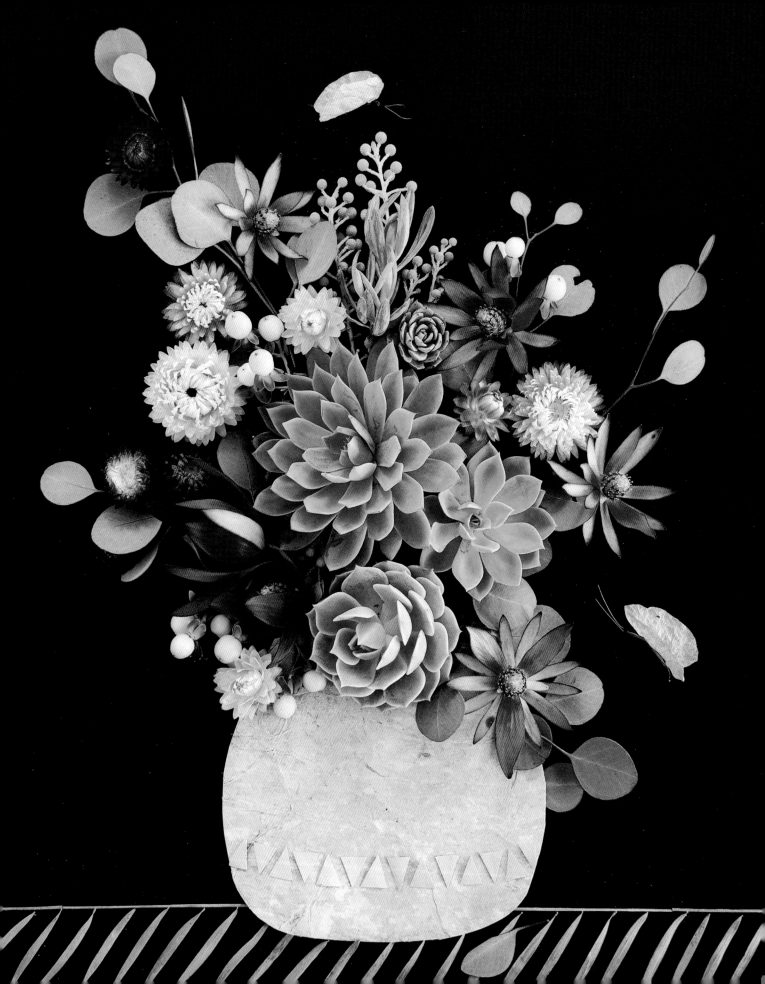

Everlasting Blooms

I always feel like I'm working out a puzzle when I'm building these pieces. Some of the most fun and exciting parts of doing the floral work is arranging the flowers. I love figuring out what colors, shapes, and textures will look right and in harmony with each other. The vase idea actually started with me wondering, *What do I do with all of this fun dried, but very alive-looking, foliage?* So, I just started playing. Hydrangea from my yard, statice, silver brunia, lavender, dried fall leaves cut to make tablecloth stripes, rose petals for butterflies…perfection.

STRAWBERRY FIELDS

For this piece I gathered every bit of the dried foliage I had laying around in my studio. It all still looked alive and fresh, so I started arranging it for fun, and then the light bulb went off: Put it in a "vase" on a "table".

GATHER

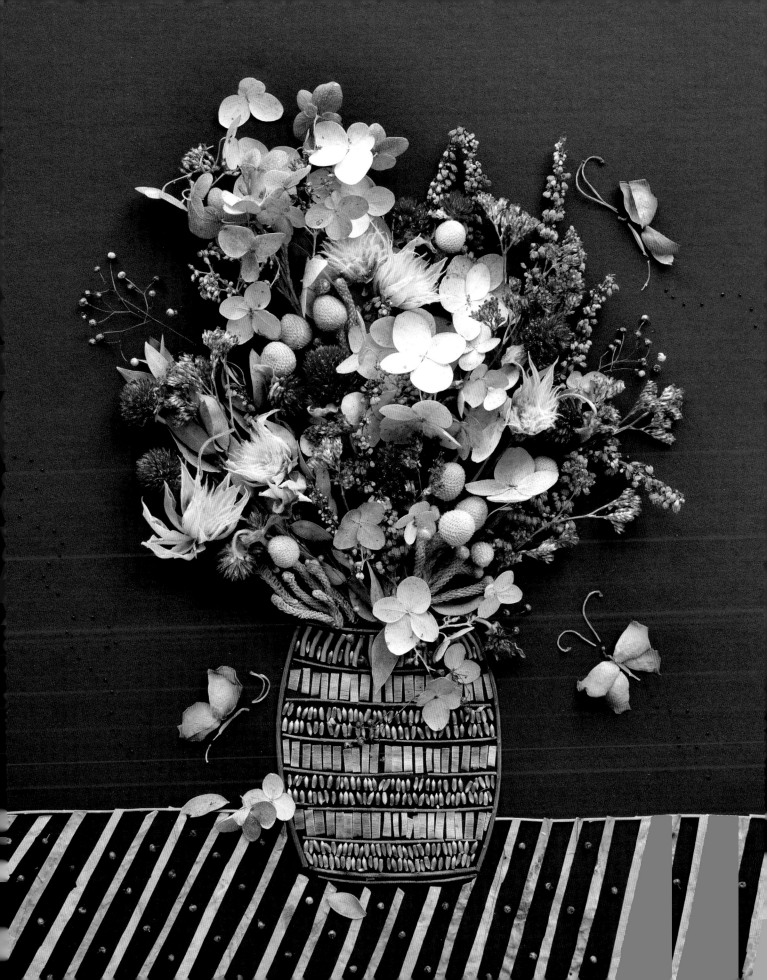

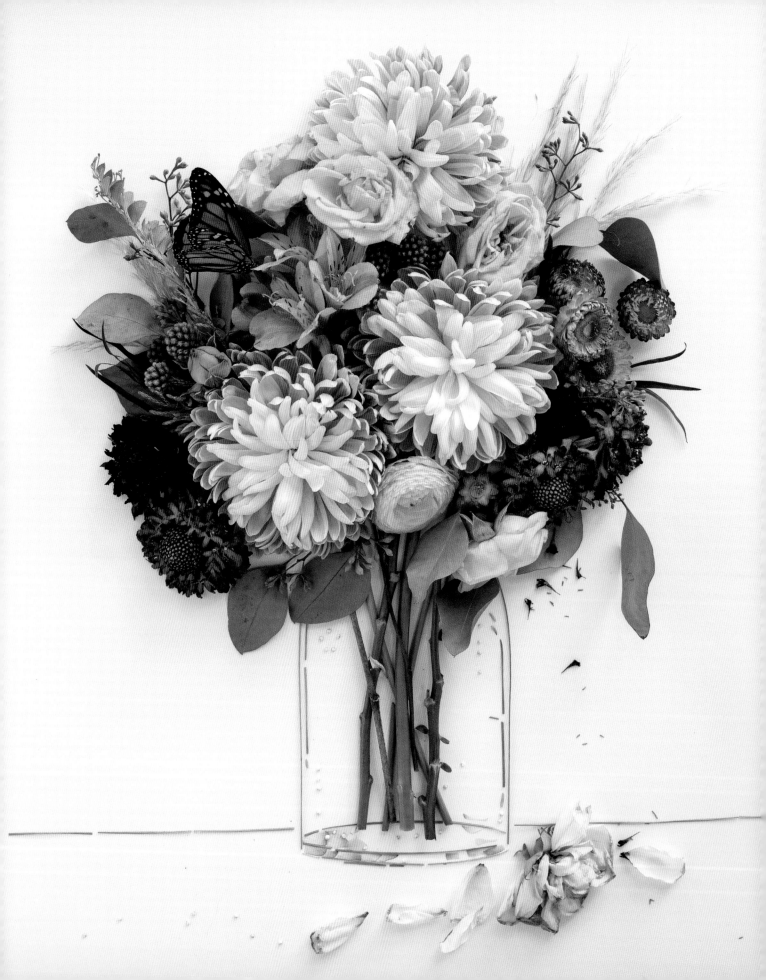

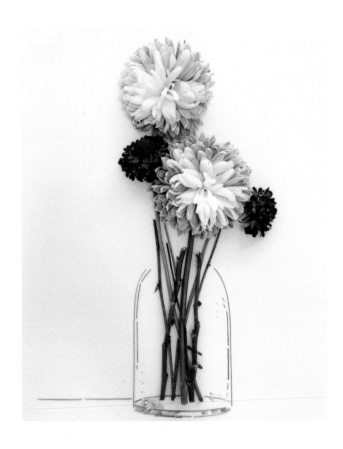
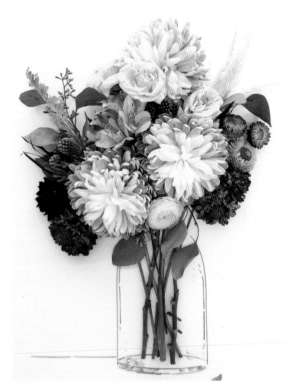

September is made with Brooke's wedding flowers. My entire SUV was packed with the flowers that I took home from her venue. I knew I had way too many flowers, but I didn't care. The thought of leaving even one flower behind was heart-wrenching to me. When I got them back to my studio, I pulled them all apart and gave them a fresh cut. I ended up with about 15 vases full of flowers, and still no idea what I actually wanted to do with them. Days passed and visiting family members were slowly leaving town. The day I finally got back to my studio to work on something, almost every flower was moldy and dead. I wondered what I could do with the few flowers that still had a little bit of life to them. I decided I'd put them in a "vase" and preserve them forever.

SEPTEMBER

La Jolla's farmers market straw flowers, one gorgeous goldfinger pincushion protea from my favorite flower shop, eucalyptus, and bright yellow mimosa make for a happy dance bouquet of flowers. The "vase" was foraged from a paperbark tree outside our local UPS store, and podocarpus collected on the sidewalk make up the table cover. My mother loves floral design, and I can see why. Putting together a vase full of flowers in this way is just as much fun as arranging one filled with water.

GOLDFINGER

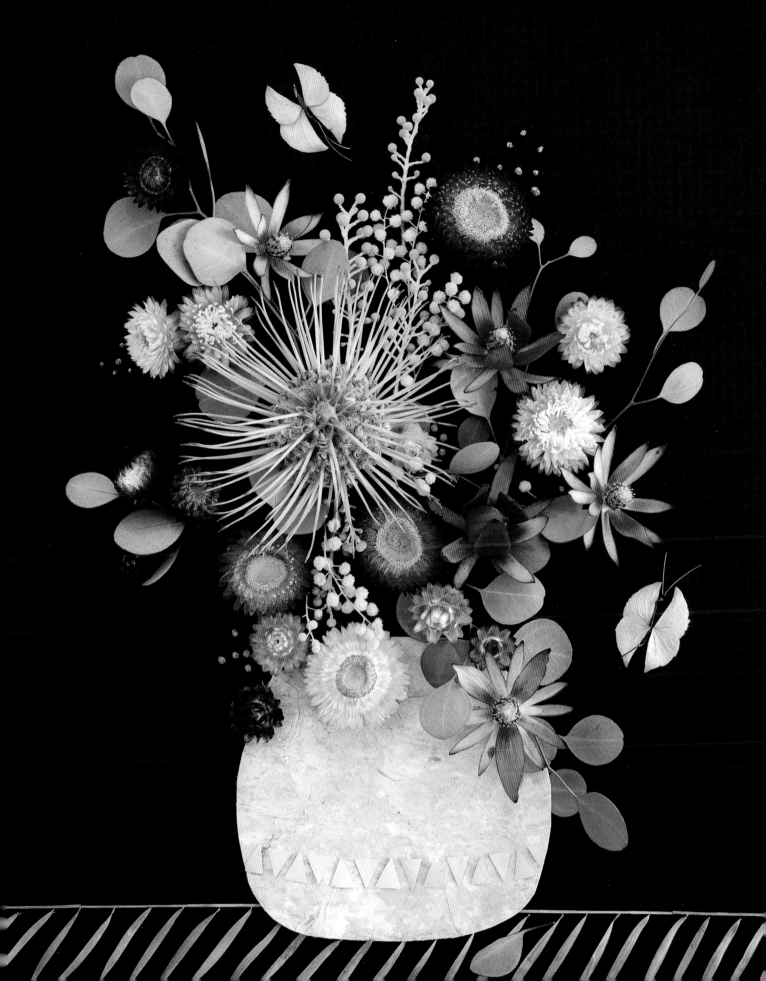

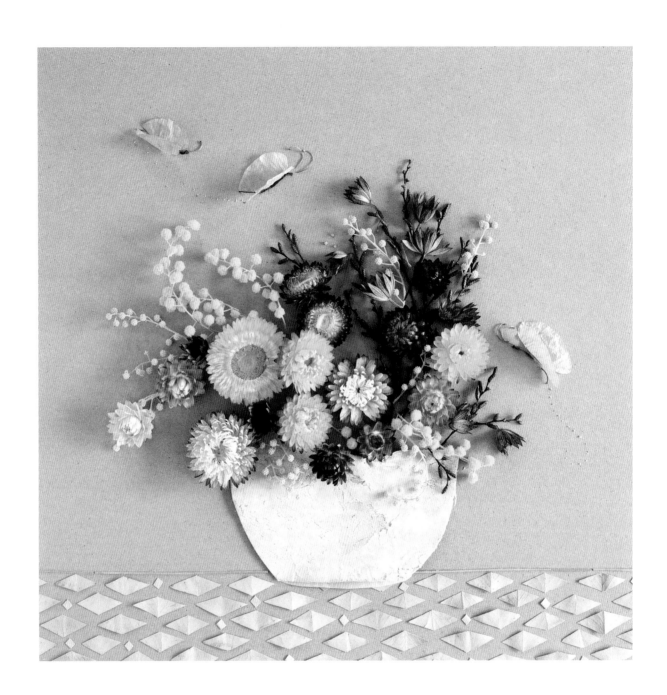

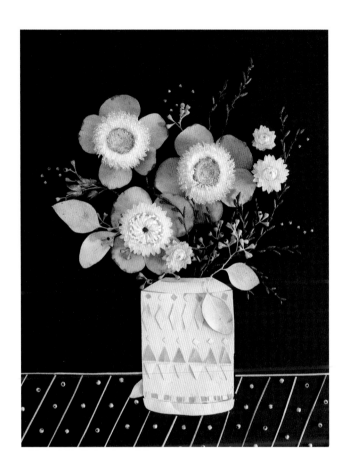

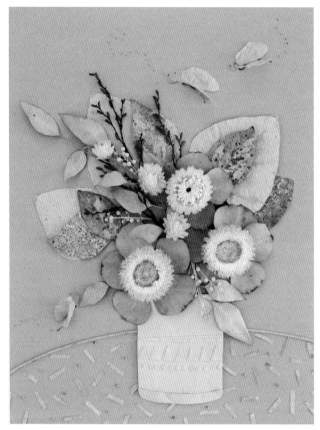

LEFT: POT OF SUNSHINE • ABOVE LEFT: DELILAH • ABOVE RIGHT: FEELING PEACHY

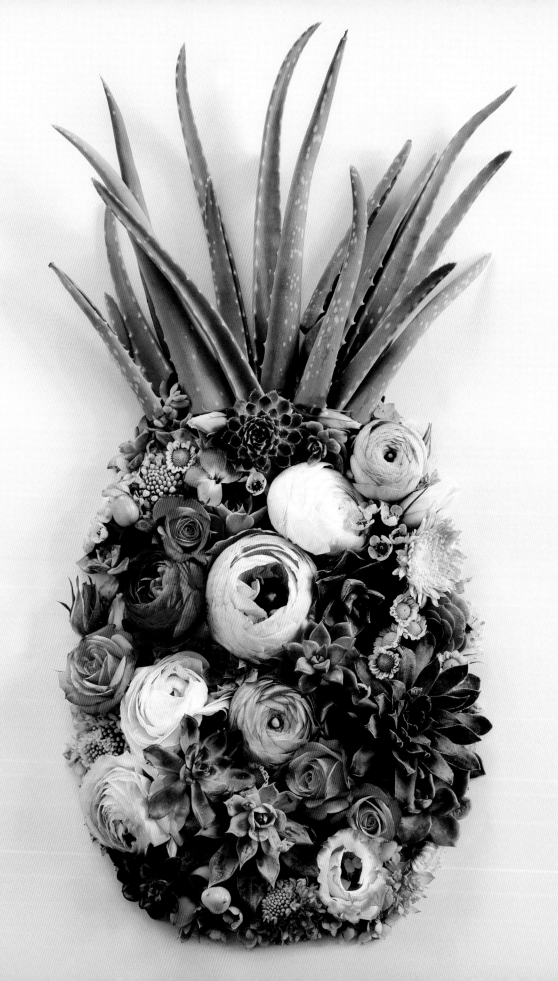

Flower Power

Flo·wer Hap·py Dance *verb* (*informal*) 1. Amazing color combinations and varieties of flower shapes working together in complete harmony.

The most beautiful Flower Happy Dance? Wax flower, ranunculus, delphinium, astrantia, dahlia, orange chincherinchee, gerbera daisy, *ornithogalum arabicum*, chrysanthemums, roses, scabiosa, aloe (for the top of my pineapple), and of course, succulents.

PINEAPPLE

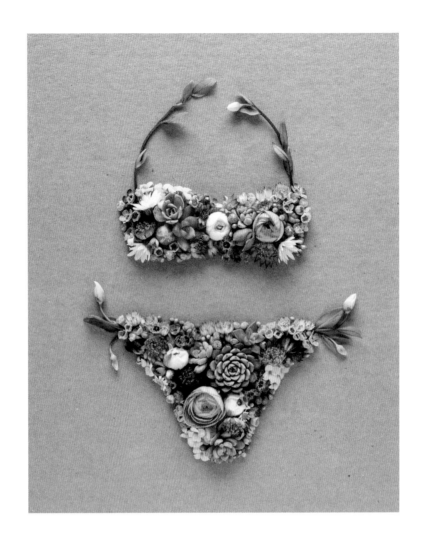

It was April in the Midwest, a time when foraging for summer blooms was not going to happen. So, off to my favorite flower shop I went for some color inspiration. I try to forage foliage as much as I can but when you're creating in a place where flowers aren't blooming all year, it feels really good to support a local small business. Ranunculus, daisies, succulents, pink wax flower, blue freesia, white and blue scabiosa, yellow and pink asters, pink hypericum, arabicum, orange star ornithogalum, pink heather, goldenrod, pink and white astrantia, and clematis flower vines combine their whimsy for these pieces.

ABOVE: NEW BIKINI • RIGHT: AWAKENING

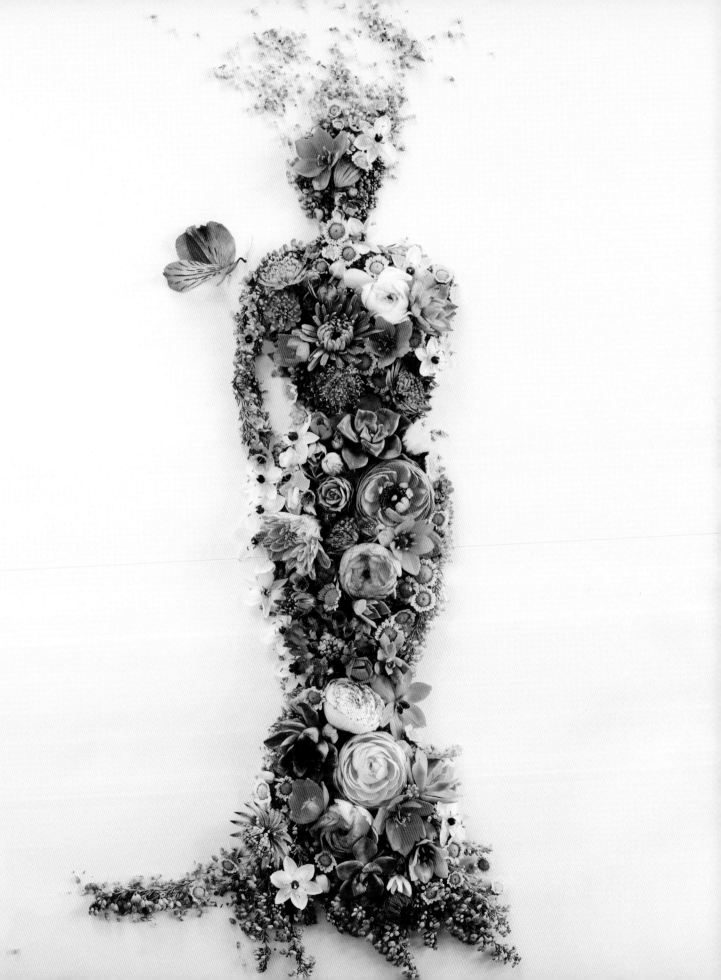

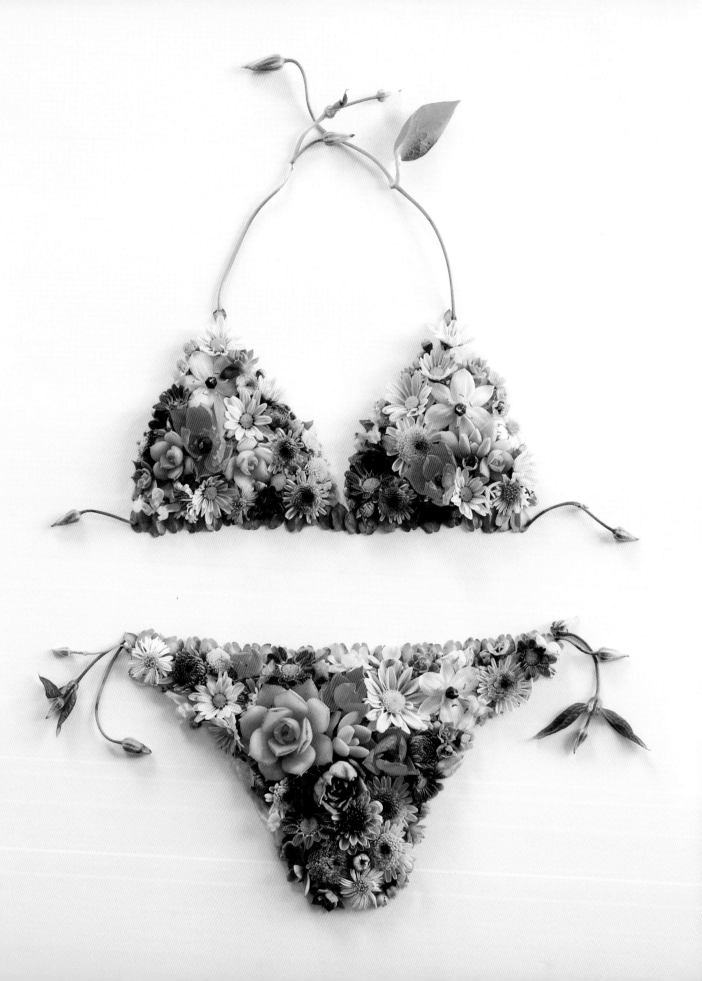

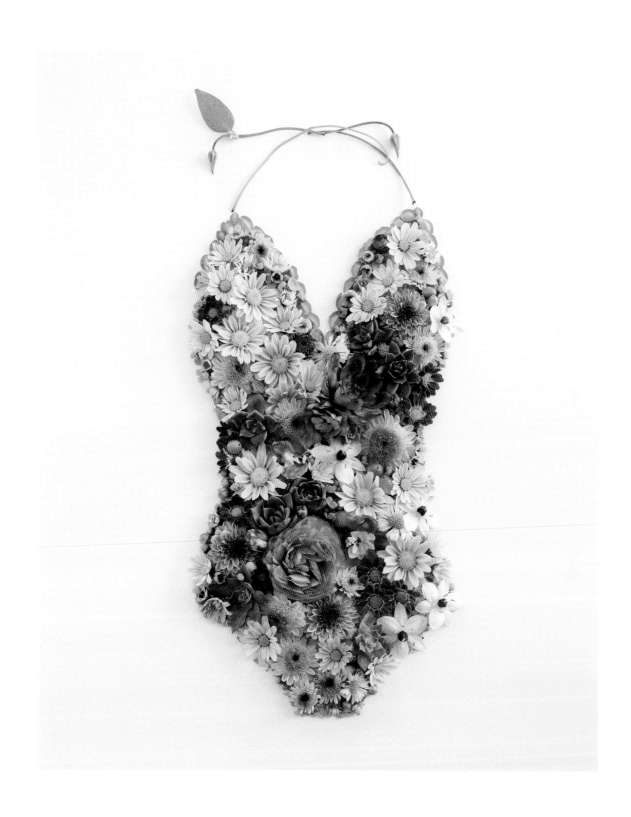

LEFT: BIKINI • ABOVE: SWIMSUIT

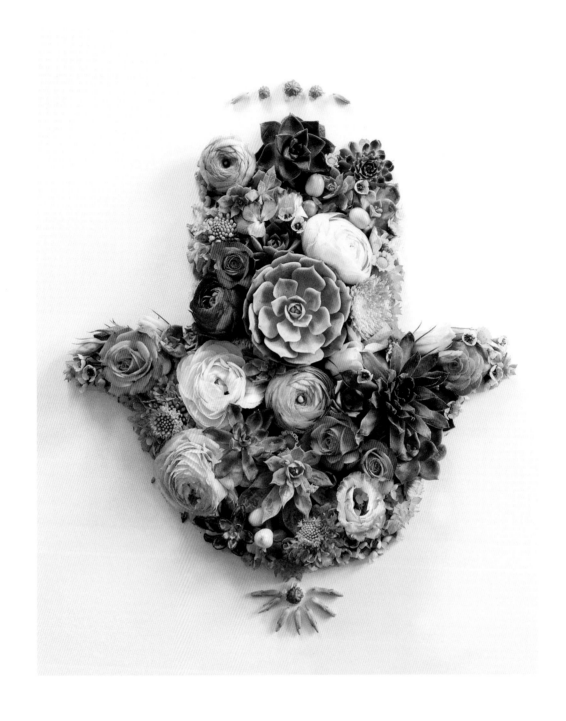

ABOVE: HAMSA HAND • RIGHT: THE WAY YOU ARE

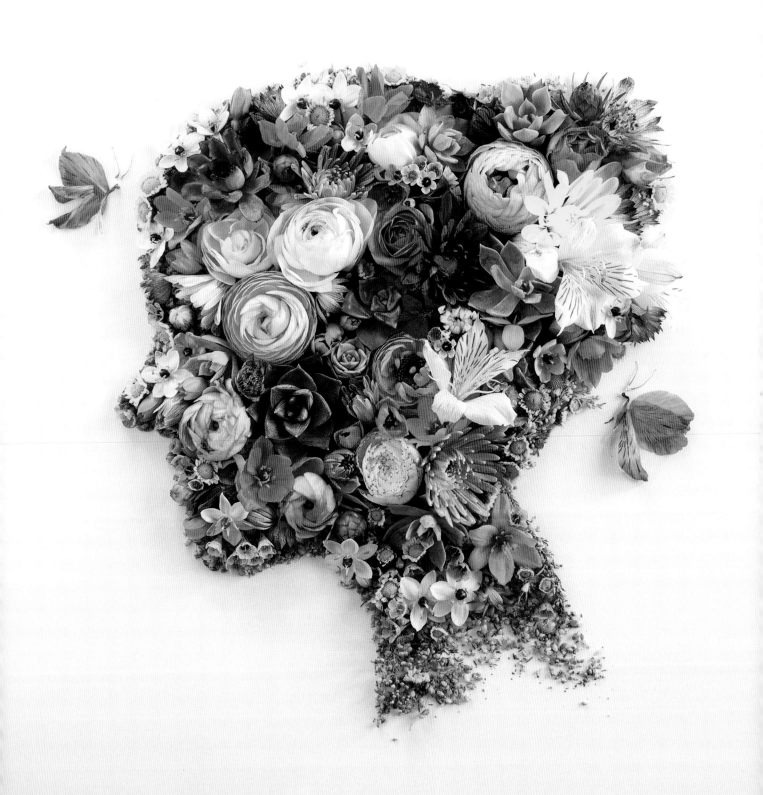

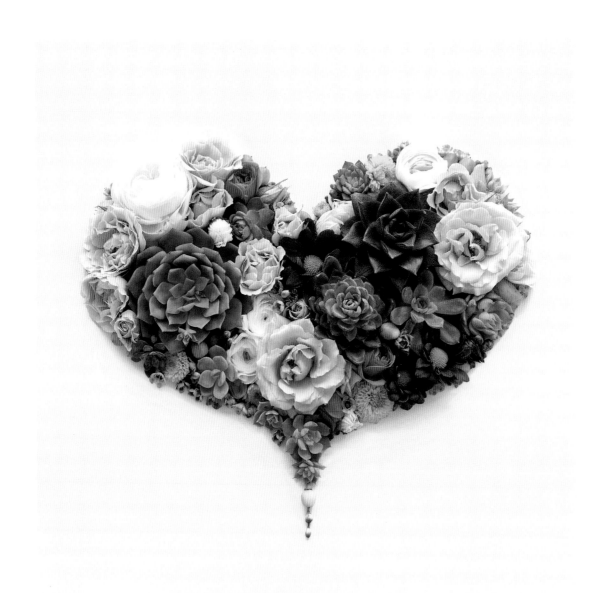

Sometimes it's just one flower that can set off a stream of inspiration. This time it was a beautiful white lily that would be the perfect bottom to the perfect dress. The body of the dress is white wax flower, white peony, and statice. My sister has been a collector of all things hearts since we were children. Even her Christmas tree is all heart ornaments! I figured I better get into the heart making groove and create my own. Spiritually, the heart shape represents love, compassion and understanding.

ABOVE: MY HEART • RIGHT: SHE WORE WHITE

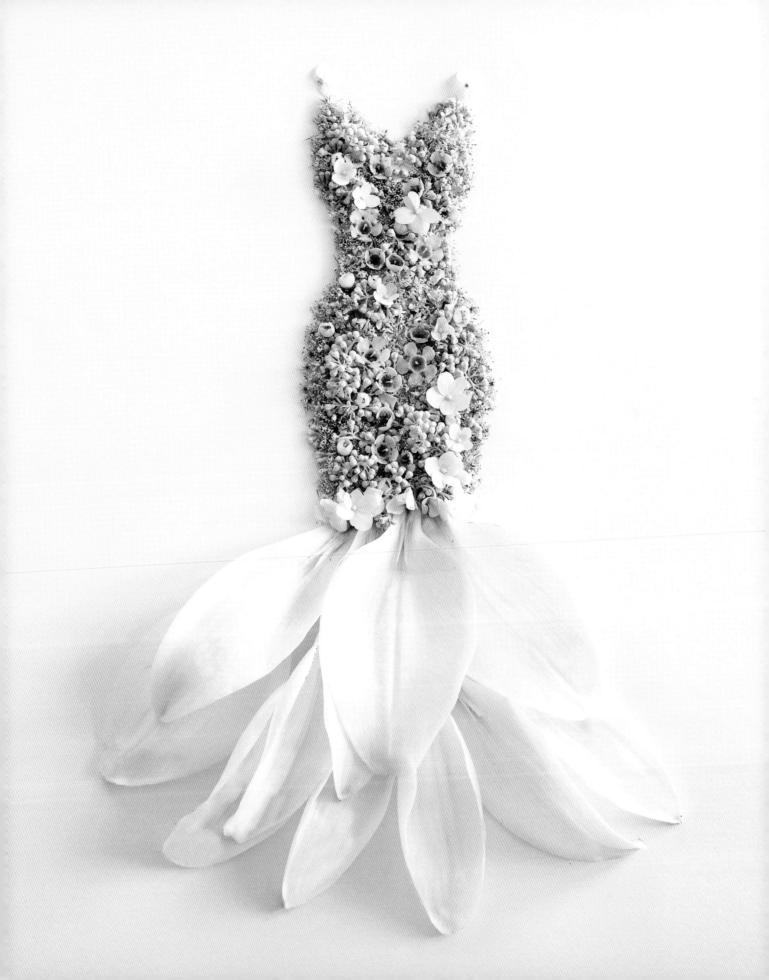

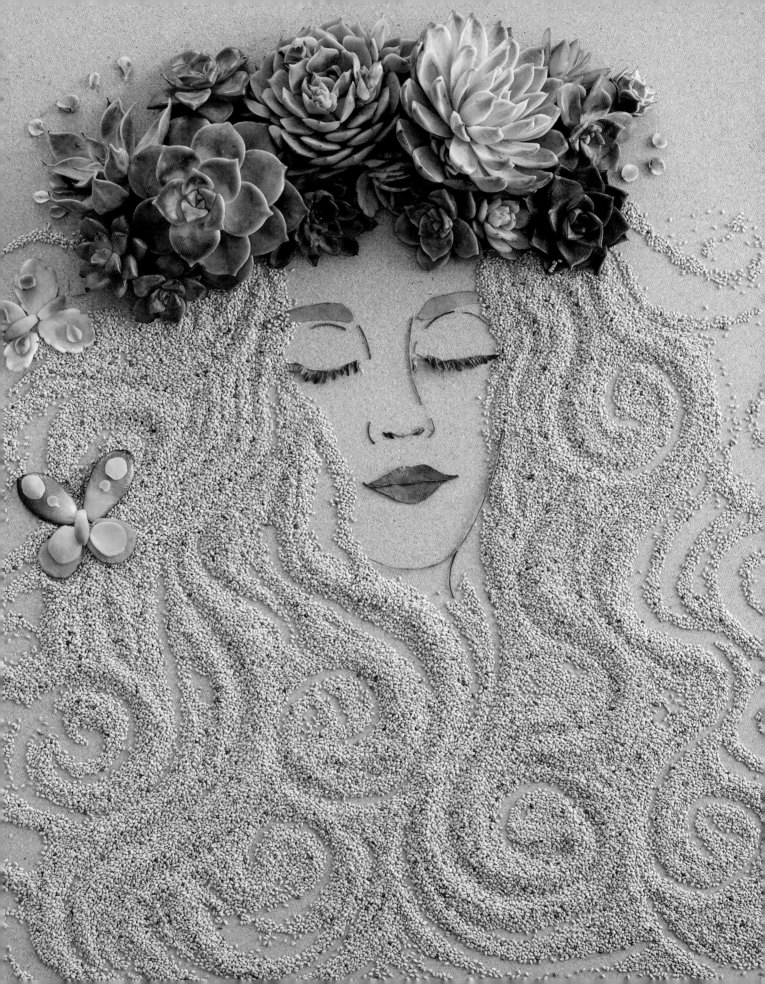

Succulents

Succulents have always been my favorite plant, and they are a dream to work with. They don't die on me and they won't blow away; they just sit where I place them and put on the best little show. I love how I can pull them apart, and then after I use them, repropagate them. I remember having so much fun building my first succulent flower crown for *Succulent Fairy*. All of these pieces were created in La Jolla, in a sweet coastal cottage on Sea Lane just steps from the beach. Running out of succulents *definitely* wasn't going to happen here.

SUCCULENT FAIRY

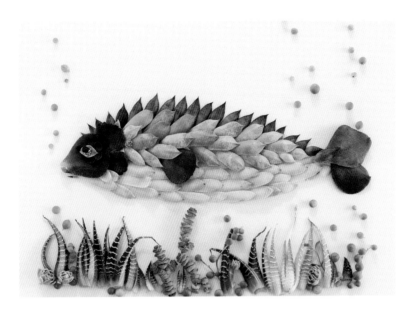

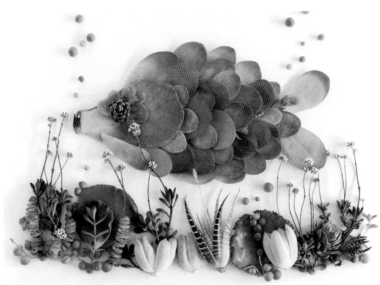

One Fish, Two Fish was a book by Dr Seuss I loved as a child of the 1960's. But I'm pretty sure the real inspiration for creating the art was all about the string of pearl succulents as underwater bubbles.

ABOVE: ONE FISH • BELOW: TWO FISH • RIGHT: TAILS OF THE SEA

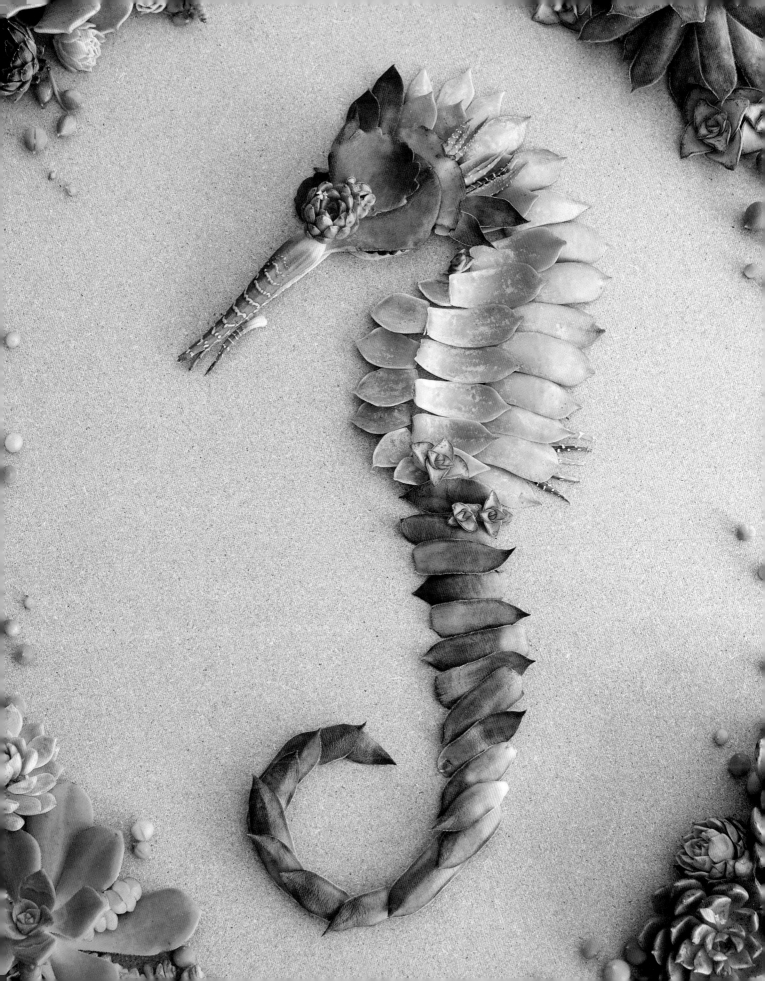

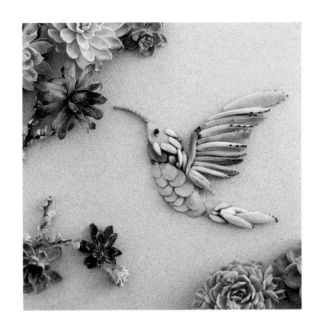

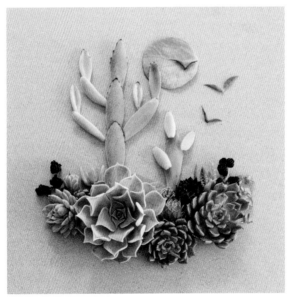

ABOVE: HUMMINGBIRD • BELOW: DESERT DREAMING

RIGHT: TORREY PINES

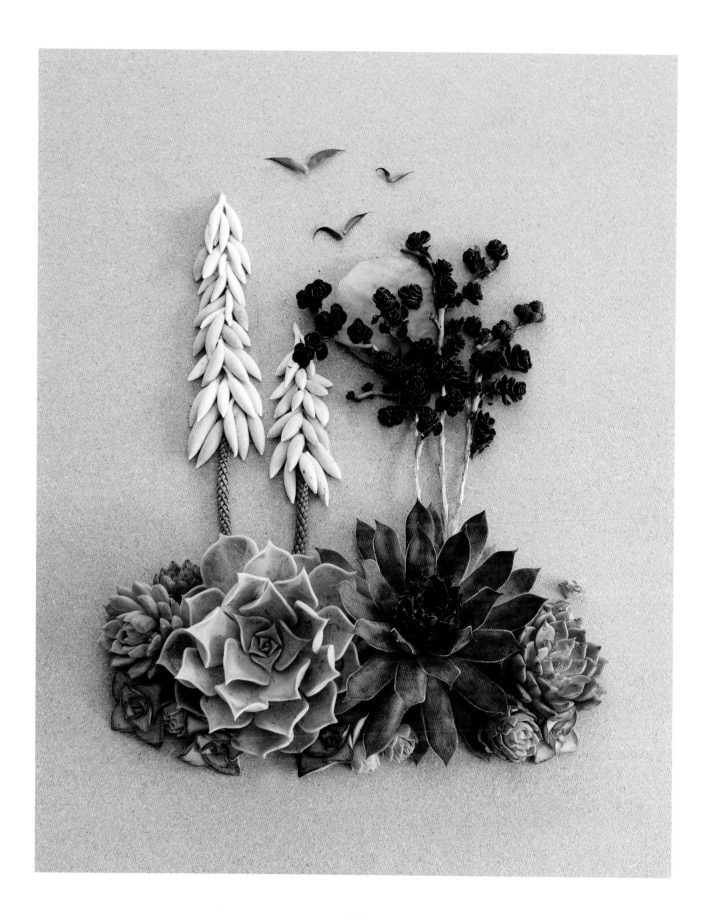

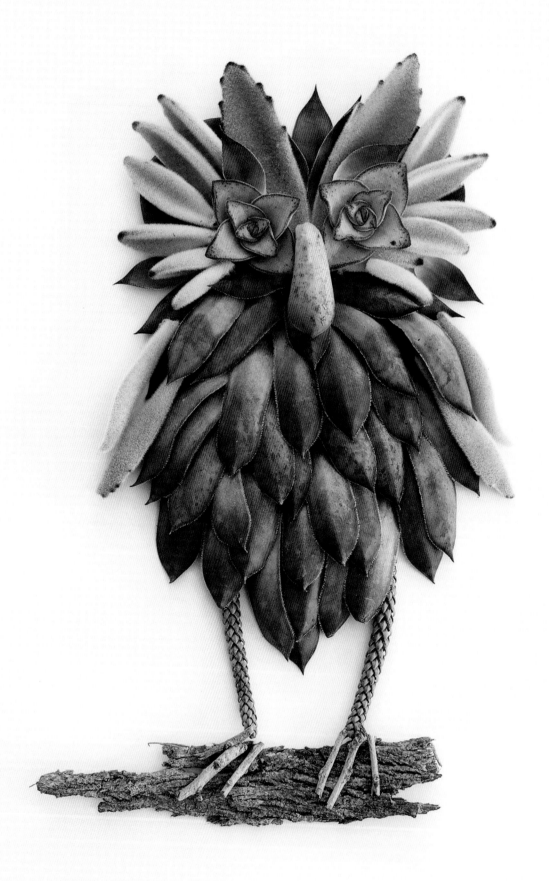

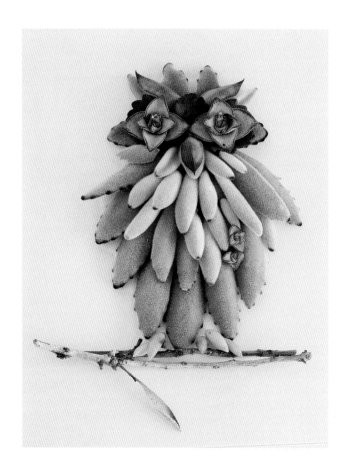

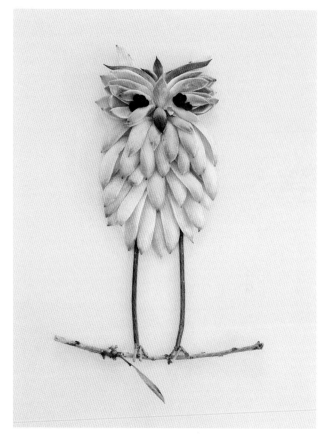

Because each succulent has its own charm and personality, they have the ability to make the cutest birds. It took one sunny yellow succulent and a couple of branches to make *Luna*; instantly adorable. It always amazes me how an expression can emerge so fast with just moving some petals around. Luna needed a friend, so *Zoey* came quickly after with her Panda plant body and wings, ivory tower and kalanchoe eyes, and sedum feet. I love the tiny ivory tower nesting in her belly.

LEFT: SPUNKY OWL · ABOVE LEFT: ZOEY · ABOVE RIGHT: LUNA

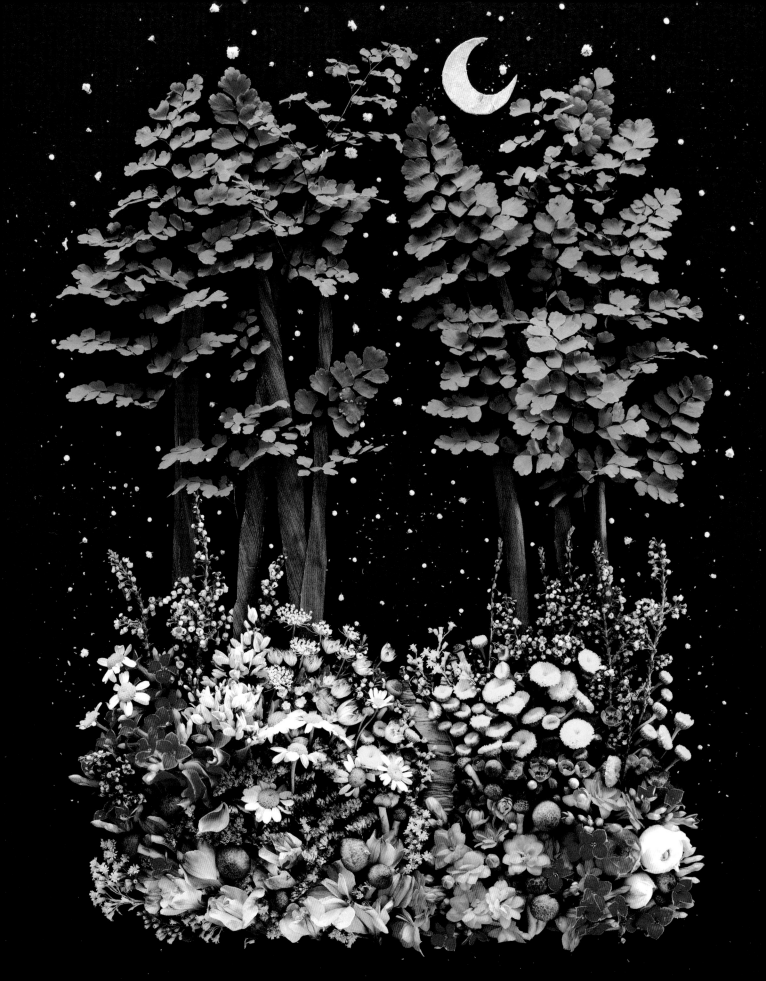

Magical Places

My favorite flower creations have always been the magical places, the small worlds and under-the-stars scenes that have come from my imagination. Most of these are inspired by the two different landscapes I live in during the year. Pieces such as *Surf Like a Girl*, *Cottage Garden*, and *Under the Tuscan Sun* were created while living in La Jolla, where girls walk their surfboards down the street to the beach, barefoot, tan, and carefree. Bougainvillea hangs thick and lush over garden gates that you wish you could invite yourself through just to sit for hours enjoying the sweet smell of roses and jasmine.

FOREST BATHING

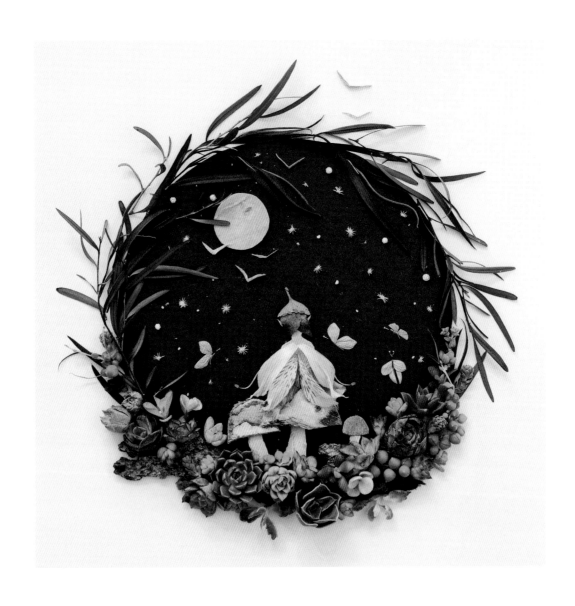

ABOVE: PIXIE GARDEN • RIGHT: HAPPY PLACE

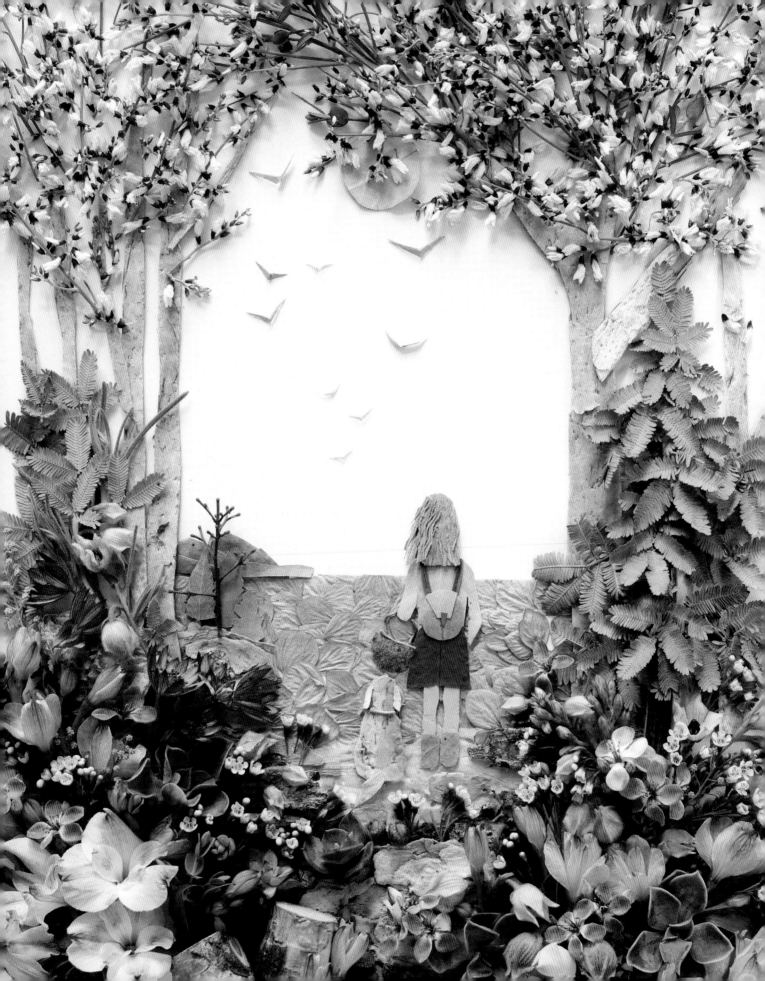

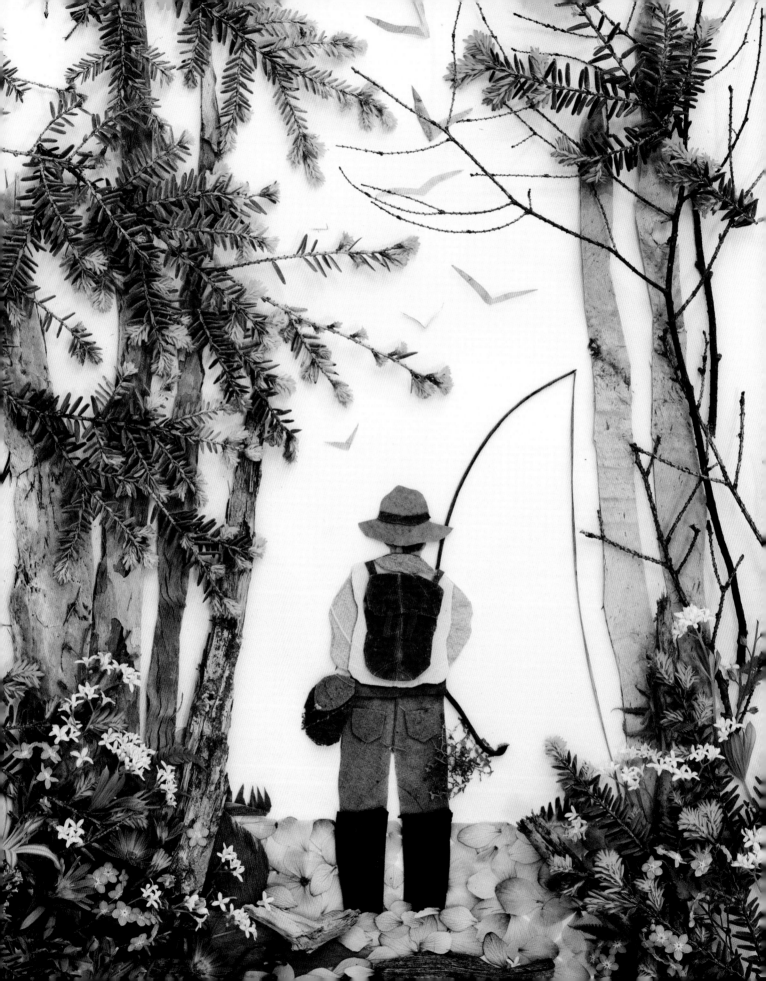

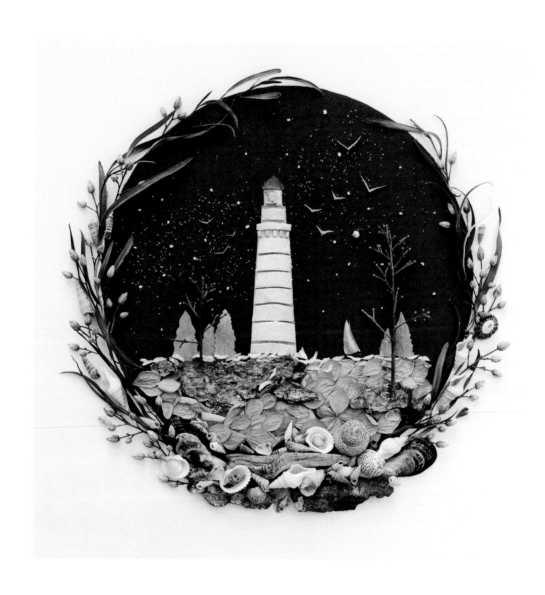

LEFT: GONE FISHIN • ABOVE: LIGHTHOUSE

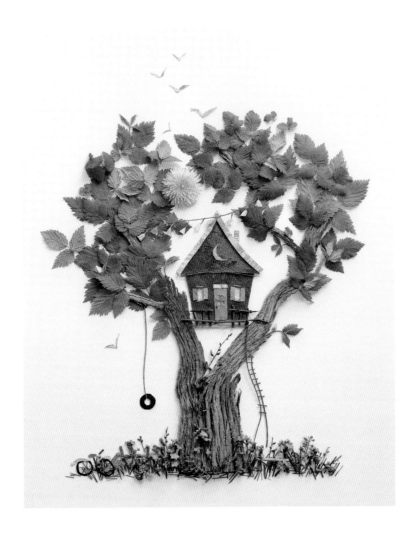

Sometimes when I look out into my garden I wonder, what's really going on deep inside all that beautiful foliage and dirt? It's an interrelationship of birds, bees, bugs, dragonflies, butterflies, and animals all coexisting. Sipping their nectar in the flowers and making their homes among the trees, flowers, earth, and sun. Planting flowers is one of the most therapeutic things I've ever done.

ABOVE: TREEHOUSE · RIGHT: AMONG THE FLOWERS

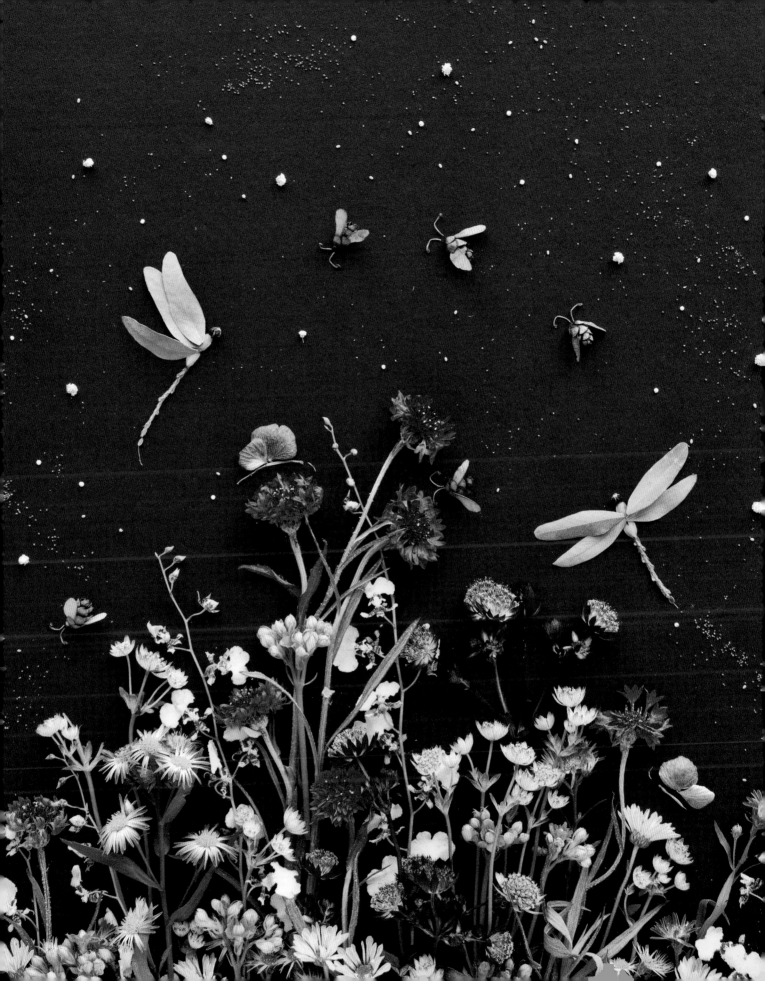

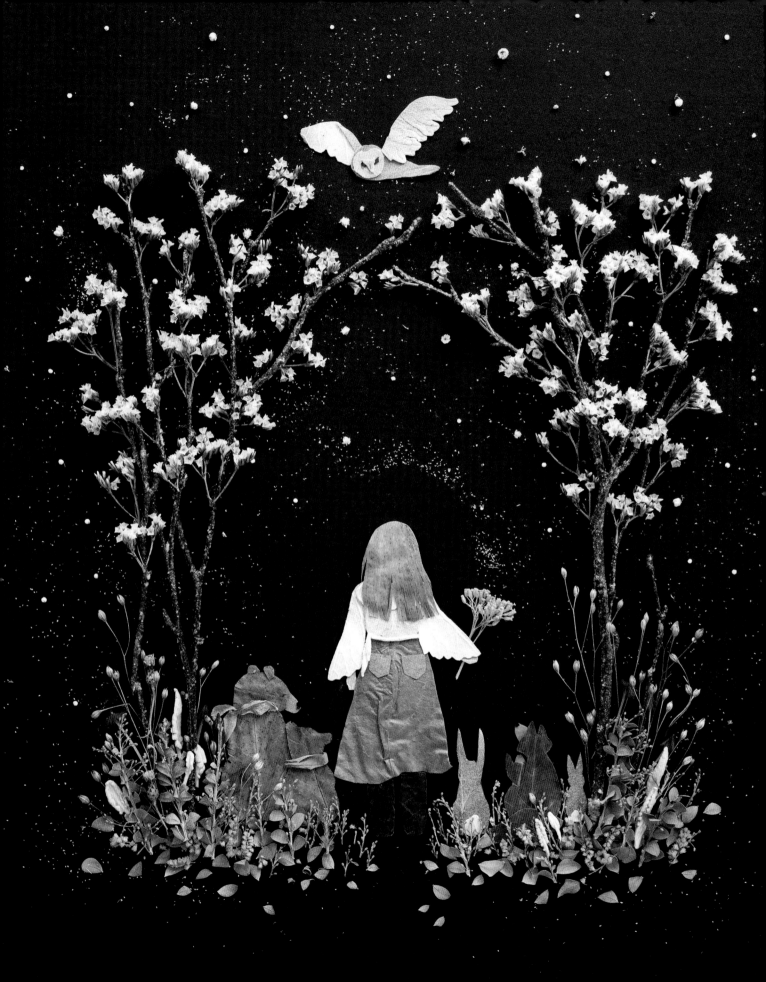

We all share an energetic frequency that is expansive and filled with love and joy. Sharing that energy is what life is all about! Animals never seem to lose their energetic connection to the universe like humans do. They remain in perfect vibration with everything around them, never disconnecting by way of fear or worry. I think all of us want to create a better connection to this higher place. *Share Your Magic* is a reminder that we can learn from Mother Nature, that we are all powerful forces of the universe.

SHARE YOUR MAGIC

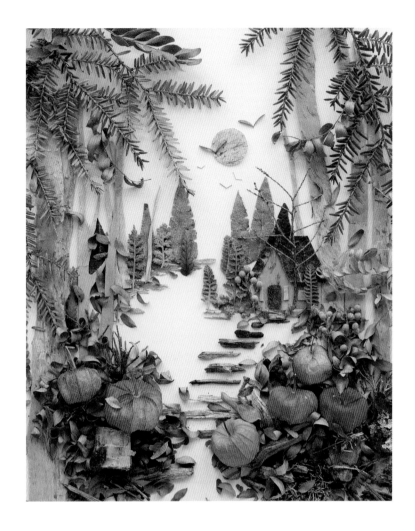

Peninsula Life, Happy Camper, Happy Place, Sweet Life, Pumpkin Patch, and a few more, were all inspired by living and working in Door County. The summer and fall here are truly magical. People flock from all over the world to enjoy the picturesque beach towns, state parks, and life on the water. Because Brooke and I own a shop in Fish Creek, one of the quaint towns neighboring the beautiful Peninsula State Park, we are often asked what makes the flowers grow so amazingly here. It's a combination of the air and water, a perfect potion for producing gorgeously abundant blooms. There are countless places to get lost among Mother Nature, to reconnect back with the earth, to feed your soul.

ABOVE: PUMPKIN PATCH • RIGHT: SWEET LIFE

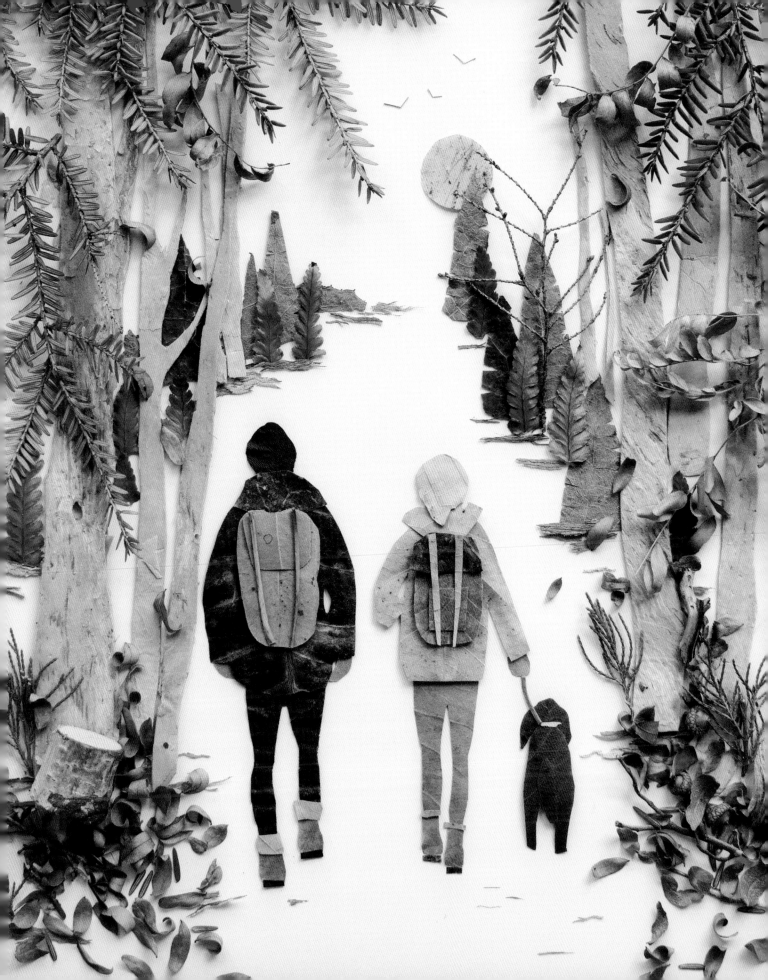

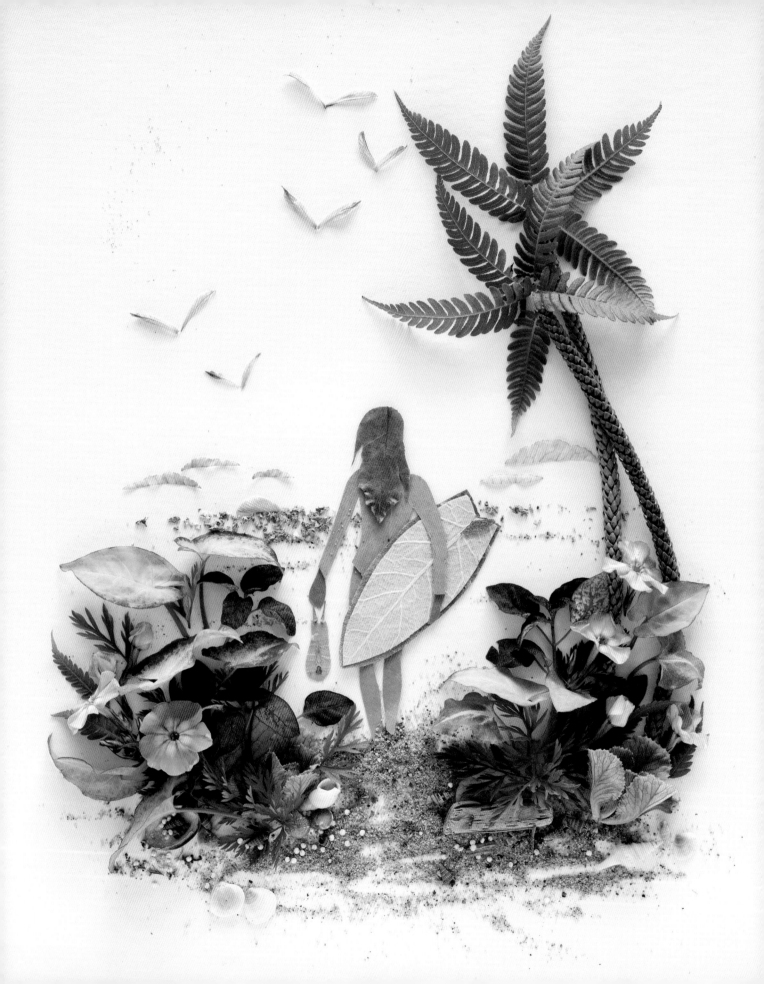

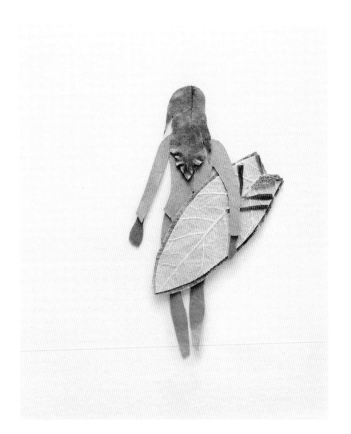
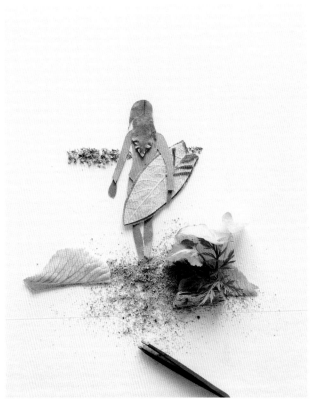

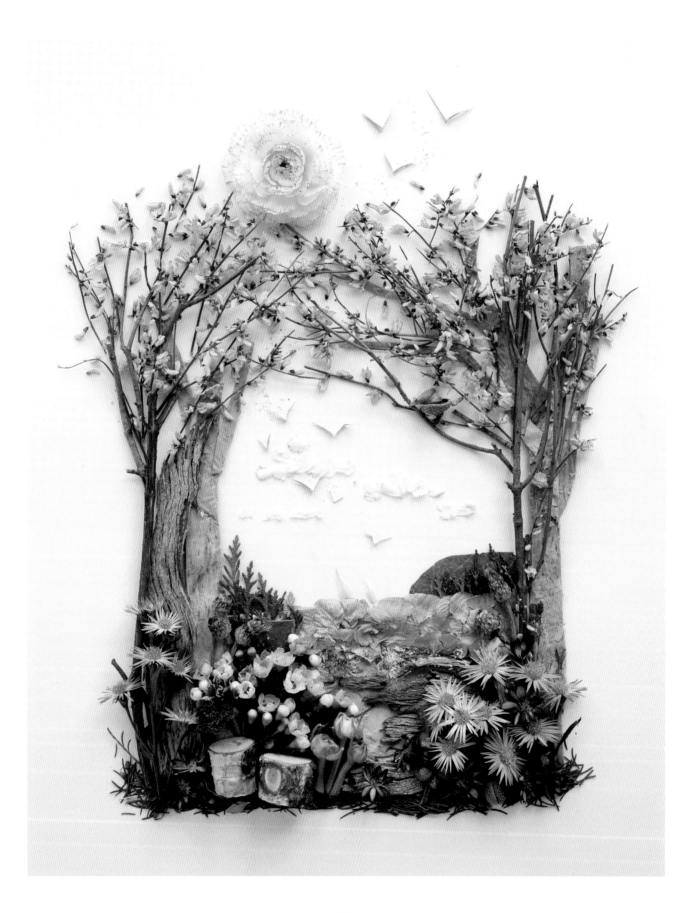

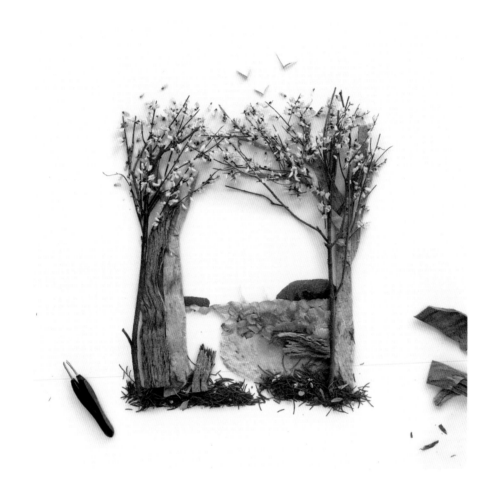

PENINSULA LIFE

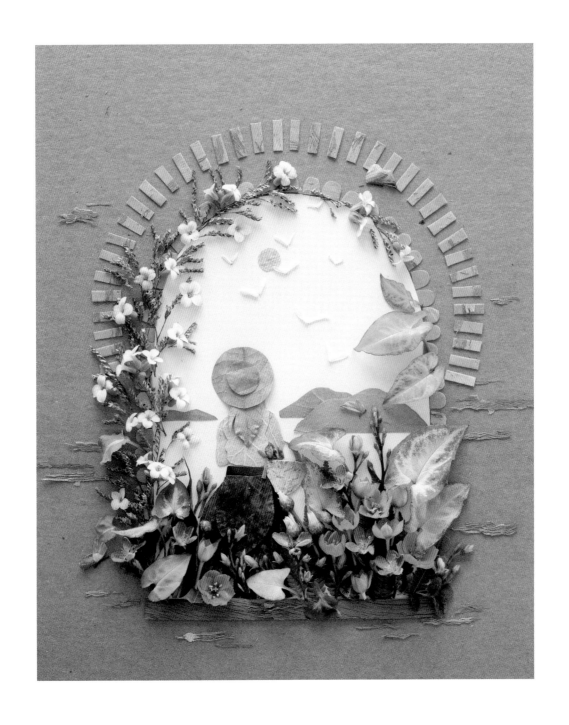

ABOVE: UNDER THE TUSCAN SUN • RIGHT: MOROCCAN NIGHTS

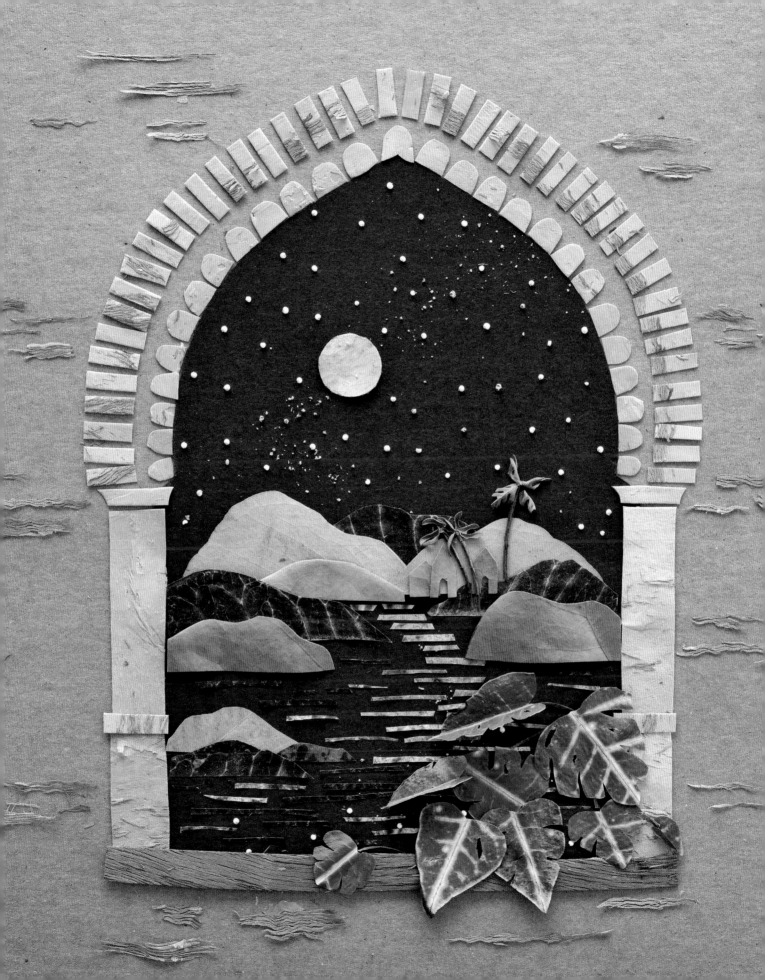

One of my favorite houses in La Jolla is the prettiest shade of pink I've ever seen. To the left side of the front door sits a tree that is usually adorned with gorgeous colorful hanging lanterns and twinkly lights. The whole yard is whimsically decorated for every holiday throughout the year. This house was my inspiration for the pink lanterns in this piece. Walking the streets of La Jolla can feel like a gardener's dream with all the inviting garden gates and beautiful flowers.

COTTAGE GARDEN

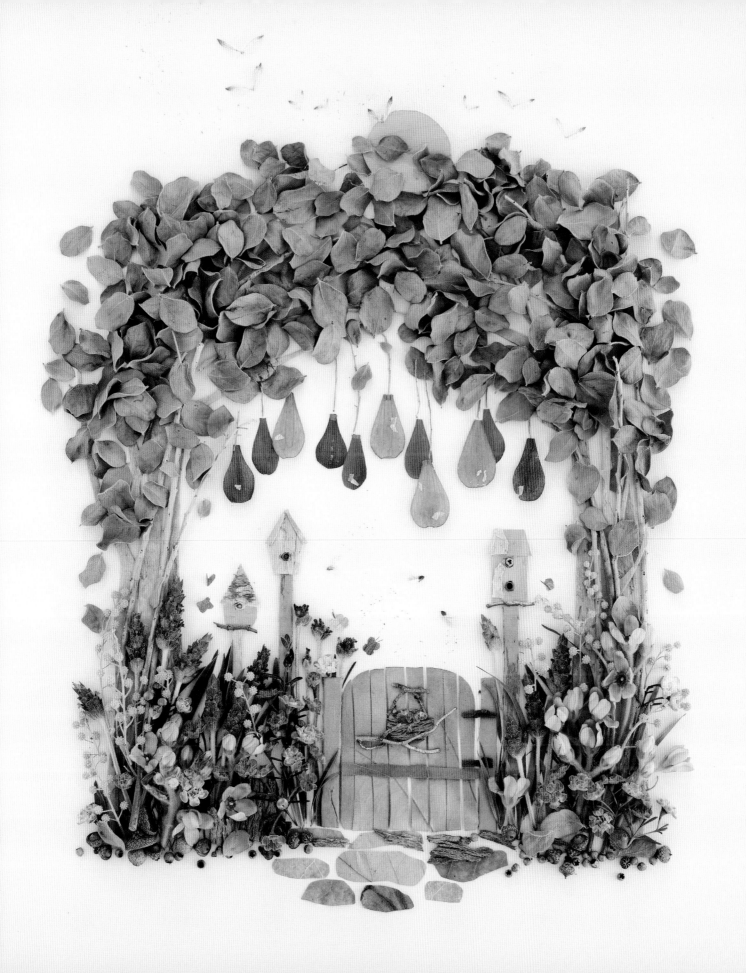

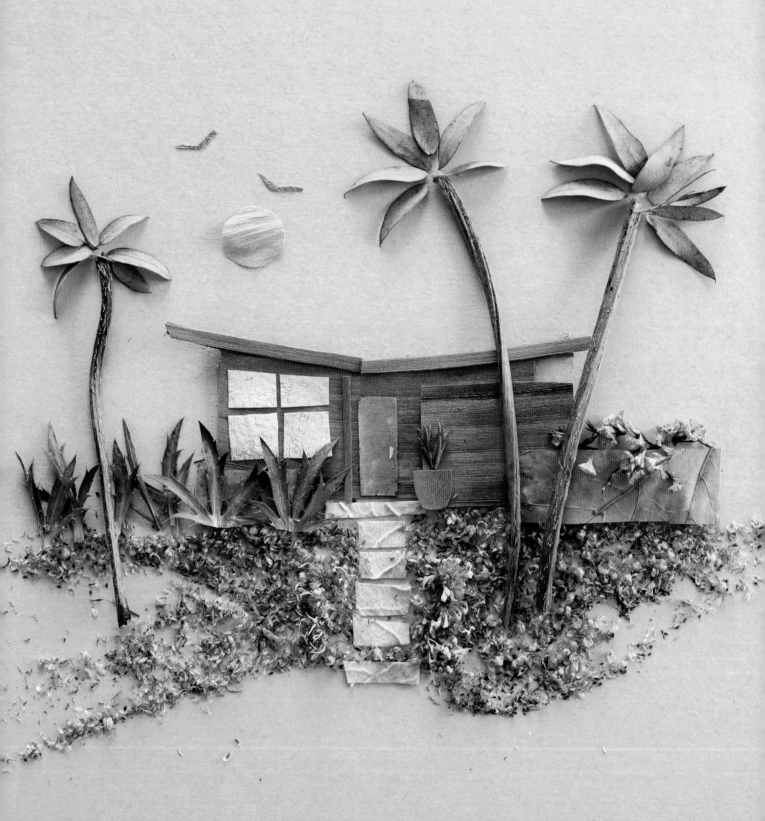

Home Sweet Home

I first started playing with parts of plants when I was a child, building little houses out of sticks, leaves, and clover. I was enthralled with creating special little dwellings for my tiny dolls. I absolutely loved constructing all the small details, like the front doors and windows, and the flowerpots for the entrances. I was the girl that never wanted a Barbie Dream House because I wanted to make my own. I'm still that girl.

MID-CENTURY BEACH HOUSE

Traveling keeps me inspired, even if it's just a trip around my neighborhood. The piece *Olivetas St.* is my version of a house that I drive by frequently in La Jolla on, you guessed it, Olivetas Street! Down the block from Olivetas Street is Windansea Beach.

OLIVETAS ST

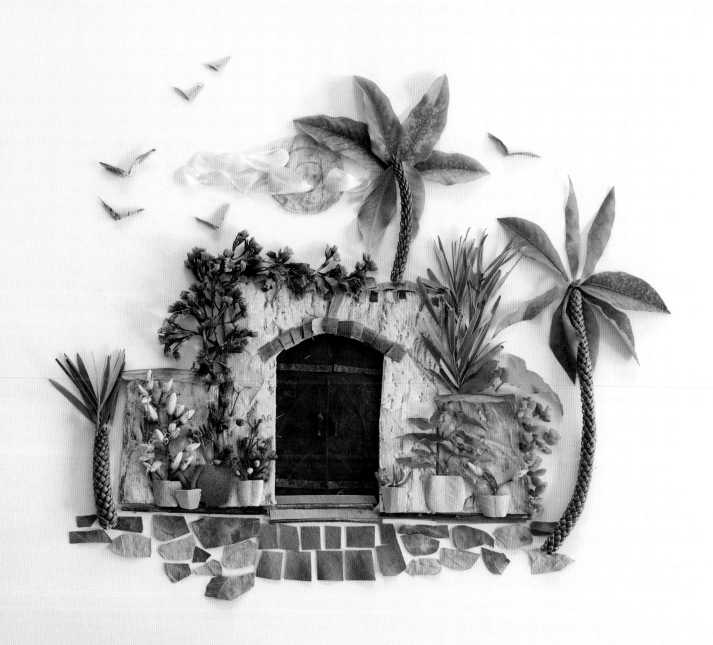

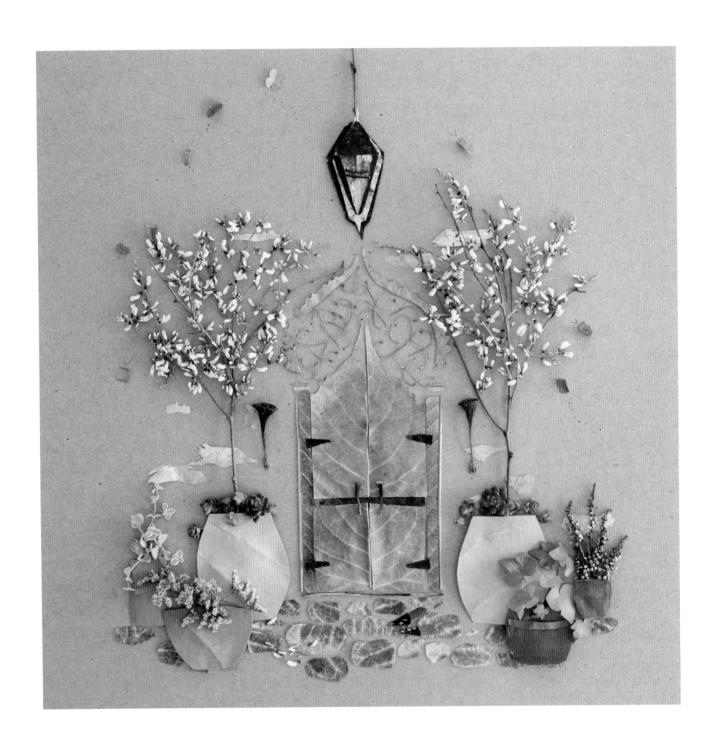

In 2018, Brooke and I were lucky enough to take a "sourcing and sightseeing" trip to Morocco. The streets in Marrakech Medina are lined with striking pink walls and the most incredibly ornamented doorways. Pottery, vintage carpets, all kinds of textiles, hand painted ceramics, and silver jewelry are aplenty in Marrakech. *Morning in Marrakech* was inspired by this unforgettable experience.

MORNING IN MARRAKECH

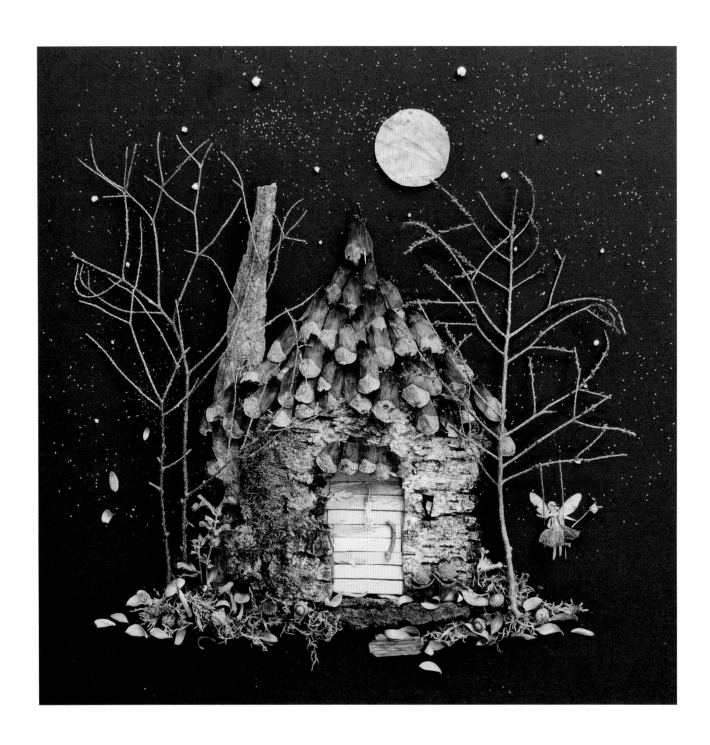

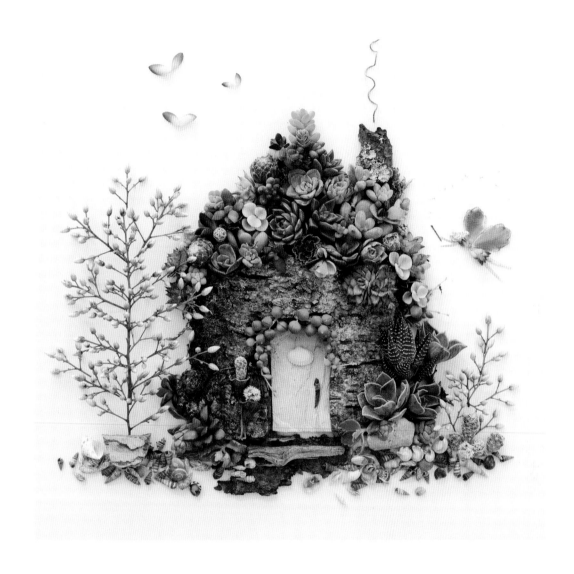

Every fairy needs a succulent dream house, just ask her!

LEFT: FAIRY DUST • ABOVE: FAIRY BLOOMS

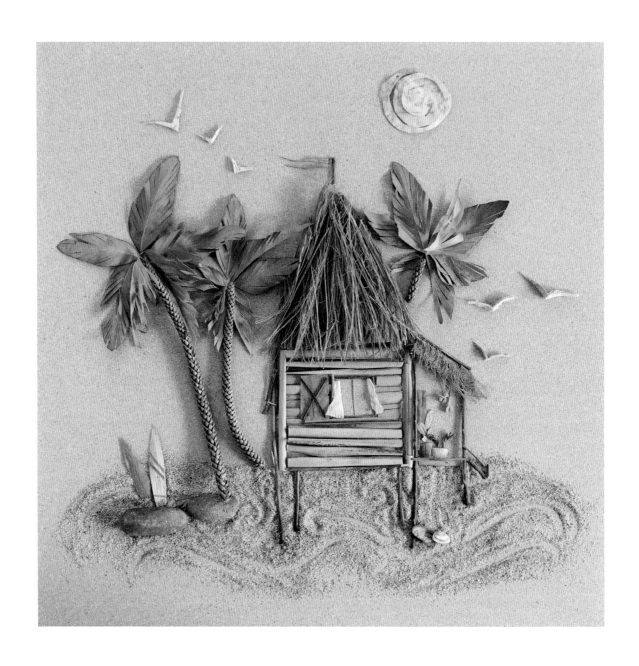

ABOVE: WIND AND SEA • RIGHT: COTTAGE ROW

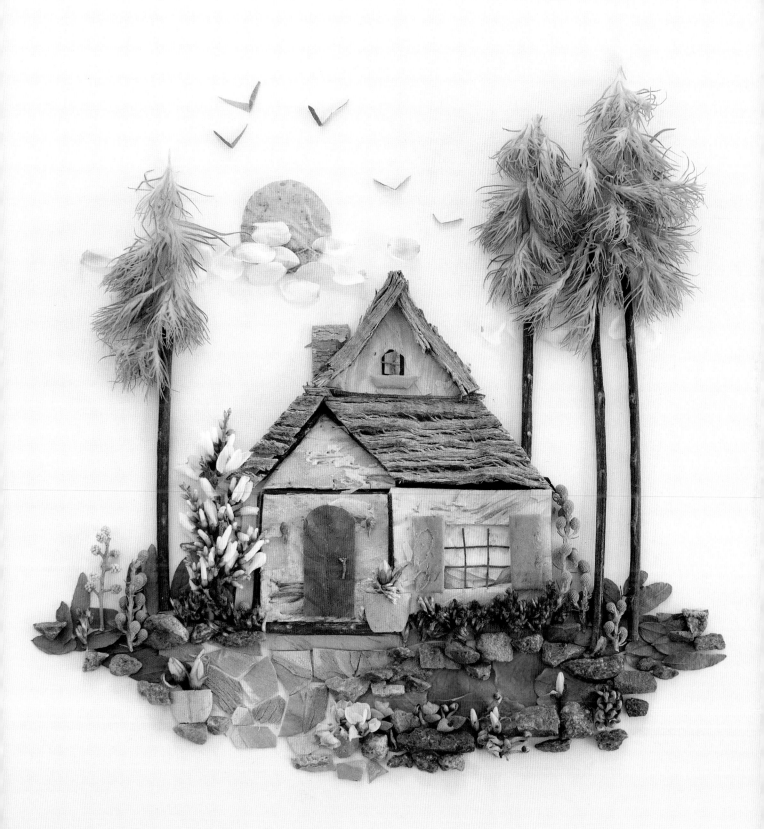

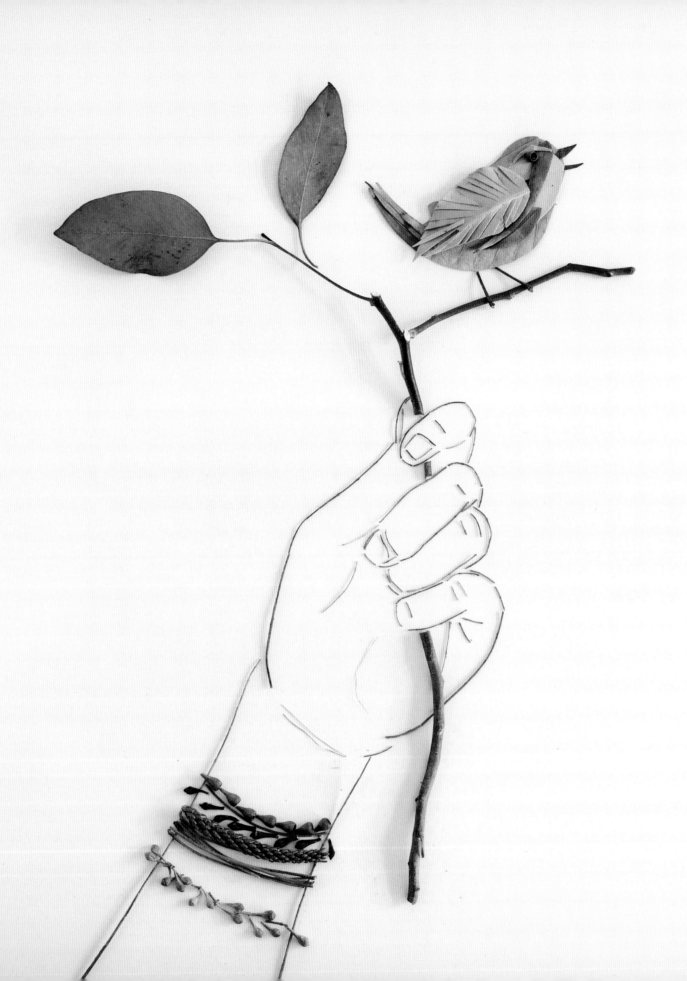

Hands

Ask any artist and they might say that hands have to be one of the hardest things to draw, paint, or re-create. All of these different renditions began with the same hand. I figured if I didn't completely mess it up, I'd try and tweak it to see if something emerged from it. Out came the little bird, then Pride, and then the American flag. The hand was the gift that kept on giving! I messed up the fingers a few times and kept having to redo them, but I knew it would be worth it in the end. And it was.

BIRDS OF A FEATHER

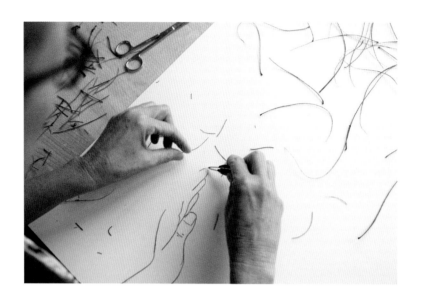

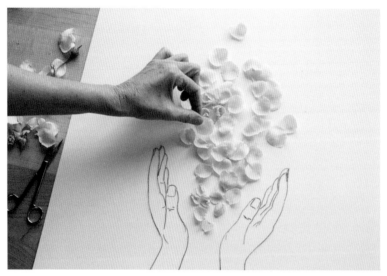

HANDS HEART

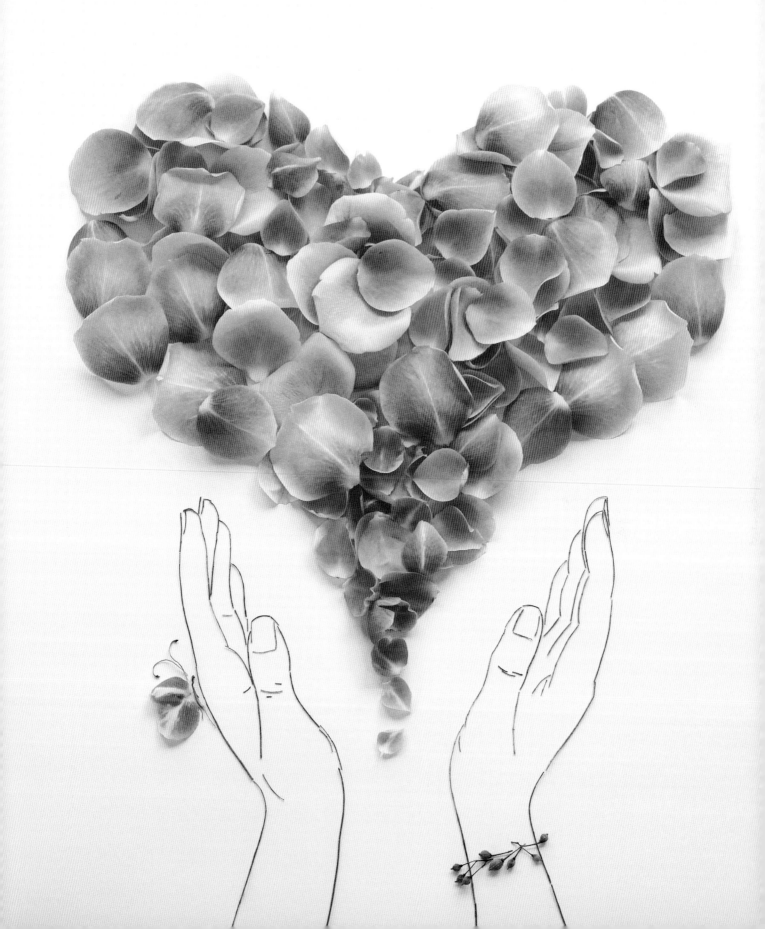

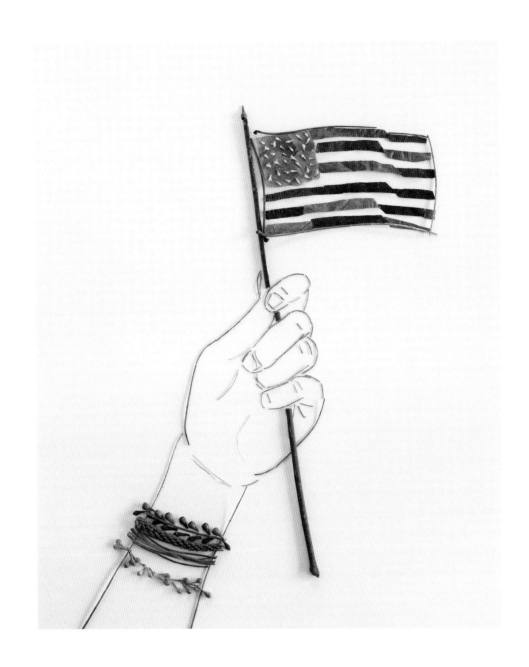

AMERICAN FLAG

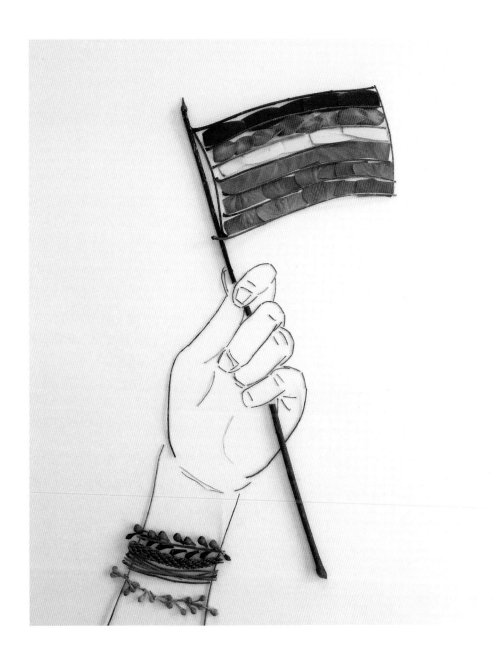

As a kid, going to the Fourth of July parade was always one of the most exciting things to do; leaning into the street and waving our tiny flags. Flash forward 60 years and it is equally important to wave a pride flag for our LGBTQ family and friends!

PRIDE

Conclusion

Foraging for foliage and using it in my art has been a transformative and beautifully essential part of my healing journey. My mother might say that it's also brought elements of my life full circle. She is not only a plant-whisperer in her own home and garden, but also has worked as a florist and floral designer, using stunning photography to document her blooms. I always thought my mother had secret plant powers, so it makes sense that she informs and inspires my own art. Her most recent gallery show, at age 82, was a showcase of her striking floral photography, alongside my own floral art.

Through the course of our lives, unexpected, and sometimes devastating, challenges come at us without warning. When my life was derailed by my debilitating illness, I grappled with the notion that my work as an artist was over, that a major part of my identity and self-expression had been taken from me. But my creative soul was stronger than my grief and it led me to the foliage art contained in this book. A new life, a new concept, but the same creative, inquisitive, and wonderously artistic woman that I am. I don't know if I would have found this magical medium if I hadn't had my other mediums taken away. This experience has taught me not only that loss makes room for the new, but to see the world on a more micro scale. To really look at everything around me, to meditate on and be mindful of the precious details, and to lean on others, like Brooke, when I'm in need of positive affirmation and a little dose of sunshine.

Fear can be the catalyst for digging ourselves deeper into a dark place, or propel us into being the very best version of ourselves. I've been back and forth on the fear scale too many times to count, and I know the only way out is to finally let go and trust things will work out. It's not my job to figure it all out. I'm leaving that to something much greater than myself. This is where life-changing opportunities are given the space to "show up" and cause us to grow.

Getting outdoors is where I can empty my head, and where inspiration can be encouraged. While I'm standing among the trees and out in the fresh air, it never takes long for the ideas to start flowing.

I hope this book has inspired you to spend more time outdoors. Try walking without an agenda; the plan isn't to go anywhere. Let yourself feel your way around, soaking up all the sounds, scents, and energy that is our Mother Earth. Make taking breaks from technology and getting outdoors a practice for sparking inspiration and healing. Let Mother Nature pull you back in, reminding you that you are not separate from her. And if by chance you find yourself walking with your head down and see earrings where you once saw acorns, sit down and play.

Brooke

People often ask if my daughter Brooke also creates foliage art. We both get a kick out of this but completely understand why people might make this assumption since we have a business together. Although she doesn't create the artwork, Brooke is the sole reason anyone is seeing it.

When I started doing this work, I was creating for myself, just for fun. I would take pictures of some of my pieces and send them to Brooke. I thought she might want to see what Mom was up to. Her first reaction was to insist that I start taking pictures with a real camera rather than my phone. With a reaction like that, I figured she didn't think what I was doing was totally terrible. Brooke gave the encouragement I needed to keep going.

Then, she asked me if she could start sharing what I was doing on social media. Although I've always had a love/hate relationship with these social platforms, the truth is, I wouldn't be writing this book if she hadn't shared my art with the online community.

Brooke has also taken on the task of "caretaker" to all my flower babies. I have zero skills when it comes to the computer-gymnastics that it takes to polish digital art and get it out into the world, so after I take photos of my finished work, she takes it from there and posts it online.

Her support and encouragement have led to my work being shared and sold around the world, which is totally mind-blowing to me! I cannot adequately describe the gratitude I have for all of her hard work and patience. Working with her as a mother and daughter team has been one of the most rewarding things I've ever done in my life. She was as important in getting this book written as I was. In my eyes (and many others), she's a total rock star.

About the Author

Vicki Rawlins is an artist living and creating between the lush woods of Door County, WI and the seaside town of La Jolla, CA. Both terrains provide equally beautiful, but vastly different foliage for her artwork made from 100% Mother Nature. With this artform, her paints are twigs and petals, and her paintbrush is a pair of tweezers and scissors. Throughout her 50+ years as an artist, Vicki has explored many mediums, including oil and watercolor painting. It was only 7 years ago that she began borrowing from the earth to create detailed botanical pieces.

The catalyst for her latest exploration in mediums is a life changing turn of events that begins with a prescribed round of a common antibiotic. One that leaves her with debilitating pain. Her journey to navigate a new normal in a new body leads her down a path of meditation, evolution, inspiration, and surrender. Flower art showed up for her when she needed it the most, revealing to her the true power of flowers.

When Vicki's not creating art in her studio, she plays the role of co-founder of Sister Golden, alongside her daughter Brooke. Their home and lifestyle store in Fish Creek, WI houses the work of independent artists and artisans from around the world. Naturally, part of the shop is a dedicated gallery space for Vicki's flower work. Sister Golden is also very engaged online both at sistergolden.com and on Instagram @sistergoldenshop.

Vicki's work has been featured by *What Women Create*, *Spirituality & Health Magazine*, *Better Homes & Gardens*, *Martha Stewart*, and *Buzzfeed*. You can find her pieces hung in homes around the globe.

Many Thanks!

Mom and Dad, thanks for nurturing all my creative passions. Mom, thank you for being a true plant-whisperer and showing me that life without plants just isn't fun. Dad, thanks for all your spiritual wisdom. Watching you go through your own physical challenges with such grace taught me so much. I miss you.

Julie, Darlene, TJ and UT, thanks for all your unconditional love and support. From hammers, nails, and paintbrushes to OG shop girls. I love you! UT, thanks for letting us borrow your wife for a whole summer so we could get up and running.

My sweet husband Craig, no words seem good enough. Since day one, you have encouraged and supported all my artistic passions. Sister Golden isn't Sister Golden without Mr. Golden. You always make me feel like I can do anything.

Andrew, you continue to teach me so much and remind me every day to get out of my own way. Thanks for being a guiding light.

Matt, where would I be without all of your camera coaching and patience? You're always there to get me out of all my photography troubles. Thanks for all your patience and being the best son-in-law ever.

To the most incredible team of women ever: Alex, Mary, Danielle, and Jill—not one print, card, journal, or calendar goes out into the world without being touched by your beautiful energy, care, and love. I can't thank you enough for treating my art as if it were your own. You are all rays of sunshine and I'm so blessed to have you all in my life.

Hannah and Miranda, thanks for everything, always.

Justina Blakeney, Cheryl Lemon, and Virginia Keselowsky, thank you, ladies, for all your "playing with plants" inspiration.

To the Quarto Group, including Rage Kindelsperger, Sara Bonacum, Laura Drew, and Erin Canning—I can't thank you enough for asking me to share my work in a book. You are a dream to work with. Thank you for making sure Brooke and I felt right at home as beginners to all of this.

To all the amazing people over the last seven years who have supported me, whether you own a piece of my art, follow along on social media, or have visited our gallery in person—I feel the love every day and no words can express my gratitude. Your enthusiasm keeps me motivated.

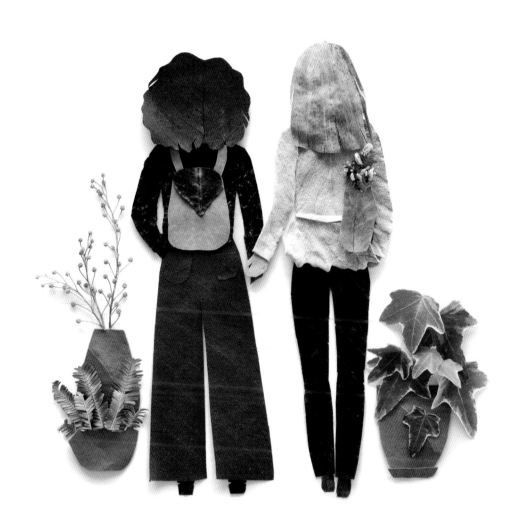

GAL PALS

Brimming with creative inspiration, how-to projects, and useful information to enrich your everyday life, quarto.com is a favorite destination for those pursuing their interests and passions.

First published in 2022 by Rock Point, an imprint of The Quarto Group,

142 West 36th Street, 4th Floor, New York, NY 10018, USA

T (212) 779-4972 F (212) 779-6058 www.Quarto.com

Rock Point titles are also available at discount for retail, wholesale, promotional, and bulk purchase. For details, contact the Special Sales Manager by email at specialsales@quarto.com or by mail at The Quarto Group, Attn: Special Sales Manager, 100 Cummings Center Suite 265D, Beverly, MA 01915 USA.

10 9 8 7 6 5 4 3 2

ISBN: 978-1-63106-870-6

Library of Congress Cataloging-in-Publication Data

Names: Rawlins, Vicki, author.
Title: The power of flowers : turning pieces of mother nature into transformative works of art : foliage art / by Vicki Rawlins.
Description: New York, NY, USA : Rock Point, an imprint of The Quarto Group, 2022. | Summary: "The Power of Flowers showcases the art of Vicki Rawlins and demonstrates how she uses foliage from the natural world to build collages of portraits, scenes, and animals."-- Provided by publisher.
Identifiers: LCCN 2022004330 (print) | LCCN 2022004331 (ebook) | ISBN 9781631068706 (hardcover) | ISBN 9780760376430 (ebook)
Subjects: LCSH: Preserved flower pictures.
Classification: LCC SB449.3.D7 R386 2022 (print) | LCC SB449.3.D7 (ebook) | DDC 635.90222--dc23/eng/20220321
LC record available at https://lccn.loc.gov/2022004330
LC ebook record available at https://lccn.loc.gov/2022004331

Publisher: Rage Kindelsperger
Creative Director: Laura Drew
Managing Editor: Cara Donaldson
Editor: Sara Bonacum
Cover Design and Interior Layout: Beth Middleworth

Printed in the United States of America